Steve Miller

BEASTS!

How to Draw Fantastic Predators, Creepy Crawlies, and Cryptids

Watson-Guptill Publications

New York

Copyright © 2007 by Steve Miller

Senior Editor: Candace Raney
Editor: James Waller
Designer: Jay Anning, Thumb Print

First published on 2007 by Watson-Guptill Publications,
Nielsen Business Media,
a division of The Nielsen Company
770 Broadway, New York, NY 10003
www.watsonguptill.com
ISBN 10: 0-8230-1668-4
ISBN 13: 978-0-8230-1668-6
Library of Congress Control Number: 2007938702

Printed in Malaysia

First printing, 2007

1 2 3 4 5 6 7 8 9/10 09 08 07

This book is dedicated to Jeff and Susan, who were brave enough
to venture into the wild unknown and join the Miller family pack.

CONTENTS

About the Artists

Steve Miller has worked in numerous areas of the entertainment field. His drawings have been used in the production of videos, toys, RPGs, and video games. He is the author of four other books in the Fantastic Fantasy Comics series—*Freaks!, Gung Ho!, Hi-Yah!,* and *Dinosaurs*—and, with Bryan Baugh, the coauthor of *Scared! How to Draw Fantastic Horror Comic Characters.*

Brett Booth is a renowned comic book artist who has gained acclaim for his portrayals of Marvel's mutants, the X-Men, as well as the web-headed wonder, Spider-Man, in the Backlash/Spider-Man crossover. He currently illustrates the comic book adaptations of Laurell K. Hamilton's Anita Blake novels for Dabel Brothers Productions.

Bryan Baugh is an animator with experience at Disney, Warner Bros., and Sony, among other animation houses. With Steve Miller, he coauthored *Scared! How to Draw Fantastic Horror Comic Characters,* and he is the author of *Zap! How to Draw Fantastic Sci-Fi Comics* and *Swords and Sorcery! How to Draw Fantastic Fantasy Adventure Comics.*

Bernie Wrightson is widely recognized as a master of the macabre and as a master artisan in various media, including paint, pencil, and—especially—pen and ink. His many comic book illustration credits include *Swamp Thing, Creepshow, House of Mystery, House of Secrets, Creepy, Eerie, Twisted Tales, Freakshow,* and countless other publications.

INTRODUCTION

HAVE YOU EVER BEEN ENCHANTED BY THE EXPLOITS OF THE FEARLESS lion tamer when the circus comes to town? When you go to the zoo, which animal do you race to see first? Do you amble toward the docile koala bears and the tame gazelles, or do you dart past those dull plant eaters and make your way to the much more exciting big-cat enclosure? At the aquarium, do you get a charge from pressing your nose to the glass of the shark tank? If you are like most people, you get a special kind of thrill from observing the exploits of the more dangerous, carnivorous members of the animal kingdom.

Animalia—the animal kingdom—is one of the five main categories biologists use to classify living things. It is the largest and most diverse category, including *all* the animals of both land and water. Tiny ants weighing just a few milligrams are members of the kingdom Animalia, as are enormous African elephants, which can range up to 27,000 pounds. Sea animals include everything from the lighter-than-a-feather Irukandji jellyfish (a stinging jellyfish of Australia) to the 200-ton blue whale. And our knowledge of the animal kingdom's immense diversity is constantly expanding, with new species being discovered every week. In fact, scientists are not exactly sure about just how many different animal species inhabit our planet, although there are probably at least a million—and that's not counting the many varieties of animals that have gone extinct.

Unfortunately, scientists are not able to discover and correctly categorize new animals at the same rate at which species are disappearing from our planet. In other words, it's believed that many species are becoming extinct before we even know that they exist.

As artists, we can depict living creatures in all their natural beauty and, in doing so, help increase the public's awareness of the plight of so many of the wonderful animals with which we share the earth.

And when it comes to the thrillingly dangerous animals that are the subject of this book, we artists have a distinct advantage over lion tamers and zookeepers: We can study, contemplate, and marvel at these deadly beasts from the security of our own drawing desks!

BIG-GAME DRAWING

DRAWING ANIMALS OFFERS UNIQUE CHALLENGES. AT FIRST GLANCE, animals seem to be constructed of a wide variety of shapes put together in all manner of ways. Once you start studying the underlying shapes of the members of the animal kingdom, however, you realize that many animals share several common design features. In fact, if you concentrate on understanding the simple building blocks of animal anatomy you will find it is easy to modify what you've learned by drawing one kind of animal and to apply it to your construction of the next. Because there's so much to learn about drawing animals successfully, you'll find a lot of new information in this book. Take it in at your own pace, and keep coming back to the areas you have trouble with. With plenty of practice you'll start getting the hang of drawing realistic animals— creatures with believable volume and fluid forms.

ANIMAL ANATOMY

Unless you run an exotic petting zoo out of your backyard, you'll need to have plenty of reference photos for your animal drawings. Always try to have either still pictures or videos on hand of the animals you're rendering. If you have cable television, look out for upcoming animal specials on the Discovery Channel or Animal Planet and record them for reference to animals in action. (You can pause the video during action sequences and sketch loose drawings, trying to capture the essence of the animal in action.)

Since most quadrupeds (four-legged animals) have a similar range of motion, you can also study your own cat or dog to see how the different forms of your pet's body look when it is in motion. My own dogs became quite weary of me moving and posing their legs in the course of writing this book! You may also find it helpful to watch some animated films or programs featuring animal characters to see how other artists have interpreted the animal form in motion. But remember always to go back to the actual animal and to base your drawings on the real creature rather than someone else's interpretation.

If you feel you are in over your head, don't worry! So many artists spend years mastering the human form that they totally forget there are thousands of others animals inhabiting the natural world. When I think back to art school, I can count on one hand the number of assignments that dealt with animal forms. On the few occasions we were required to draw a creature with more than two legs, it was usually a horse, so it wasn't until I started freelancing that I was required to start drawing furry, feathered, and finned beings with any regularity.

All Creatures Great and Deadly
The animal kingdom isn't all that peaceable. If you were really to find all these creatures together in one place, it wouldn't be too long until some fights broke out!

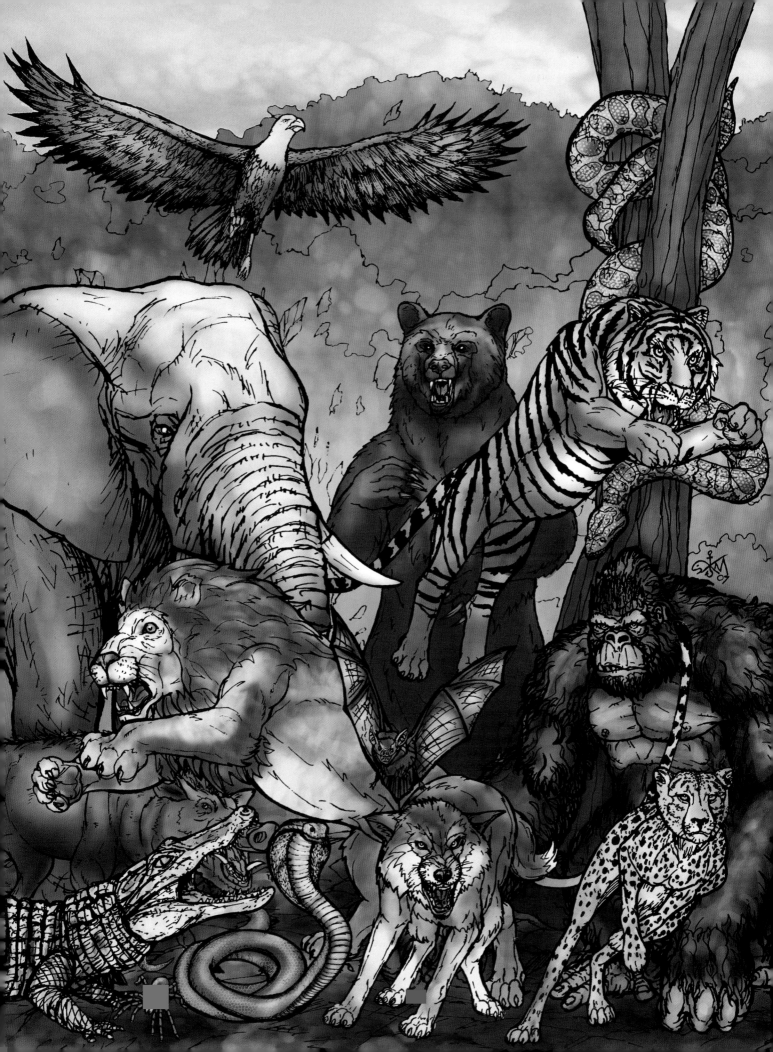

By then I had a pretty good understanding of human anatomy, but now I needed to learn how to draw animals with the same level of accuracy. Once I started studying animal anatomy, I realized that although animals may look very different from us, many of their body parts are the same. Since we share so many of the same bone configurations and joint placements as our animal friends, human anatomy isn't such a bad starting place after all.

You may find it helpful to call some of an animal's anatomical features by the names of their human equivalents. Instead of forelegs and hind legs, you can think of animals' limbs as arms and legs. Once you look at a few of the skeletons I've drawn for you, you'll even see how similar the human hand and foot are to animals' paws.

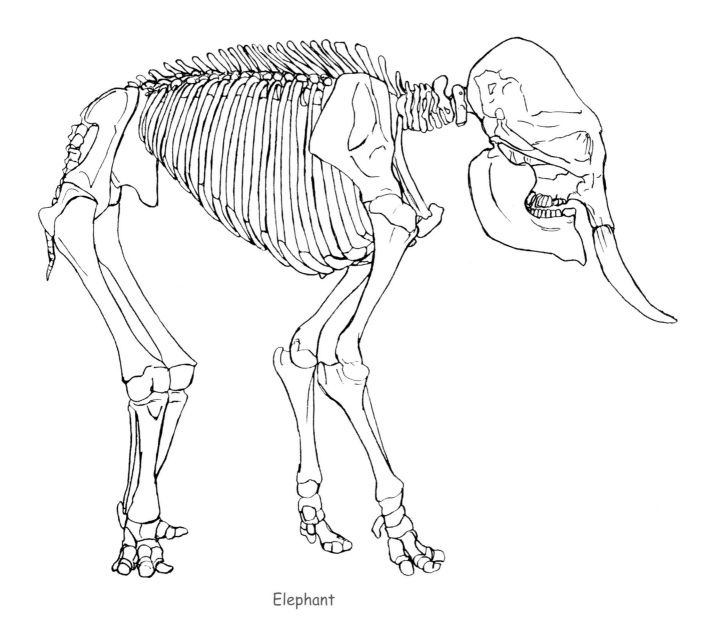

Elephant

Support Structures

Look at these skeletons of four animals. The final configuration of the various animals may be quite different, but the underlying bone and joint structures are very similar. Recognizing this may be helpful if you are having trouble remembering which way a particular limb moves or bends. If you reference your own anatomy, you should be able to figure out pretty quickly how the same limb functions on an animal.

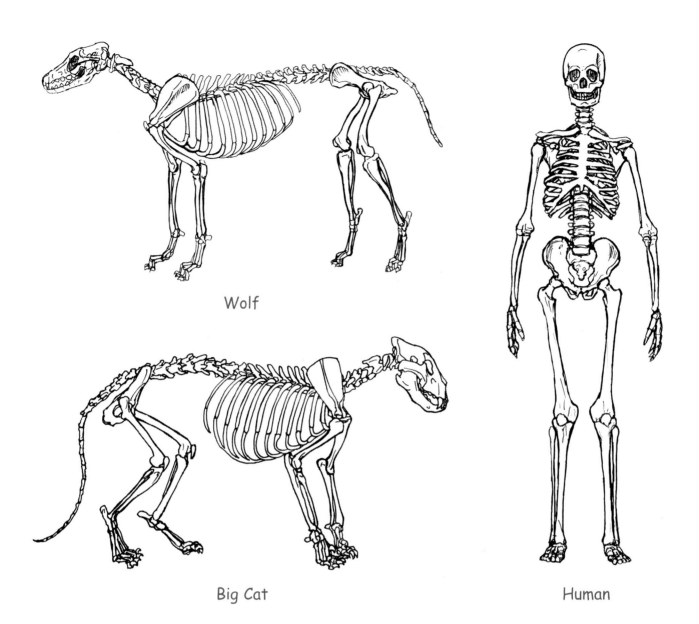

Wolf

Big Cat

Human

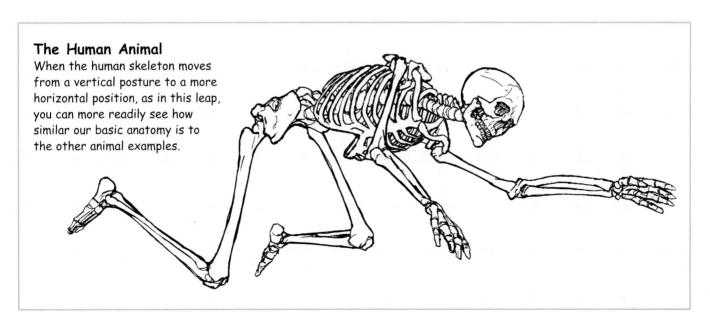

The Human Animal

When the human skeleton moves from a vertical posture to a more horizontal position, as in this leap, you can more readily see how similar our basic anatomy is to the other animal examples.

BASIC BUILDING BLOCKS

On these pages I've shown a few of the many animals you will encounter later in the book, and I've broken them down into the basic shapes you will have to master if you want to become an artistic expert in the wild kingdom. Just as animals' and human beings' skeletons share with us many of the same bones, so do they also have many of the same basic divisions in their major body masses. I've divided each of these animals into head, neck, shoulders, torso, pelvis, legs, and tail. These basic anatomical structures will reappear in most four-legged animals. I've also included some more exotic examples that, although obviously quite different from one another, can still be easily constructed by utilizing basic building-block shapes.

These studies are here to teach you one of the primary lessons of drawing from life—to give your animals a sense of *volume*. A drawing will appear flat and awkward if you don't adequately convey the animal's weight and mass. Starting with blocky shapes will help you build a believable animal form. Do remember, though, that you are drawing living, organic beings—not mechanical robots—so once you have the building blocks established, start rounding them off and putting lively curves into your final drawing.

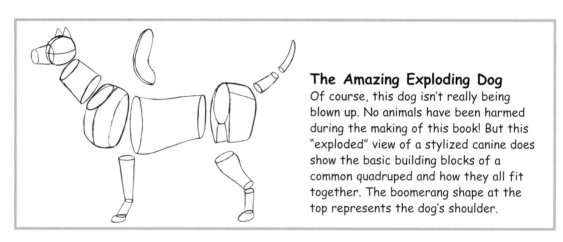

The Amazing Exploding Dog
Of course, this dog isn't really being blown up. No animals have been harmed during the making of this book! But this "exploded" view of a stylized canine does show the basic building blocks of a common quadruped and how they all fit together. The boomerang shape at the top represents the dog's shoulder.

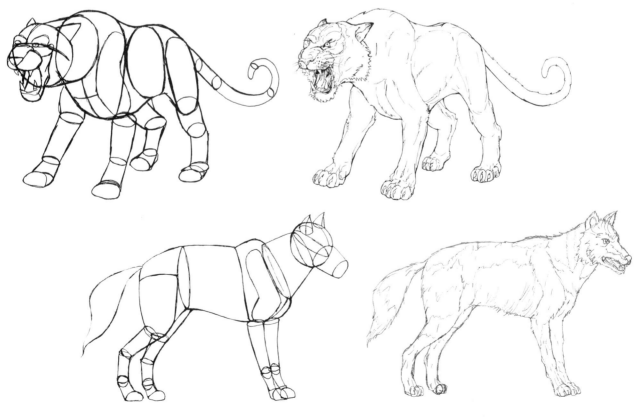

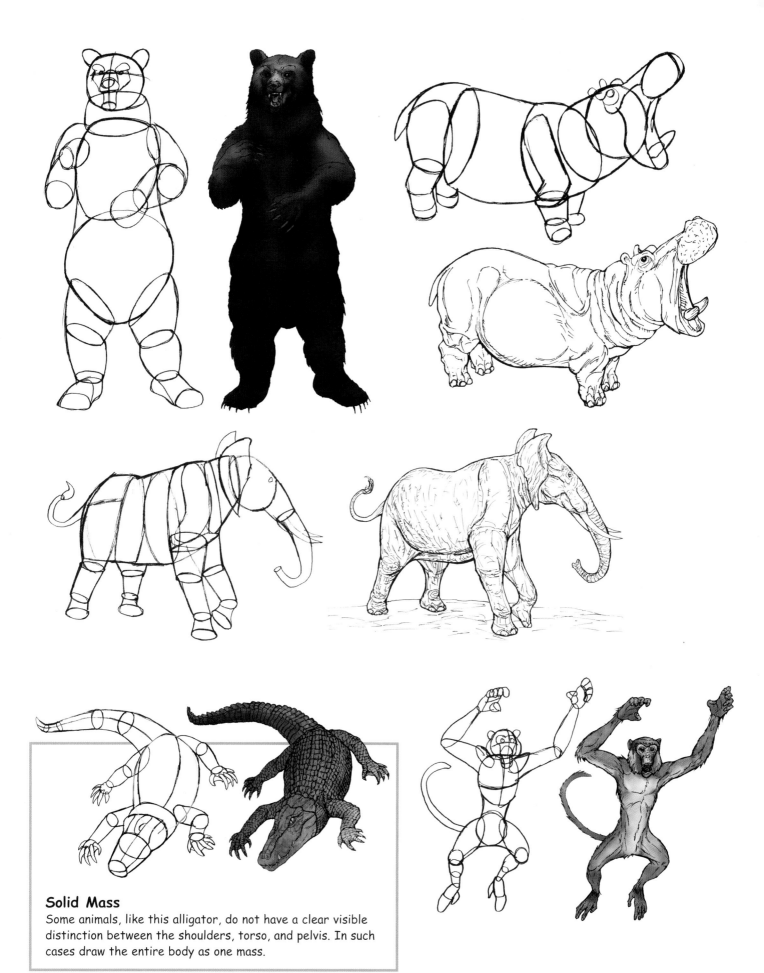

Solid Mass

Some animals, like this alligator, do not have a clear visible distinction between the shoulders, torso, and pelvis. In such cases draw the entire body as one mass.

ANIMAL LIMBS

One common error you must try to overcome early on is misunderstanding how animals' legs work. An animal's legs are not stuck on the bottom of its body; they actually begin much higher up, originating in the shoulders and the hip. This is often hard to see, since the limbs arch away from the body gradually and are very close to the body at the point of origin. The difficulty in seeing this is compounded by fur and by the fact that some animals' skin fits them more loosely than does a human's skin—so deciding where the limb originates is a little like trying to figure out where someone's arm is when they are wearing a baggy sweater.

When a quadruped moves, the motion will begin up high on the body and work its way down. Unless you draw the whole shoulder or hip mass that's involved in the movement, the animal will appear stiff and unnatural. Even though the shoulders and hips will often be concealed by fur or other skin coverings, it is important always to be mindful of their locations when constructing your animals' forms.

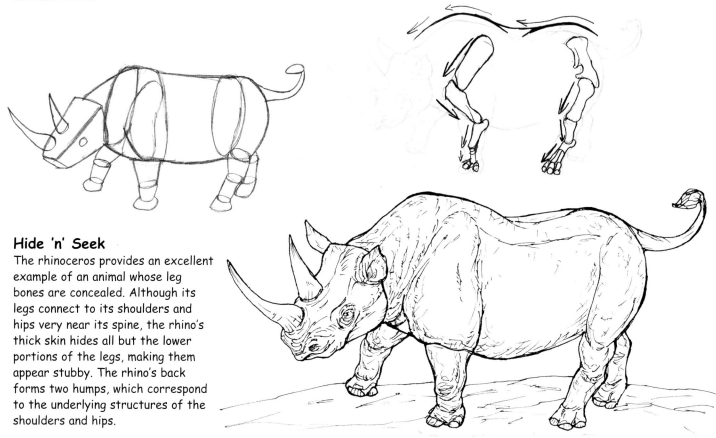

Hide 'n' Seek

The rhinoceros provides an excellent example of an animal whose leg bones are concealed. Although its legs connect to its shoulders and hips very near its spine, the rhino's thick skin hides all but the lower portions of the legs, making them appear stubby. The rhino's back forms two humps, which correspond to the underlying structures of the shoulders and hips.

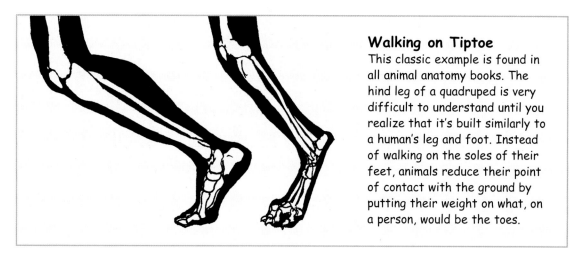

Walking on Tiptoe

This classic example is found in all animal anatomy books. The hind leg of a quadruped is very difficult to understand until you realize that it's built similarly to a human's leg and foot. Instead of walking on the soles of their feet, animals reduce their point of contact with the ground by putting their weight on what, on a person, would be the toes.

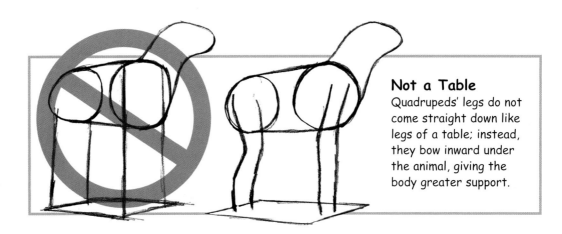

Not a Table

Quadrupeds' legs do not come straight down like legs of a table; instead, they bow inward under the animal, giving the body greater support.

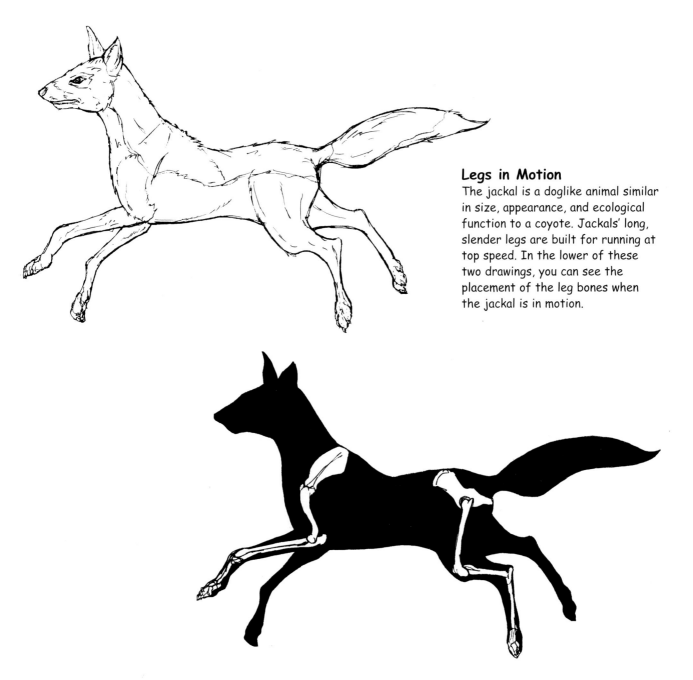

Legs in Motion

The jackal is a doglike animal similar in size, appearance, and ecological function to a coyote. Jackals' long, slender legs are built for running at top speed. In the lower of these two drawings, you can see the placement of the leg bones when the jackal is in motion.

ANIMAL HEADS

When we view a picture of an animal, we tend to focus on its head and face first. That means that it's very important that the head and face convey a sense of emotion and liveliness. Unless you start off with an accurate underdrawing for this step, the details will look "off" no matter how well they're rendered individually. Fortunately, it's easy to get a good solid mass for most skulls by starting with a simple oval.

Headfirst

Look at the human skull and compare it to the skulls of the elephant and polar bear. Sure, the features are different and arranged differently, but the important basic structures are similar. The largest mass is the bony bowl enclosing the brain, and it's this shape that the initial oval will represent.

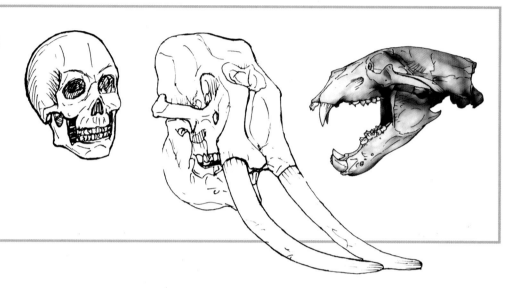

Putting on a Face

Once you have the basic oval, you can divide it horizontally and vertically with guidelines. This sets up a frame on which anatomical features such as the eye sockets, muzzle, and jawbone can be added. Always be mindful of the guidelines so that you place your marks evenly.

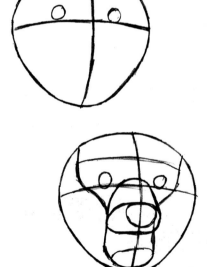

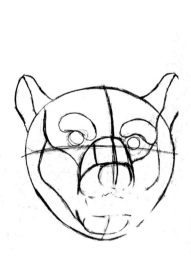

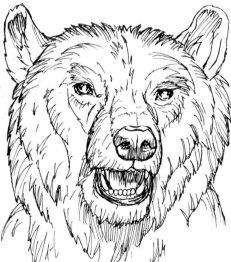

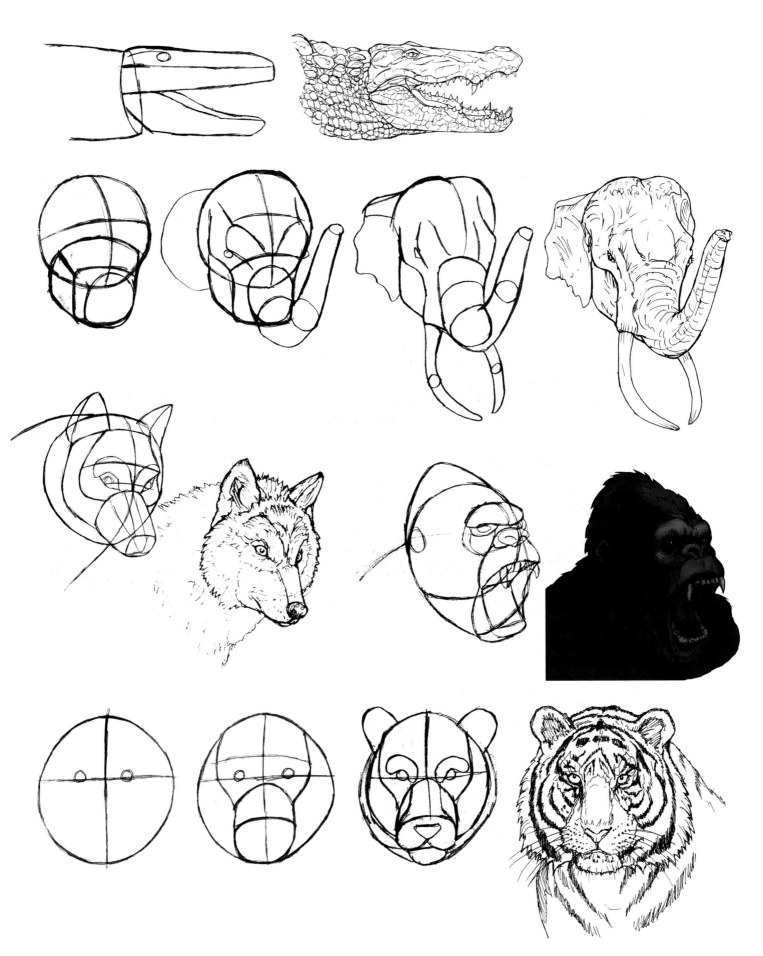

DRAWING FUR

Drawing fur can be challenging, since it's difficult to convey fur's hairy, fuzzy, or shaggy texture realistically. You certainly want to avoid trying to draw each individual hair—which would quickly give your drawing an overworked look. As the illustrations here show, there are a couple of tricks you can use to make your animals' furry coats look real.

Wolf's Clothing

I've tried to emphasize the shagginess of this wolf's fur. Instead of using consistently shaped and sized marks, I've varied the direction and placement of the fur clumps. Doing this will give your final drawings more dynamism and life.

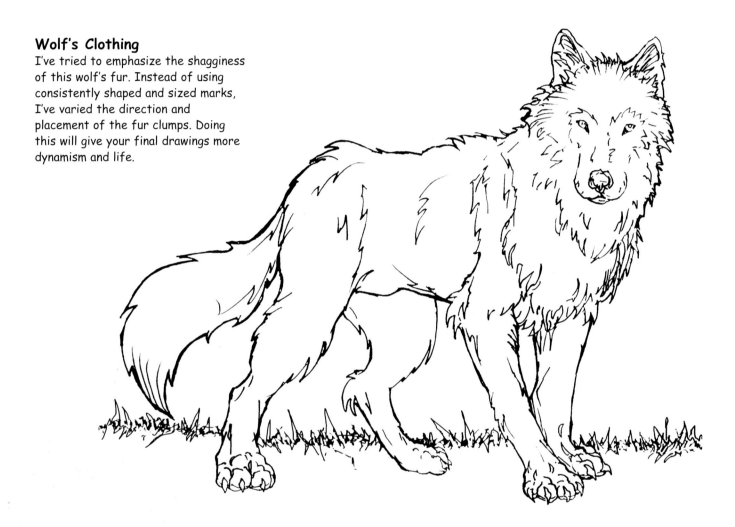

Uneven Lines, Odd Numbers

When drawing fur, vary your line weights and the size and direction of your marks; uniform marks look mechanical and unnatural. Another good rule of thumb is to draw fur tufts in odd numbers rather than even. Groups of three or five look more organic than groups of two or four.

TOOLS OF THE TRADE

For safety reasons, I suggest keeping all man-eating-animal drawings at least a pencil's length away from your hands at all times. Here's a quick rundown of the tools you'll need to corral your wild ideas while unleashing your ferocious imagination.

PENCILS

First up are mechanical pencils, which can be loaded with a wide variety of leads. Clutch mechanical pencils, sometimes called leadholders, use a lead (typically 2 mm to 4 mm) that's inserted into the hollow pencil shaft. Tiny mechanical claws grasp the lead, and when the eraser-end button is pressed, the lead is freed to move forward. Then, when the button is released, the claws again clutch the lead and hold it in place. You must use a special sharpener to add a point to a clutch pencil's lead. The feeding mechanism is a bit tricky for beginners, but the clutch pencil delivers a great range of marks. (By the way, a pencil's "lead" is not made of lead; it's actually a mixture of graphite—a form of carbon—and clay.)

Another type of mechanical pencil is the ratchet pencil, sometimes called a "clicky" pencil. The lead in a ratchet pencil is advanced by pushing a button located at the end of the pencil or on the side. Each time you click the button, the lead advances a few millimeters. The super-thin lead used in ratchet pencils never needs sharpening and produces marks of a single, uniform weight.

Wooden pencils consist of a thin lead surrounded by a wooden cylinder. The wood pencils that artists use are categorized with letters and numbers that tell you how hard or soft the lead is. Hard leads, which make very light lines, are designated by the letter H; softer leads, which make darker lines, by the letter B (for black). A pencil marked H is relatively hard; one marked 2H is harder; 3H is harder still (and so on up the scale). B pencils grow softer as the numbers increase—a 5B pencil is much softer than a 2B pencil. The common writing pencil falls in the middle and is designated HB. Slightly harder than an HB is the F (for fine point).

Artists also commonly use colored pencils when laying down an initial drawing. The "leads" in colored pencils are made of a combination of pigments or dyes and a binding agent. Colored pencils are available in hundreds of different colors, but the ones most commonly used by comic book artists are *nontransferable* (or *non-photo*) light blue and light green pencils. Because photocopiers will not reproduce these pencils' marks, they're perfect for sketching out lines without having to worry about erasing mistakes.

Get the Lead Out
Pencils are the comic book artist's most basic tools.

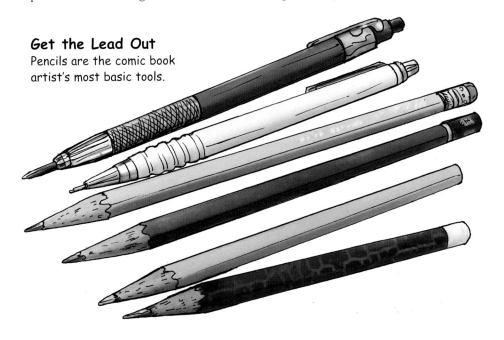

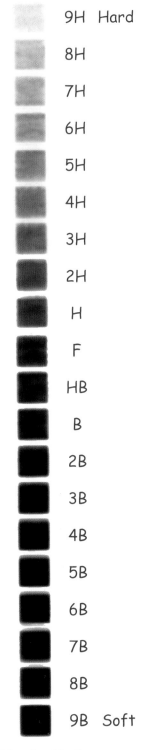

	9H Hard
	8H
	7H
	6H
	5H
	4H
	3H
	2H
	H
	F
	HB
	B
	2B
	3B
	4B
	5B
	6B
	7B
	8B
	9B Soft

Harder/Softer, Lighter/Darker
The harder the lead, the lighter the mark; the softer the lead, the darker the mark. This scale, which runs from the hardest/lightest (9H) to the softest/darkest (9B), shows the comparative values of artists' pencils.

ERASERS

Many different types of erasers are available to the artist, which is a good thing, because we tend to make many different types of mistakes! At first glance it might seem like all erasers are pretty much the same, so that it doesn't matter which you use. Wrong! Use the wrong kind of eraser and you may do more than remove a few stray pencil marks: You might end up rendering the paper's surface undrawable or even tearing the paper.

As a general rule, remember: If it's pink it stinks! Pencil-top erasers and the big pink blocks you used in school might be fine for correcting math mistakes, but they wreak havoc on drawings. They may smear soft pencil lead or leave colored marks on your paper. It is much better to use an eraser specially designed for artists.

One such eraser is called a kneaded eraser. It's made of a pliable gray material with a consistency like Silly Putty's. Art gum erasers are also popular with artists—they're great, all-purpose mistake fixers that won't damage your work. White plastic erasers are good for removing large areas of pencil marks quickly, but you should limit their use to heavier papers and lighter pencil leads since they tend to tear thinner papers and smear softer leads. Fortunately, erasers are cheap, so for a few bucks you can purchase several different kinds and figure out what works best for you.

To Err Is Human . . .

. . . to find a good eraser is divine. Make sure you have a good eraser—or several erasers—on hand to deal with mistakes. A kneaded eraser, art gum eraser, and white plastic eraser are depicted here, clockwise beginning at center left. Also: Keep your pencil points sharp by using a sharpener regularly. The sharpener shown at right is one of many varieties available.

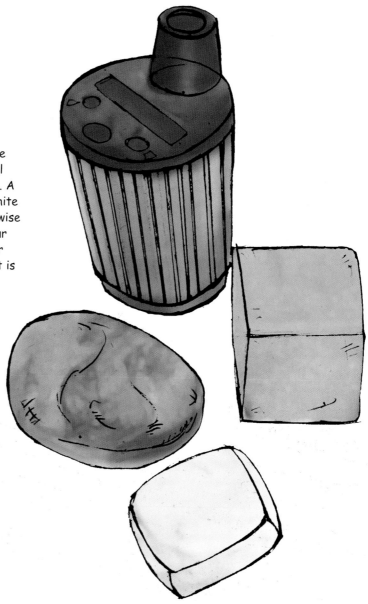

PENS, BRUSHES, INK, AND PAINT

Once you get your drawing just how you want it, you may want to go over it in ink to give it a bit more permanence. If your artwork is going to be reproduced for publication, you are definitely going to want the darker lines that ink produces. When you ink, it may seem like you're just tracing your drawing, but you are actually sharpening and finessing your linework and helping to make your art shine.

Felt-tip pens or markers provide a fast and effective way to produce a variety of marks and effects or to quickly fill in large areas with black, but they do have a couple of drawbacks. For one thing, their ink tends to brown with age. This may be fine if you just want a fast solution and don't plan on selling or displaying the original art, but if you want artwork that looks good in a frame, you'll want to use an India ink–based pen instead. Second, marks made by felt-tip pens tend to be uniform, so if you want a different line weight you have to switch pens. (You can coax a little variation out of some of these pens by varying the pressure.)

Technical pens are similar to markers, but although a technical pen gives a uniform line weight, it does offer a little more control than a felt-tip pen. Technical pens have ink-filled cartridges and are either refillable or disposable, depending on the brand.

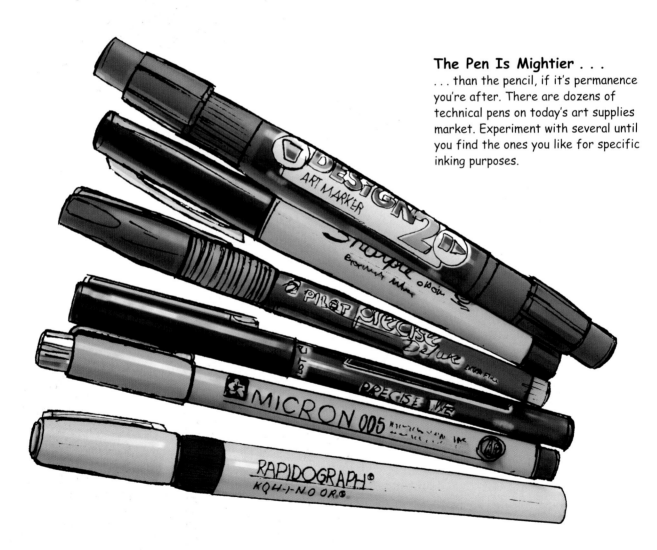

The Pen Is Mightier . . .

. . . than the pencil, if it's permanence you're after. There are dozens of technical pens on today's art supplies market. Experiment with several until you find the ones you like for specific inking purposes.

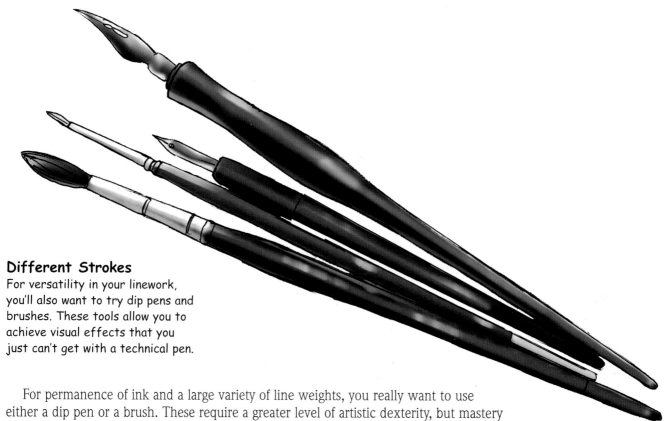

Different Strokes

For versatility in your linework,
you'll also want to try dip pens and
brushes. These tools allow you to
achieve visual effects that you
just can't get with a technical pen.

For permanence of ink and a large variety of line weights, you really want to use either a dip pen or a brush. These require a greater level of artistic dexterity, but mastery of these tools pays off with lively and lush linework, which will greatly enrich any illustration. Because brushes and dip pens do not have ink reservoirs, they must be dipped and redipped into a bottle of ink as you draw. There are several excellent brands of ink, but their availability fluctuates from area to area. The Internet has eliminated some of this uncertainty, but it's still a good idea to patronize a local art supplies store, if possible. The clerks there should be able to help guide your choice.

For organic-looking fur and the greatest variety of line weights, you will also want to use a brush. I suggest a red sable 00 or 02; these are smaller brushes with plenty of life.

Not only does ink give your skilled linework permanence, but it also creates extra-resilient errors. Erasers aren't going to be of much help if you make a stray mark with a pen or ink-filled brush, so you will also need to purchase a jar of white gouache for corrections. (Gouache is opaque watercolor paint.) You will also need a separate brush for your white paint so that you don't accidentally end up mixing your ink and paint together. The paint should not be so thick that you can't easily apply it nor so thin that it doesn't cover mistakes in one or two strokes. I suggest adding a couple of drops of water to the paint until it has the consistency of sour cream.

Black & White

Inking your lines will make
them permanent—but that's a
drawback if you make a
mistake! So besides black ink,
you'll need some white gouache
paint to correct errors.

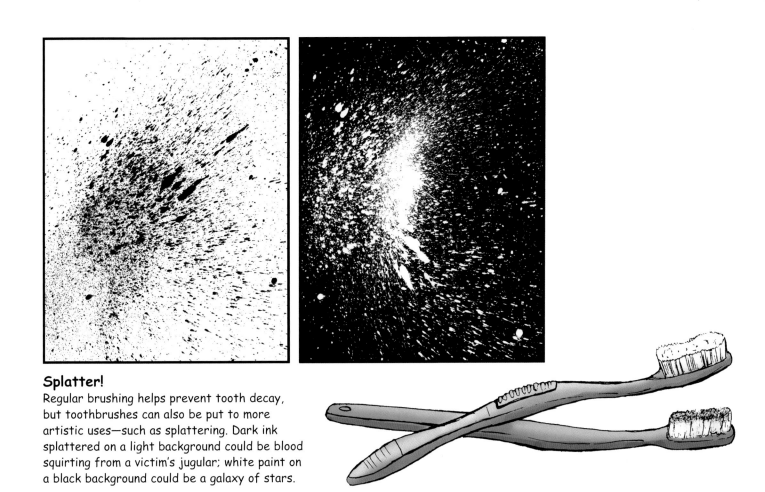

Splatter!

Regular brushing helps prevent tooth decay, but toothbrushes can also be put to more artistic uses—such as splattering. Dark ink splattered on a light background could be blood squirting from a victim's jugular; white paint on a black background could be a galaxy of stars.

White paint is also an excellent way to turn a black background into a star-filled night sky—either by dabbing spots of paint onto the background or by splattering it onto your drawing. For this trick, you might want to play around with your old toothbrush—or your brother's or sister's, if they aren't looking! (You can also splatter dark ink onto a light background.) Depending on how much paint or ink you load the toothbrush with, you can create a fine mist or a heavy spray. You can use this effect to create shading, rock textures, dirt, water splashes, and even the blood spraying from an unfortunate victim as it is brought down under the sharp canines of a predator. This is a difficult effect to learn to do properly, so use scrap paper to cover areas you don't want splattered. And it can be messy, so if the room you draw in is carpeted, you may want to try it out in your garage or even outside.

PAPER

Besides getting comfortable with a variety of pencils and pens, you also have to decide which kind of paper works best for you. If you think there are a lot of choices when it comes to drawing tools, then you will be absolutely stunned at the variety of papers available to today's artist.

Start by buying several different types in small quantities until you find something you are comfortable with. Be aware that more expensive papers are not always better—or not for all purposes. I use plain printer paper for almost all my sketching work. When I need something more durable, I use two-ply bristol board with a smooth finish. (This is stuff most comic books are drawn on.) Paper availability and quality fluctuates quite a bit, depending on which raw materials are available to the paper industry. So when you find something you like, it's a good idea to buy a large quantity.

FEROCIOUS FELINES

LARGE FELINES CAN BE FOUND IN THE WILDS OF THE AMERICAS, AFRICA, ASIA, AND Europe. These awe-inspiring cats can weigh several hundred pounds, but despite the enormous difference in size between, say, a lion and a house cat, the various species of cat are all amazingly similar in both structure and behavior. All cats are carnivores—and extremely efficient predators.

In fact, the big cats are the ultimate hunters on land. Because they eat meat almost exclusively, their anatomical features are perfectly designed for taking down large game. They have strong, muscular bodies, razor-sharp teeth, and long, retractable claws.

The largest cats—lions, tigers, leopards, and jaguars—are members of the genus *Panthera*. They are set aside from the rest of their feline cousins by their ability to roar. Roaring cats are sometimes called the "great cats," while other large species (such as cheetahs and pumas) are simply called "big cats." This distinction between the great and the merely big is underscored by the practice of calling the offspring of great cats "cubs" while the young of the big cats are called kittens.

By the way, if you're researching great cats, big cats, or other kinds of animals, a trip to the zoo is a wonderful way to do some fieldwork before you start doing drawings. One word of caution, though: I find that the animals in my local zoo are better fed than most of their relatives in the wild. Thanks to all those good, regular meals, their bellies are a little fatter and their muscles aren't as well defined.

LION

The lion has long enjoyed the title King of the Jungle, which is a bit of a misnomer, since lions are mostly to be found on the African plains (called savannas), *not* in the jungle. On the other hand, according the lion a royal title makes sense: As with human royalty, the lion's rule seems to combine equal parts of nobility and scandal. A single male lords it over his family, mating with several different lionesses. The male prefers to loaf around during the day, sending the ladies out to do all the hard work of hunting. (Though accomplished hunters, lions are not above exercising their royal privilege by stealing the hard-earned kills of other predators.)

Fortunately, the animal kingdom does not have nightly newscasts or tabloid newspapers—or lions might find their realm under siege! Their success in maintaining their rule is due in part to the fact they are the only cats to live in large family units, called *prides*—a similar setup to that of human royal families, who keep all the relatives together and protected in one castle. And, as human history shows, royal families tend to be constantly looking for more and better territory to rule over. The same goes lion families. Never content to be just the top cats in their own domain, they constantly seek to dethrone rival prides.

Lions employ complex group-hunting techniques that often involve three or more members of a pride, with different lions assuming different roles during the hunt. One lion may scout out the most vulnerable target and then signal another to chase the prey into the path of yet a third ambusher. Lions' natural prey includes wildebeests, buffalo, zebras, antelopes, giraffes, and warthogs.

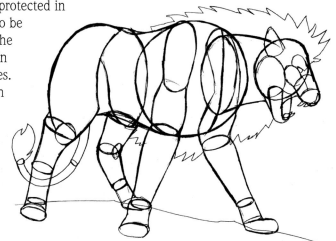

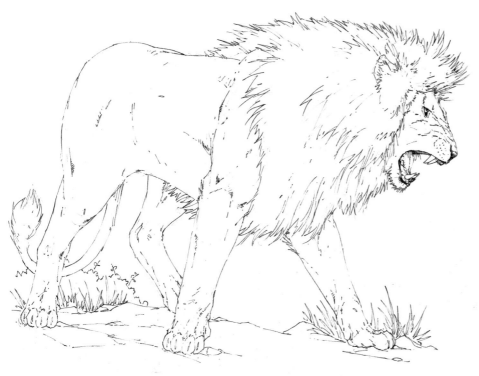

King of the Beasts

A male lion stands about four feet tall at the shoulder and may grow to be eight and a half feet in length (more than ten feet when you throw in the tail) and to weigh five hundred pounds or more. All lions are light brown to dark ochre in color; males also have brown manes, which darken with age.

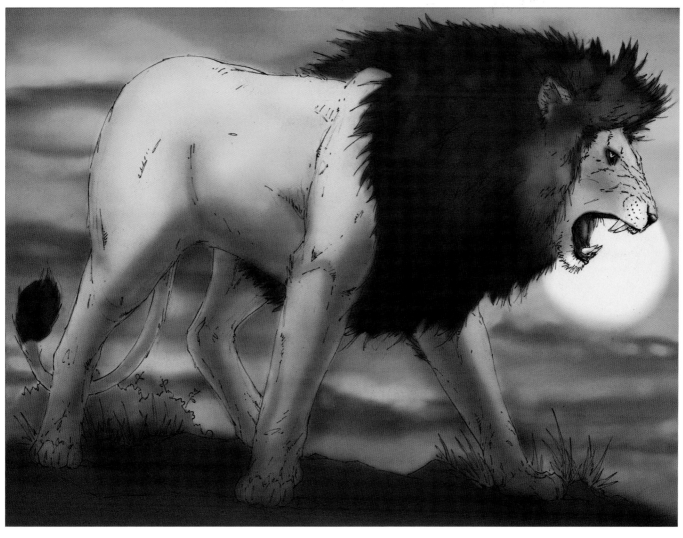

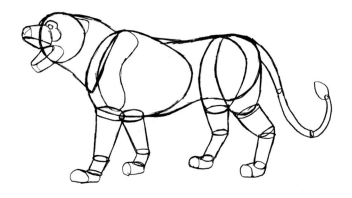

Buff Bodies

Compared to other felines, lions are heavily muscled, and their muscular limbs give them a real advantage during high-speed chases. (When pursuing prey, lions can achieve speeds of thirty-five miles per hour.) When drawing a lion, emphasize its musculature by downplaying the furriness of its hide. Draw long descriptive lines indicating where the limbs connect to the body. Note, too, that lions have large, padded paws with massive claws—excellent for swiping at prey or pinning a foe to the ground.

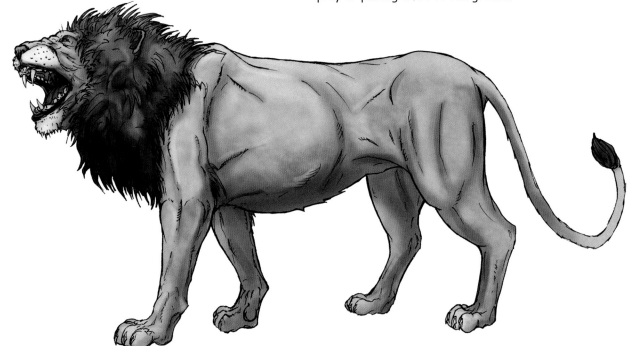

Cat Anatomy

When drawing cats of whatever species, you're dealing with the same basic anatomy—with only slight variations in the shapes of bodies, limbs, and skulls. In fact, tigers and lions are so similar on the skeletal level that it takes an expert to tell the difference between their bones.

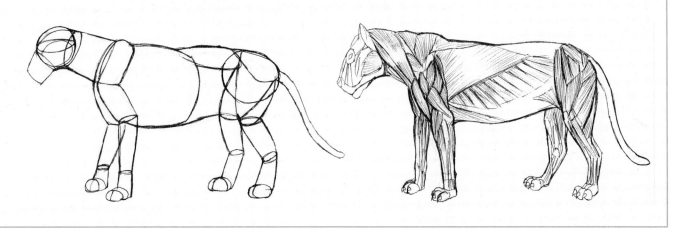

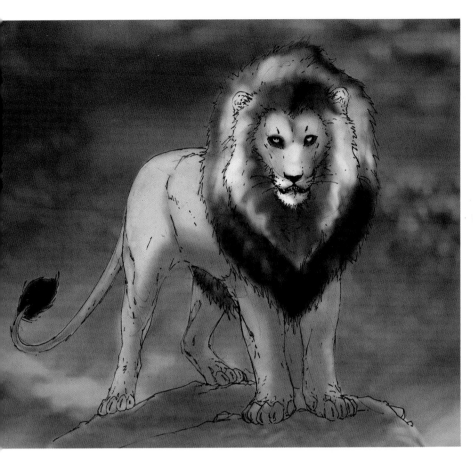

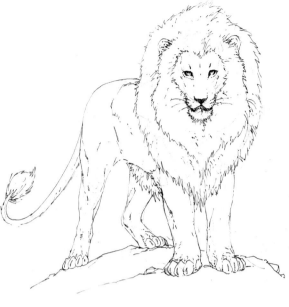

A Noble Pose

The lion is the king of the beasts, so try to position your royal feline in a pose that suggests nobility.

The Lioness

All lions, male and female, have prominent brows and small muzzles. But because they lack manes, female lions—called lionesses—look very different from males. Lionesses are also considerably smaller, weighing less than three hundred pounds as compared to the male lion's five-hundred-plus-pound bulk.

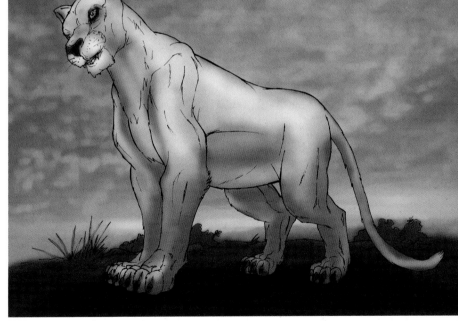

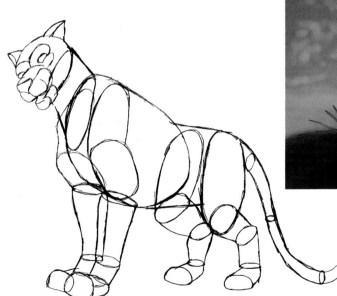

TIGER

According to a popular old saying, when you latch onto something powerful you are said to "have a tiger by the tail." Slightly less well known is the second part of the saying, which goes, "Now the tiger has you by the throat." Then there's the third part—which consists mostly of terrified screaming. The lesson is that you don't ever want to grab a real tiger by the tail without first making sure your last will and testament is in order.

Tigers are the largest and most powerful of all the great cats. Adult tigers range from four and a half feet all the way up to nine feet in length. Male tigers are larger than females. The largest are the Siberian tigers (Siberian males average about five hundred pounds), and the smallest are the Sumatran tigers, with males weighing about 250 pounds. Tigers also have extraordinarily long tails—up to four feet long!

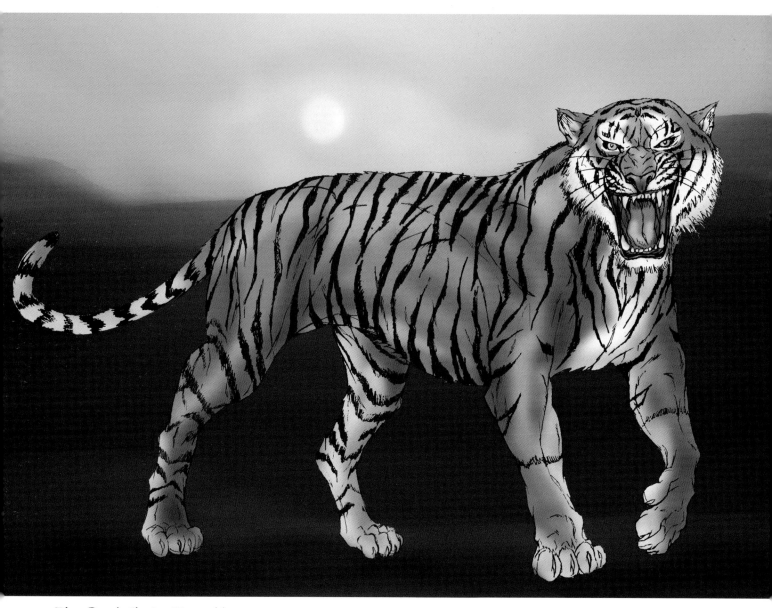

The Food Chain Stops Here

The solitary lifestyle of the tiger means it must defend its hunting grounds from all intruders. Tigers are at the top the food chain wherever they live, so their main competition comes from other tigers. Normally tigers will avoid human contact, but if they feel threatened or perceive a person trespassing on their ground, they will attack.

Despite popular misconceptions, the habitats of lions and tigers do not overlap. Today, lions are found in the wild only in Africa, whereas wild tigers' home is Asia, including parts of India, Indochina, China, and even the harsh climate of eastern Siberia. Most tigers live in forests or grasslands, for which their striped camouflage is ideally suited; their bright orange coat is not a problem since the animals they prey on are color-blind.

Unlike lions, tigers are solitary hunters, so they must scout, chase, trap, and kill all their own food. For this reason a tiger must be a master of stealth. A tiger will stalk its prey for a long time and will not initiate the attack until it is just a few yards away.

Wild tigers are endangered everywhere they live, but because tigers breed well in captivity, the number of captive tigers in the United States alone may now exceed the total world population of wild tigers. The distinctive tigers known as white tigers—animals with blue eyes, pink noses, and very pale off-white coats—are the result of the selective inbreeding of captive tigers.

When drawing tigers—or any animals with stripes or spots—draw the entire animal *before* you add the markings. That way, if you need to make any revisions you will not have to redraw all those stripes!

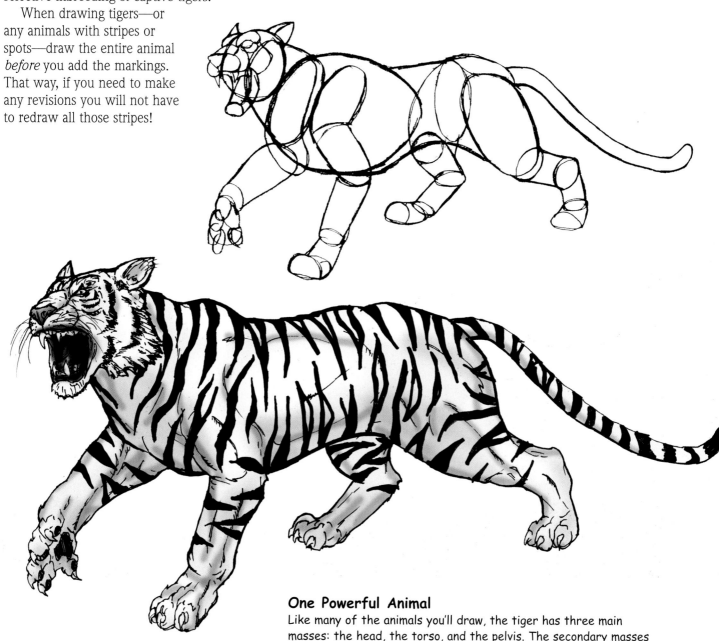

One Powerful Animal
Like many of the animals you'll draw, the tiger has three main masses: the head, the torso, and the pelvis. The secondary masses are the neck, the limbs, and the tail. Always start with simple shapes and move toward the more complex. You can make your tigers seem more muscular by emphasizing the powerful front leg muscles

CHEETAH

The fastest human sprinters have been clocked at speeds of about twenty-eight miles per hour. That's less than half the speed of a cheetah! If the animal kingdom ever competed in the Olympics, the cheetah would take the gold in every race under three hundred meters.

This agile cat's aerodynamic physique—slender, long-legged body, deep chest, narrow waist, and small head—allows it to tear across the plains at speeds up to seventy miles per hour. (In size and shape, its body resembles a greyhound's.) Its blunt, semi-retractable claws act like running spikes, giving the cheetah stability and traction. Adult cheetahs can weigh up to 140 pounds and grow to four and a half feet in length—with their tales adding another three feet or so. The cheetah's tan coat is patterned with small, round, black spots.

Its high degree of specialization makes the cheetah an exceptional runner, but it is not adapted for much else and is therefore under constant threat of losing its prey to its natural enemies (lions, hyenas, and leopards) and other predators of greater size or numbers.

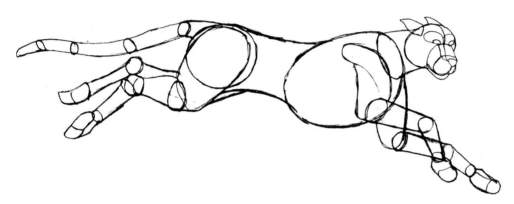

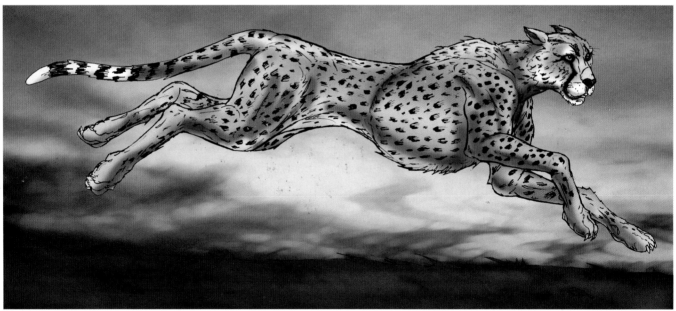

Built for Speed
The cheetah is the lightest of the big cats, so no extra fat on this guy! Think of an Olympic sprinter—strong but not at all stocky. You want to give your cheetah the same sort of physique. Keep the legs long and thin; by emphasizing the joints you will maintain a lean look. The cheetah's head is relatively small and creates a smooth, streamlined shape as it transitions into the neck.

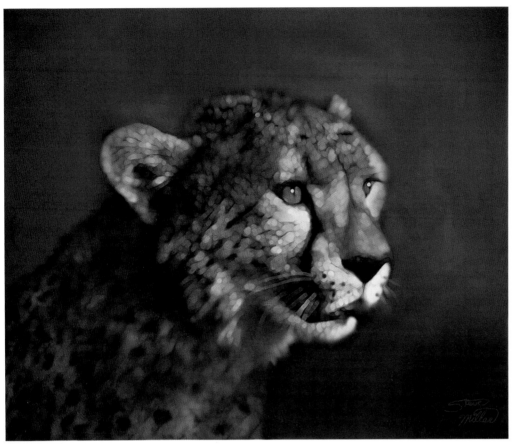

Tracks of Its Tears

Running down the sides of the cheetah's muzzle from the corners of its eyes are black "tear" marks. These marks serve the same function as the black stripes that athletes sometimes put on their cheeks: they help the cheetah to see during brightly sunny days.

Steering Mechanism

The cheetah's tail usually ends in a bushy tuft, which acts as a steering rudder, helping the cheetah make sharp turns when in hot pursuit of its prey.

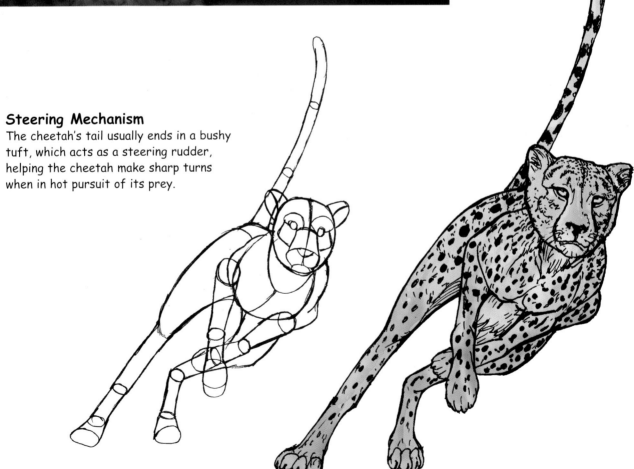

LEOPARD

There's another old saying: A leopard can't change its spots. But why would it want to? It's the spots that make the leopard one of the most stunning of the big-cat species.

The leopard is native to both Africa and Asia, and in Africa it sometimes shares its hunting grounds with another spotted cat, the cheetah. The two are sometimes confused, but leopards are much larger and more massive than cheetahs. Male leopards can weigh up to two hundred pounds, and they stand, on average, about twenty-five inches high at the shoulder. Females stand about twenty inches high at the shoulder and can weigh up to 140 pounds. The leopard's long, athletic body is set on somewhat short, stocky legs, giving the animal a sleek profile. Its paws are broad, with sharp retractable claws, and its ears are small and rounded, not pointed.

Leopards' fur is shorthaired and smooth. Their yellow-orange coats are patterned with dark rosettes that help leopards blend into their surroundings. But not all leopards appear to be spotted. Some individuals—sometimes called black panthers—have very dark blackish-brown coats. Although these leopards also have black spots, the spots are very difficult to see against the dark background, and so the cats seem to be all black. (Note that black panthers are *not* a separate species—just a variation on the norm.)

Leopards are the best climbers of all the great cats, and they spend much of their solitary lives relaxing in tree branches. Leopards will drag their kills into trees so they can eat at their leisure without sharing their meals with scavengers.

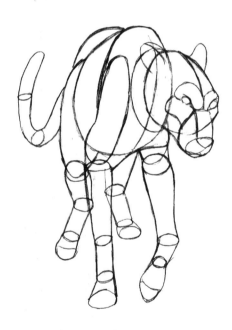

One Sturdy Cat
Leopards, like cheetahs, are spotted, but the leopard has a much sturdier frame. So long as you keep the leopard's body muscular and its head proportionately large, you should avoid any confusion between the two.

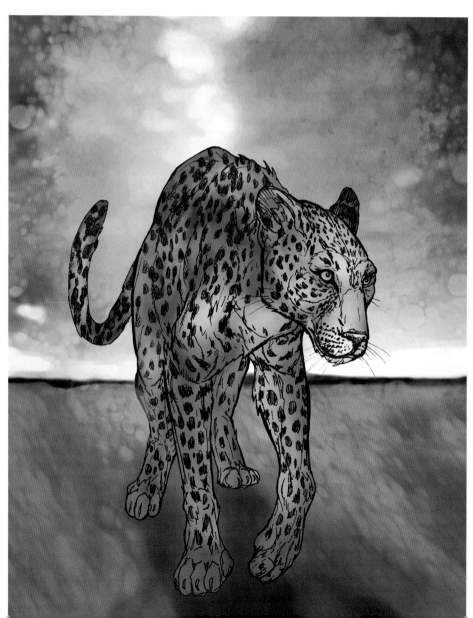

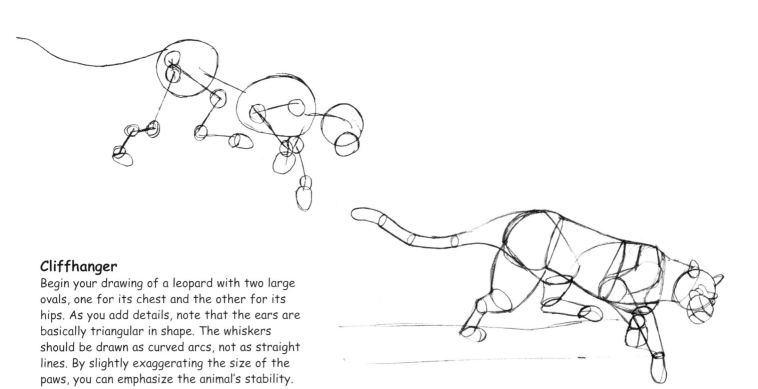

Cliffhanger

Begin your drawing of a leopard with two large ovals, one for its chest and the other for its hips. As you add details, note that the ears are basically triangular in shape. The whiskers should be drawn as curved arcs, not as straight lines. By slightly exaggerating the size of the paws, you can emphasize the animal's stability.

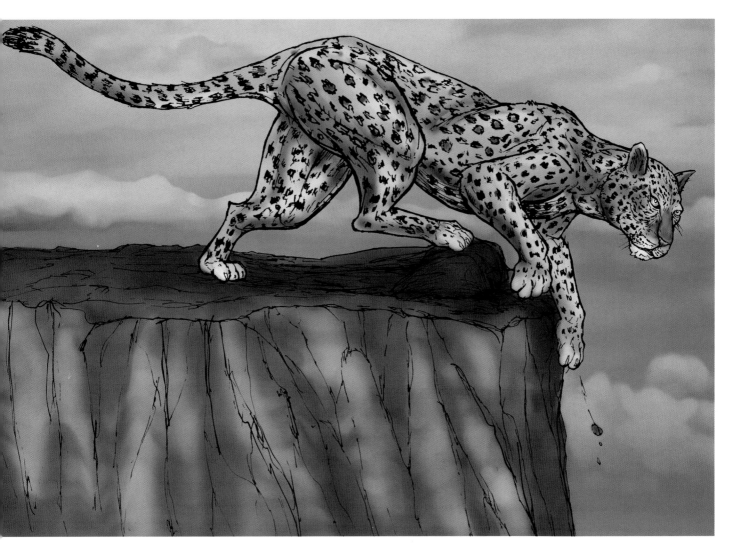

Jaguar

In Amazonian folklore there is a story about a turtle falling from a tree and killing a jaguar when its shell strikes the jaguar's head. In another tale, a jaguar catches a turtle just as the turtle is trying to escape down a hole—but then the terrapin fools the cat into believing that its leg, which the jaguar has snared, is actually a tree root. As entertaining as these tales are, they don't seem very truthful. In fact, jaguars are intelligent, accomplished hunters that regularly snack on turtles—as well as on cows, rodents, peccaries, deer, birds, tapirs, fish, armadillos, sheep, monkeys, iguanas, capybaras, crocodiles, and just about anything else that hops, flies, runs, or slithers across their path. Jaguars, in other words, have one of the most diverse diets of all the big cats.

Jaguars vary in size, but they can weigh more than two hundred pounds. Sleek and deadly, these silent stalkers terrorize parts of South America, much of Central America, all of Mexico, and parts of the southwestern United States. The jaguar is not only the largest and most powerful wild cat in the western hemisphere, but it is also one of the most adaptable, managing to survive even in areas where civilization has encroached on its habitat. The secret of the jaguar's successful spread across so much territory lies in its compact and well-muscled body, its keen hunting abilities, and its adeptness as a climber. The jaguar is a solitary animal, choosing to live alone except for a brief courtship period during mating season.

Ready for Action
Jaguars have a relatively low-to-the-ground profile, with a short, stocky limb structure. By drawing the limbs slightly bent you create tension—making the cat look ready to spring on its prey. Note the jaguar's stout-looking head. Its jaws are extremely powerful—giving it the strongest bite of all the big cats.

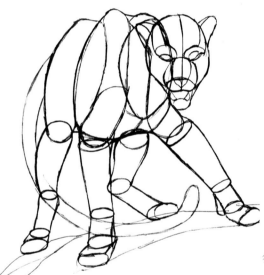

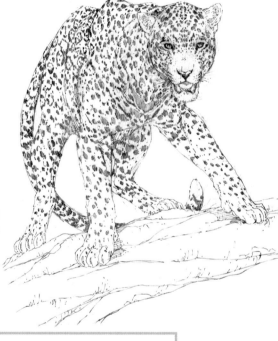

Spotting a Cat
Jaguars' coloration is generally a tawny yellow, but they can range to reddish-brown and even black. The fur is covered in rosettes, for camouflage. The spots are similar to those of a leopard, but the jaguar's are larger, and the overall pattern has fewer rosettes. The rosettes should be added last—after you have the basic feline shape down. Don't worry if the jaguar looks weird without its spots. I find that all the spotted and striped cats look radically different once their markings are added.

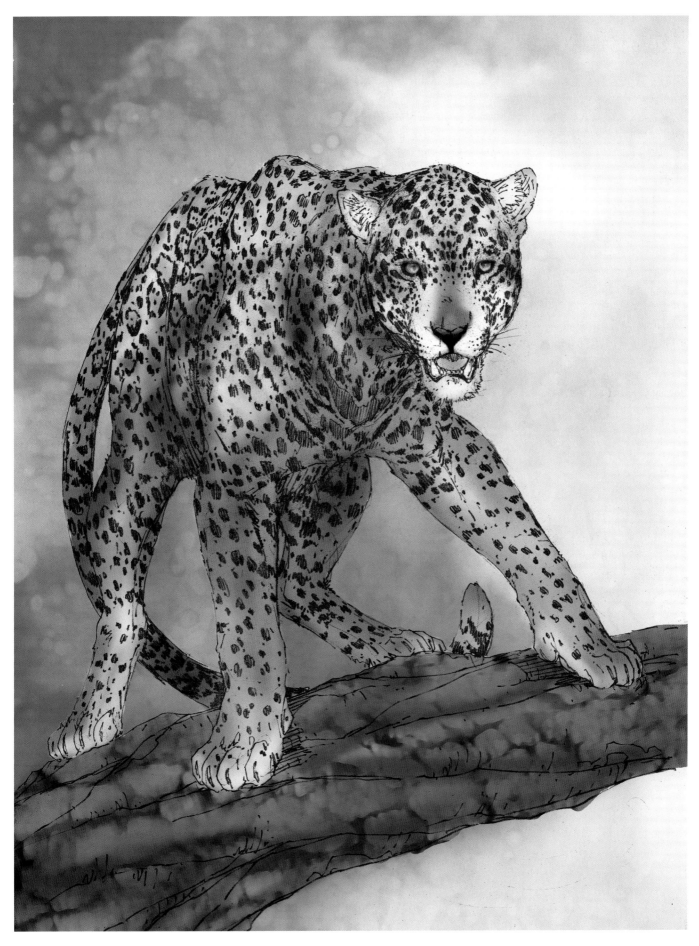

PUMA

The nimble puma has more pseudonyms than any other feline. Its rap sheet lists numerous aliases, including, mountain lions, American lion, brown tiger, catamount, deer tiger, Floridapanther, ghost cat, Indian devil, king cat, Mexican lion,mountain screamer, painter, panther, red lion, red panther,red tiger, silver lion, sneak cat, *suçuarana,* and paintedcat. Whatever you call it, though, you don't want to meet a puma in the wild.

This large, solitary cat is extremely fast, able to run at speeds of forty-plus miles per hour, and it is one of the best jumpers in the animal kingdom, capable of horizontal jumps of twenty feet and vertical jumps of eight feet. Pumas can measure up to eight feet long from nose to tail, and they weigh about 150 pounds on average—making them about the same size as leopards. They have retractable claws, and their large, rounded ears give them excellent hearing. They also have excellent eyesight, although their sense of smell is poor. The puma's coat is a golden tawny color with lighter patches on the underbody, jaws, chin, and throat; the muzzle is typically whitish in color.

Pumas prefer to eat wild deer, but they also include rabbits, mice, and even insects in their diets. As their hunting grounds have shrunk because of land development, they've widened their diet to include domestic cats and dogs. Puma attacks on humans are uncommon, however; there have only been sixteen fatal puma attacks in the United States over the last hundred years.

House Cat on Steroids
Pumas have extremely flat faces—they almost look like house cats on steroids! By keeping the puma's head small you will emphasize the cat's strength. Pumas have no markings on their fur, so your drawing should clearly show the cat's major anatomical features. Use zigzag lines where the fur curls around the shoulder blades, the pelvic girdle, and the tops of the legs.

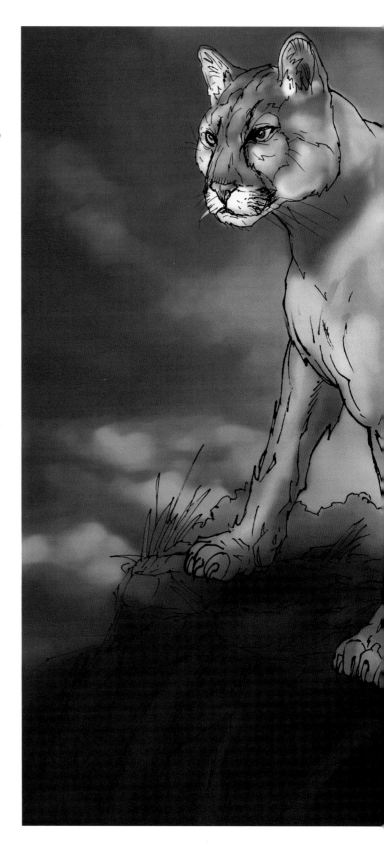

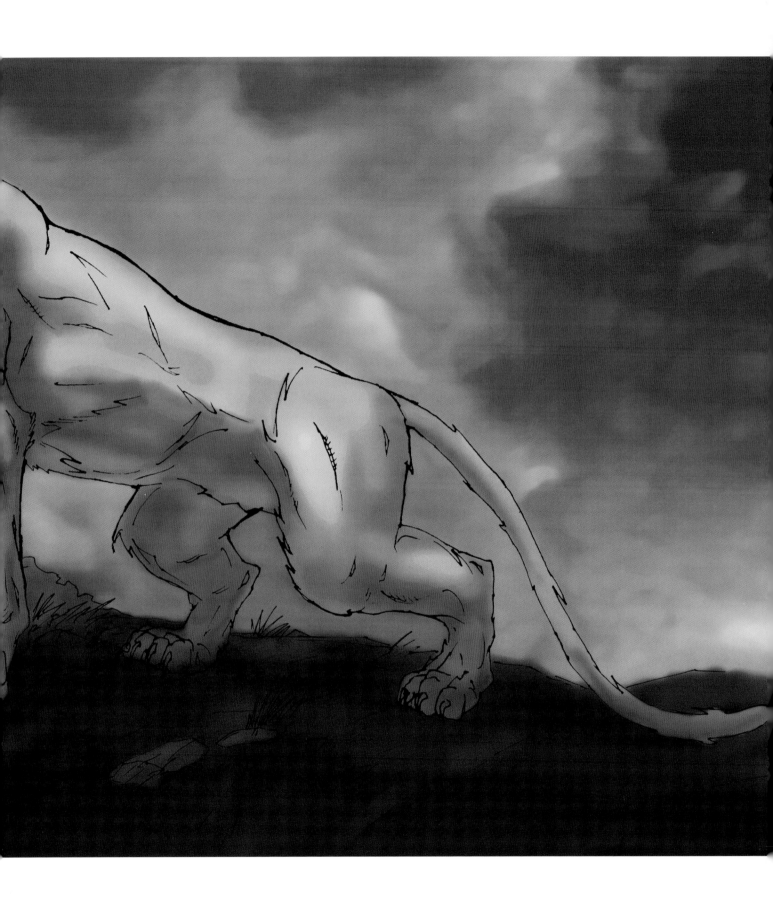

DEADLY DOGS

THE DOG MAY BE MAN'S BEST FRIEND, BUT IT ISN'T TOO HARD TO IMAGINE THE time—back before they were domesticated—when dogs were our greatest competitors as hunters. And there are still lots of species of wild dogs around to remind us of what that prehistoric time must have been like.

Canidae is the scientific name for the family of mammals commonly known as canines. Canidae includes all domestic and wild dogs—wolves, foxes, coyotes, dingoes, and jackals. Hyenas, though included in this chapter, belong to a separate family, Hyaenidae, but I'm grouping them with the canines because they so closely resemble dogs in both appearance and behavior.

Canines (and hyenas, too) prefer to live in open grasslands where their skills as hunters can best be utilized. Canines are all "digitigrades," which means that they walk on their toes—giving them their light and nimble stance and aiding them in running. They capture their prey by various means: by pursuing an animal and catching it, by chasing it until the prey is too tired to run any farther, or by surprise ambush attack. Dogs' bodies are generally long, with a compact frame, although one look at the contestants in a local dog show will reveal just how flexible that frame can become with selective breeding.

Canines have keen senses, particularly their sense of smell, which is housed in their long muzzles. Dogs have more than twenty-five times the number of olfactory receptors as humans, and they rely on smell both for hunting and for decoding scent messages left by other animals. That's important, because in the wild it's a grievous mistake to confuse your friends with your foes. And in cluttered landscapes you can't always rely on your eyes; even thick underbrush, which makes visual identification impossible, cannot hide the scent of prey.

WOLF

Who's afraid of the big bad wolf? Well, just about every animal that shares its habitat, that's who. The wolf is highly skilled predator as well as an integral component of the ecosystem, because it helps maintain the health of the animal populations it preys on. Although it may seem cruel, the wolf's predation helps to keep these animals' numbers in check, preventing overpopulation, while ensuring that the strongest and healthiest specimens of the prey species survive.

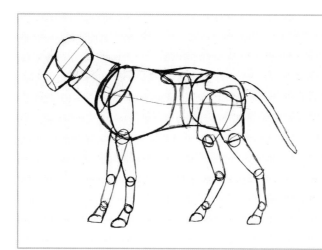

Your Pet as Artist's Model
If you have a pet dog, take some time to watch how he or she moves. Make quick sketches of your dog in action, at play, and at rest. Many quadrupeds (four-footed animals) display similar body language. The better you get at observing how animals in general move, the better you will be at depicting the specifics of particular animals.

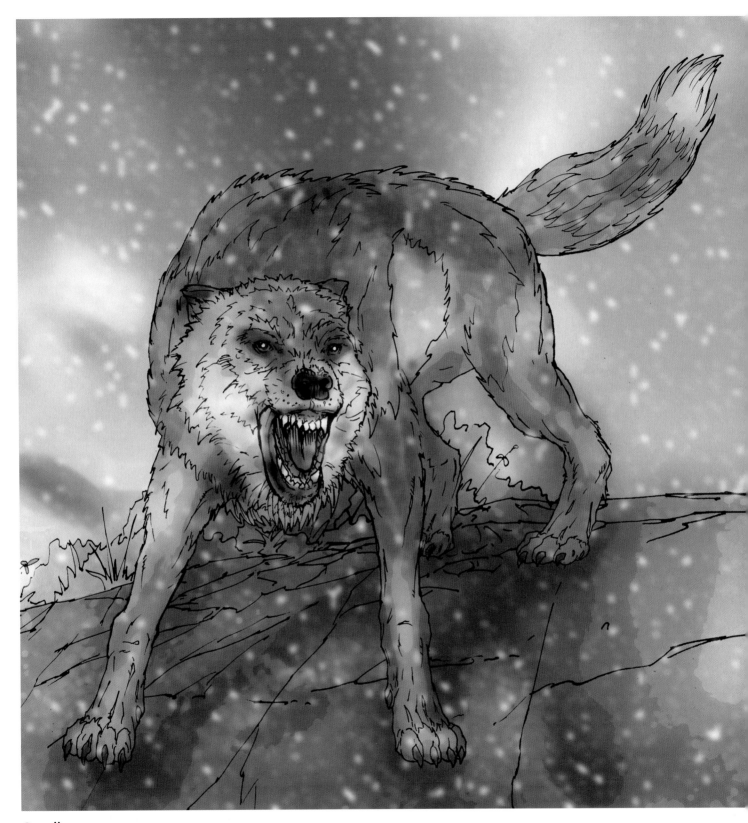

Snarl!

The wolf is the largest canine. Clever predators that hunt in packs, wolves have struck terror in the human heart since the beginning of time—but the wolf is also the ancestor of the (comparatively tame!) domestic dog.

Wolves are the largest wild canines—growing to a height of nearly three feet at the shoulder and weights of up to 130 pounds—so they are definitely the top dog of their food chain. Although wolves are indeed big, their bulky fur coats make them seem even larger than they really are, and they can further increase their perceived size—and frighten away rivals—by bristling their coats, making the fur stand straight up.

Wolves have no natural predators, which is not to say they don't face fierce competition on their hunting grounds. They hunt deer, caribou, musk oxen, mountain goats, fish, birds, elk, bison, moose, big horn sheep, and beavers and other small mammals—animals that appear on several other predators' grocery lists, as well. If live prey is hard to come by, they'll settle for carrion. Wolves live in packs, with a complex social order. The aggressive and submissive behaviors they exhibit are very familiar to us: They're the same behaviors we witness in our pet dogs, which, of course, are the descendants of wild wolves.

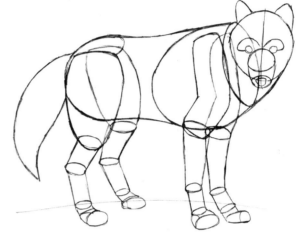

Built for Stamina

Wolves, unlike many other predators, are built for stamina. They're tailored for long-distance travel and can roam large territories in search of food. Draw the wolf's body as thick and muscular, but keep the limbs thin and wiry.

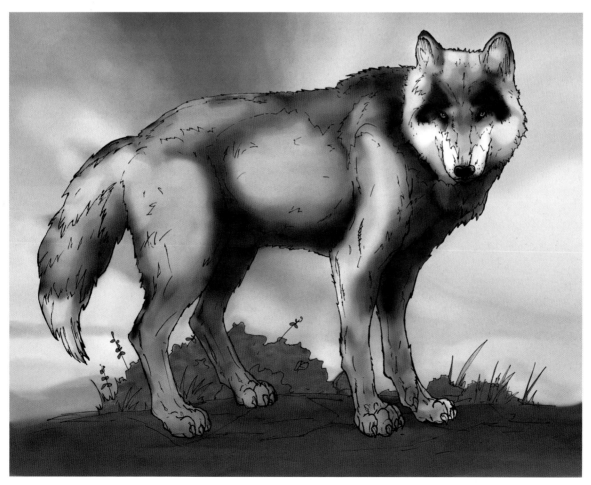

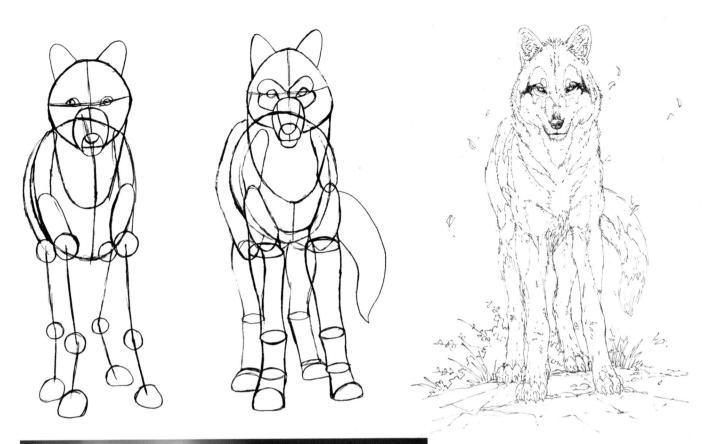

Portrait of a Predator

Wolves have large paws, yellow eyes, relatively long legs, bushy tails, enormous teeth, and stout, blocky muzzles. They have two coats of fur—an overcoat and an undercoat—so you can't really see much of the underlying muscular or skeletal shapes.

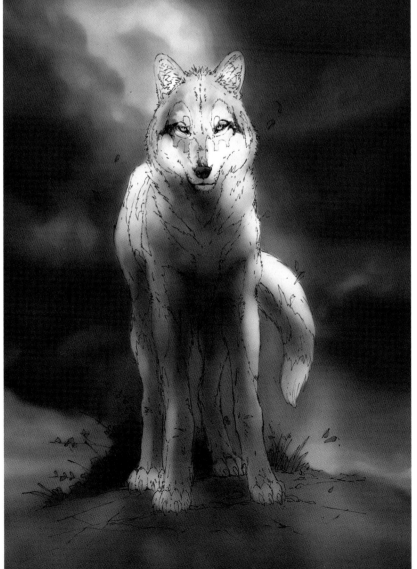

African Wild Dog

A popular proverb goes, "If you lie down with dogs, you'll get up with fleas." If you lie down with the African wild dog, however, you most likely won't get up at all.

The African wild dog is a primitive killer. The wild dog's coat is dramatically mottled in shades of brown, black, and beige—a patterning that earned the animal its Latin name, *Lycaon pictus,* which means "painted wolf" (and which strikes me as a pretty good description). An African wild dog can weigh up to eighty pounds and stand as tall as thirty inches at the shoulder. The dogs have large, rounded ears, which act as cups to capture sound, and dark brown circles around their eyes to aid their vision in bright sunlight.

African wild dogs differ from wolves (and other dog species) in having four toes instead of five. Their prey consists of antelope, zebras, wildebeests, springboks, gazelles, and impalas. They live and hunt in packs ruled by a leader referred to as the alpha male.

They are light and limber hunters, so keep all the body dimensions thin when drawing an African wild dog. They're also highly intelligent. By keeping the head high and the ears erect, you can depict an animal that looks alert and ready.

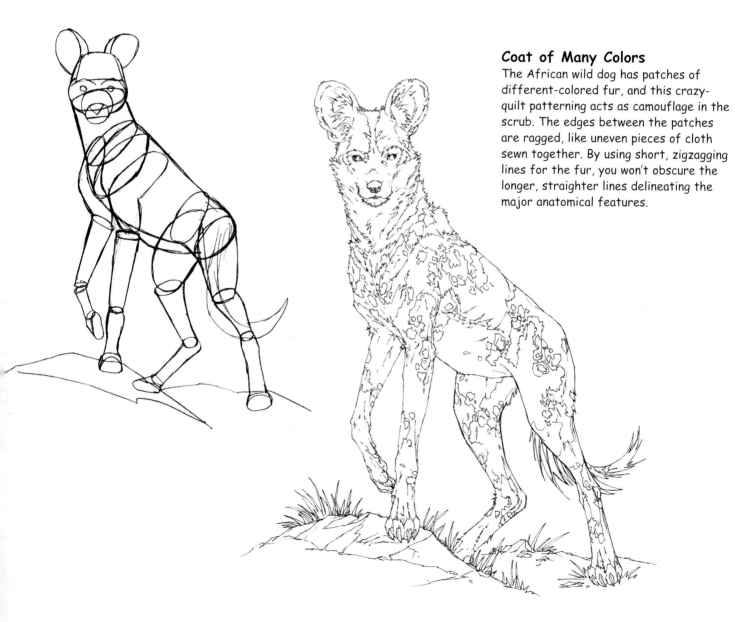

Coat of Many Colors
The African wild dog has patches of different-colored fur, and this crazy-quilt patterning acts as camouflage in the scrub. The edges between the patches are ragged, like uneven pieces of cloth sewn together. By using short, zigzagging lines for the fur, you won't obscure the longer, straighter lines delineating the major anatomical features.

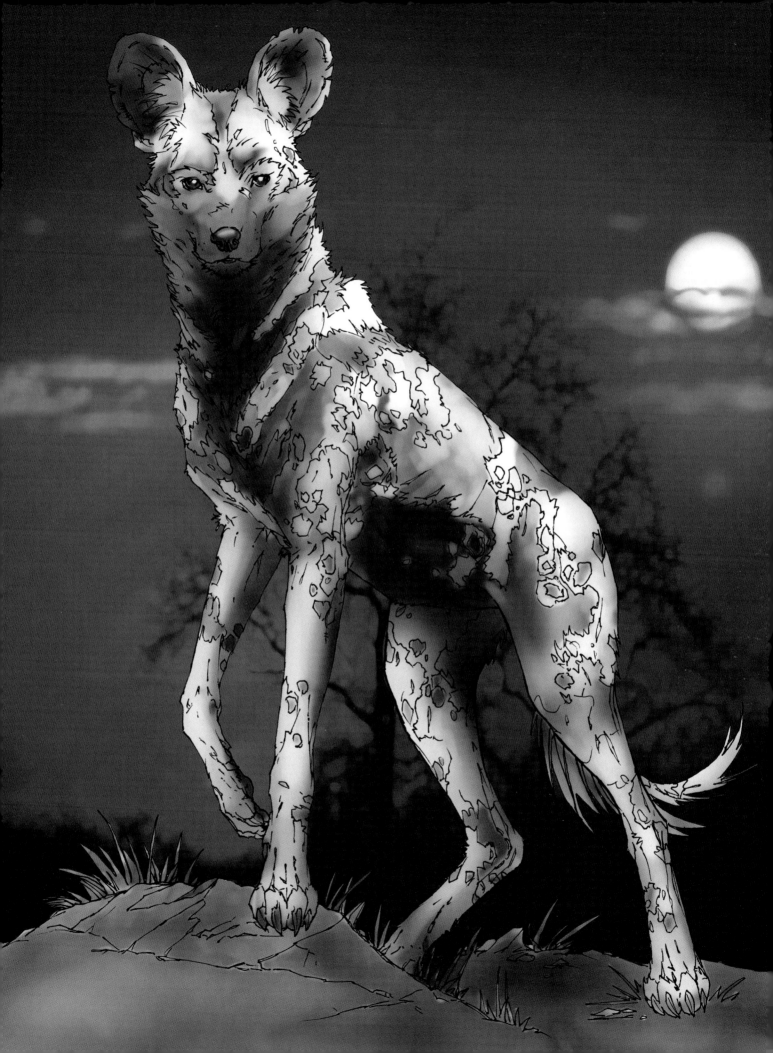

HYENA

Hyenas are well known for the excited, laughter-like sounds they make, but there is nothing funny about encountering a clan of bloodthirsty hyenas in the wild. Although they're doglike in appearance and behavior, hyenas belong to a different family (Hyaenidae) and are actually more closely related to mongooses than to dogs. There are several species, the best known of which is the spotted hyena—a ferocious meat-eater that is the second-largest carnivore in Africa (after the lion). Among spotted hyenas, females are larger than males and can weigh up to 190 pounds and measure almost four feet long. (Add another foot or so if you're counting the tail.)

Hyenas are social animals that live in large groups, called clans, and have adapted a variety of hunting methods depending on their environment and the prey. Clans will work cooperatively to bring down large prey and then share in the kill, allowing the clan leader to eat the first, choicest cuts of meat. For smaller prey, a lone hyena will hunt and kill on its own. Hyenas have an excellent circulatory system and enormous hearts, which give them great stamina and allow them to pursue their quarry over great distances.

Although hyenas are thought of primarily as scavengers, they are proficient at hunting their own game. (And although they are primarily meat eaters, hyenas do treat themselves to an occasional piece of fruit.) Their diet consists mostly of wildebeests, zebras, gazelles, buffalo, topi (a kind of antelope), eggs, and insects. They've gotten a gruesome reputation for feasting on the dead, but this actually provides a valuable service to the ecosystem by eliminating carcasses, which are breeding grounds for disease.

The hyena has a short, coarse coat that is mottled brown, tan, and red. It has a small head and muzzle; its nose and the tips of its large, rounded ears are black. Its shoulders are pronounced, and its unusual, hunched-looking posture results from its front legs being longer than its back legs. Its bushy tail disperses heat during the day but traps warmth (like a blanket) at nighttime.

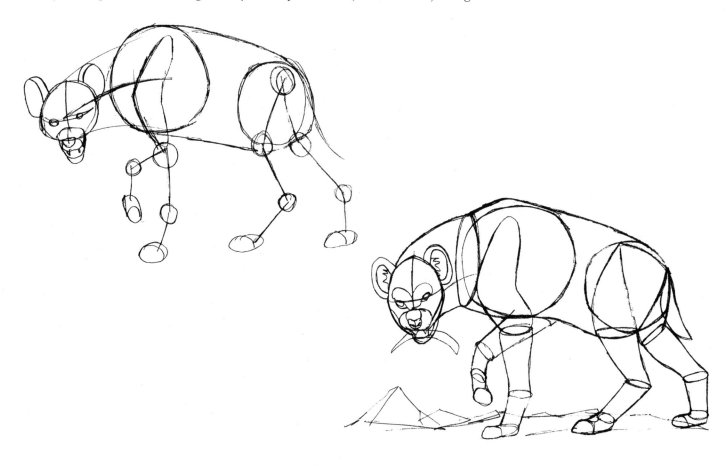

The Laughing Killer

The hyena's pronounced shoulder hump is always evident and gives the animal a sinister look. With its hunched stance and high-pitched laughter, it's easy to see why the hyena is so often depicted as the villain of the grasslands. The shoulder blade and the upper section of the front limb together form a boomerang shape, as can be seen in the step drawings opposite. The angle of the "boomerang" changes slightly as the leg moves, but this a quick and effective way to place the front leg accurately. As you progress through the steps, add a little extra weight to this shape to emphasize the strong leg muscles.

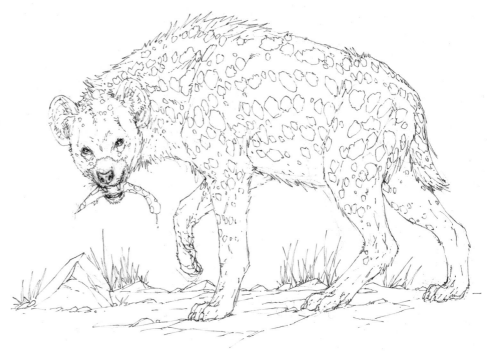

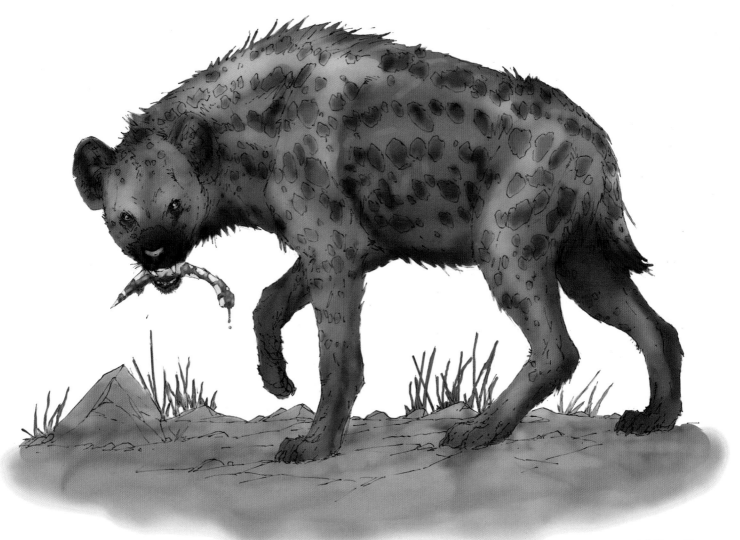

BRUTISH BEARS

I DON'T KNOW HOW THE TEDDY BEAR BECAME SUCH A POPULAR BEDTIME companion, but it wasn't because real bears make good slumber-party guests. Large, muscular mammals with strong limbs, large heads, and wide paws, bears must constantly hunt, forage, and eat to maintain their metabolism. Plus, they're always storing a little something extra away for those long, cold months of hibernation.

Bears live in all parts of the world except for Antarctica, Africa, and Australia. Eight species are alive today: American black bears, Asiatic black bears, brown bears (of which the grizzly bear is a subspecies), giant pandas, polar bears, sloth bears, spectacled bears, and sun bears. Most bears are omnivores (meaning that they eat both plants and meat); the only exception is the polar bear, which follows a strict, meat-only diet. All bears are plantigrades, which means that the soles of their feet are flat.

A female bear is called a sow and a male bear is called a boar—but unless you have a death wish you should probably not call either a pig. A group of bears is referred to as a sloth—which also seems like a misnomer, since it would be a grave mistake to think of bears as lazy.

Even though bears are extremely strong, you should avoid drawing too many secondary anatomical features (like muscle definition or skeletal protrusions) when depicting them, because all these elements are hidden under bears' thick fur. Allow the large, bold shapes of the bear's anatomy to convey its size and ferociousness.

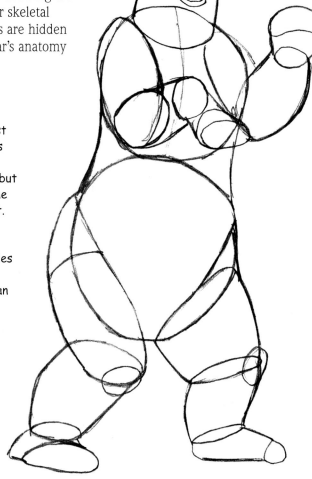

White Knight
When a polar bear rears up, it appears almost human because of its ability to balance on its hind legs. Even though it is a highly muscled creature, you can't really make out anything but the major anatomical features because of the bear's dense fur and protective layers of fat. Drawing a bear is sort of like drawing a football player in uniform: He may be very strong, but you can't see the individual muscles under all the padding and the loose jersey. That's why it's always a good idea to define an animal's form and girth with rounded circles outlining the major body parts.

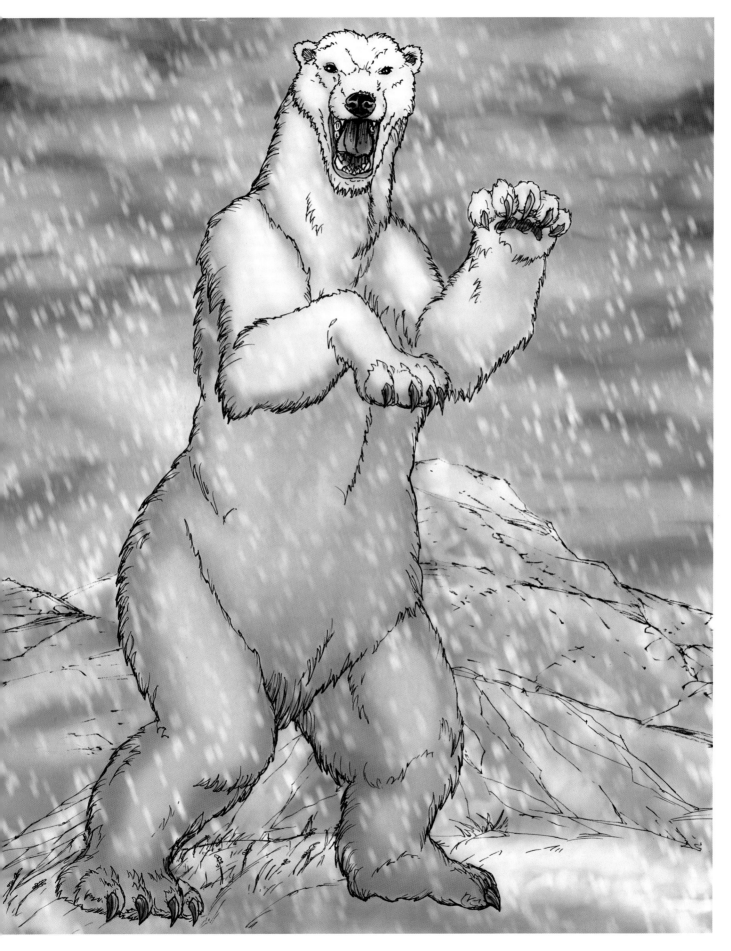

BLACK BEAR

Food is the most important thing in the world to black bears; they are always hungry and let little stand in the way of satisfying their appetites. One black bear reportedly loved honey so much that it ate a beehive—bees and all! The hunters who killed it found more than two quarts' worth of half-digested honeybees in its stomach! Stories like this help you understand why food plays a key role in almost all encounters between bears and human beings.

American black bears are large, solitary, mostly peaceful creatures that prefer to inhabit dense forests but also live in swamps and even in scrub desert. The bears can grow up to six feet long and may weigh up to three hundred pounds. Not all black bears are black: their long, thick fur actually ranges in color from black to brown. Although powerful, they would much rather avoid confrontations with people than to attack. Unfortunately, many of the things we carry around— suntan lotion, lip balm, toothpaste, soap—smell like food to a black bear. And problems inevitably arise when campers feed wild bears. This teaches the bears to regard people as suppliers of food— and to be fearless in approaching them.

Black bears' front claws are longer than their rear claws, making them excellent tree climbers— so forget everything you've learned from cartoons about climbing a tree to escape a bear! Black bears are also good swimmers, so you can't get away by diving into the water, either! There's a popular myth that you should play dead if a bear attacks, but an attacking black bear is in predatory mode, so your lying still will only cut down on the bear's hunting time. Your best bet is to avoid bears at all cost, but the experts say that if a black bear does approach you, your best defense is a loud, aggressive offense. Yelling, banging pots and pans, and waving your arms should send the bear scampering away. Also, it's good to remember that although black bears have an excellent sense of smell, their eyesight is poor. If you do spy a black bear, it's very likely that you've noticed it before it has noticed you—meaning that you can slowly retreat.

When asked to name the most frightening bear, most people would probably say the grizzly bear, but black bears are actually more likely to attack humans. Nevertheless, fatal attacks are uncommon: Black bears have been responsible for only fifty-six deaths in the United States over the last century. Most encounters end with the bear running off into the woods—*except* when the bear senses the prospect of food. So keep your picnic baskets far away from Yogi and Boo-Boo and you should be OK.

A Nice Fur Coat
Bears' thick coats hide most of the underlying anatomy. Concentrate on getting the bear's basic shape down. You can convey a lot just by choosing how to line up the head, torso, pelvis, and limbs. Interestingly, bears' toes are arranged "backwards": The biggest toe is on the outside and the littlest toe is on the inside.

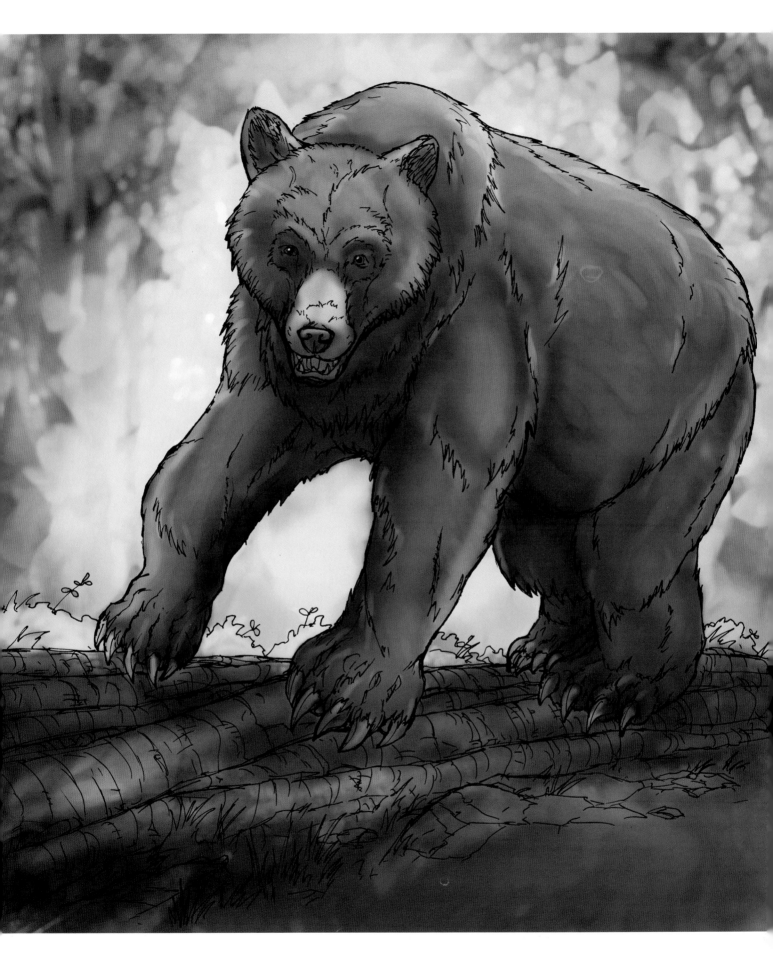

Grizzly Bear

Grizzly—the name alone sounds ferocious. But in reality the name has no connection to the word *grisly*. *Grizzly* actually means "gray haired" and refers to the bear's silver-tipped fur.

The grizzly is a subspecies of the American brown bear. At their biggest, these solitary mammals can reach seven feet in length and weigh up to fifteen hundred pounds. Grizzlies have thick fur that ranges in color from black to brown, reddish-brown, or even blond. They have big heads, long muzzles, and a large hump just past their shoulders; this hump is actually muscle designed to give the bear's front limbs extra swatting power! A grizzly's front claws, which can be almost five inches long, are usually quite evident in the tracks they leave.

Grizzlies live in cool mountain forests and river valleys far away from people. Fierce predators, they prefer to hunt at night. But they don't just eat meat. Like most other bears, grizzlies are omnivores, and they include leaves, roots, berries, mushrooms, fish, and even large insects in their diet. They don't view humans as food, but they will attack if they feel threatened, so the best offense is a good defense: Avoid them at all cost. Grizzlies are not good climbers, but they do have a very long reach—so keep this in mind if you head to the nearest tree when trying to escape a marauding grizzly!

Grizzlies and black bears cannot necessarily be distinguished by their colors since a black bear's coat can lighten to a brownish hue approximately the same shade as a grizzly's. A bear's size and shape are the best ways of identifying it. Typically, grizzlies are about twice as massive as black bears—weighing, on average, eight hundred pounds as compared to the average black bear's four hundred pounds. And there's also that shoulder hump, which makes the grizzly's rump lower than its front end. The rump of a black bear, by contrast, is usually higher than its shoulder, or at about the same level.

Less Is More
Sometimes less is more. Much of this grizzly's anatomy is hidden by fur, so I've concentrated on putting the most detail around his facial features and have allowed the rest of the body to be described only by the outline of the fur.

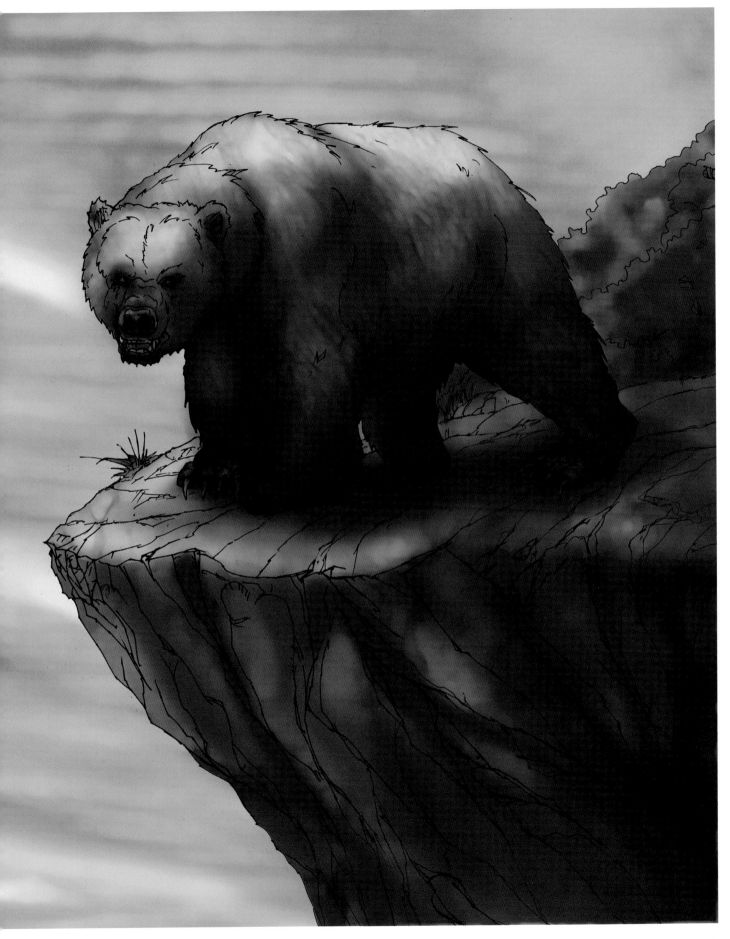

Polar Bear

The polar bear has one of the best fur coats in the world—fashionable year round in the bear's Arctic habitat. The polar bear's entire body is covered with fur—even the bottoms of its paws, for better traction.

Male polar bears are eight to eleven feet long and generally weigh between five hundred and eleven hundred pounds, but they can reach weights up to fifteen hundred pounds. Females are significantly smaller, measuring six to eight feet long and weighing, on average, between 350 and six hundred pounds (though they can occasionally reach seven hundred pounds). Polar bears are found throughout the Arctic—in Alaska (where the polar bear population numbers somewhere between three thousand and five thousand), Canada, Russia, Greenland, and on the Arctic islands of Norway. Polar bears are the most nomadic of all bear species. (They're also among the biggest bears; only the Kodiak bear, a brown bear subspecies that's closely related to the grizzly, can grow larger.) The bears' nomadic lifestyle allows them to hunt across several hundred square miles of open wilderness.

Because of their hugeness, polar bears look as if they might be clumsy, but they are actually sure-footed and graceful—and they are as comfortable swimming in the water as they are lumbering across land or ice. Their skill at swimming is aided by their partially webbed feet, and polar bears have sometimes been observed in the sea more than a hundred miles from the nearest solid ground.

Unlike other bears (which are omnivorous), polar bears are strict carnivores. They feed primarily on seals—and the occasional young walrus. Like most predators, they also scavenge food, eating walrus and whale carcasses.

Snowshoes with Claws

Polar bears have short tails and small ears. Their heads are comparatively small and streamlined, while their bodies are more elongated than those of other bears. The highest point of a polar bear's back is halfway between its shoulders and rump. Polar bears' paws are very large, reaching up to twelve inches in diameter. The paws act like snowshoes, spreading out the bear's weight as it moves over ice and snow. The forepaws are round, the hind paws elongated. Each toe has a thick, curved, non-retractable claw. The claws are used for grasping prey and for traction when running or climbing on ice.

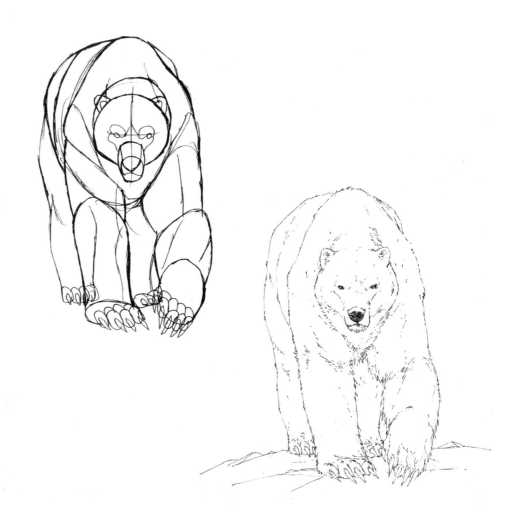

Polar bears are *extremely* dangerous to human beings. Remember: Most polar bears seldom see humans, and because of their inquisitive nature are apt to come over and investigate—and to treat as a possible meal—anyone or anything that ventures into their territory. Thankfully, modern conservation efforts have resulted in a better understanding of polar bears and of how we can discourage their encroachment into populated areas.

Beneath their fur and hide, polar bears have a thick layer of fat to help them stay warm, so their musculature is completely hidden. When drawing them, you should therefore concentrate on getting the basic shapes right.

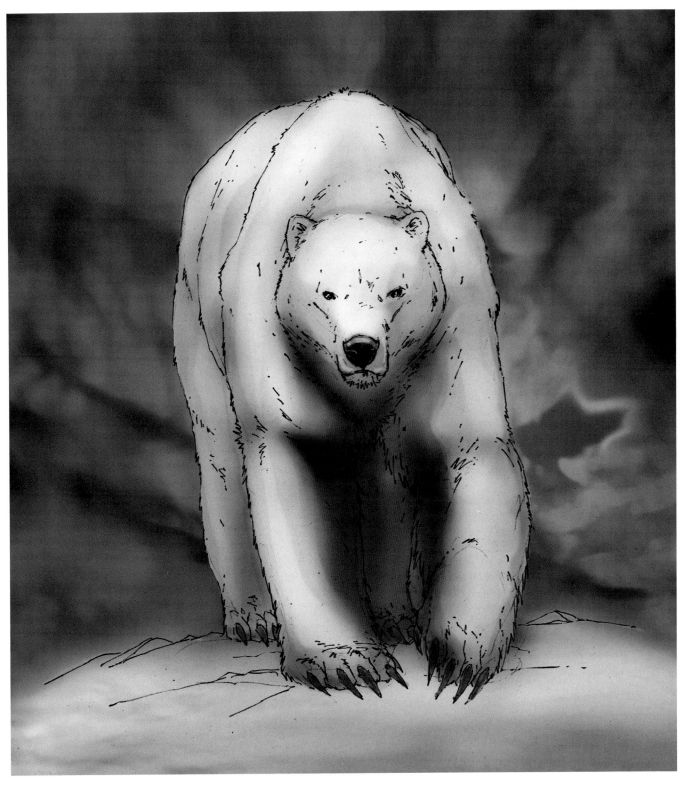

MORE MARAUDING MAMMALS

A SCIENCE TEXTBOOK'S DEFINITION OF *MAMMAL* WOULD PROBABLY SAY something along the lines of "a warm-blooded vertebrate animal that produces milk and is usually covered in hair [blah, blah blah]." How boring! Mammals are some of the most visually exciting animals on God's green earth.

Think of your favorite animal stars from television and the movies. King Kong? Mammal. Flipper? Mammal. Free Willy? Mammal. Wilbur from *Charlotte's Web*? Mammal. Dumbo? Mammal. The list goes on and on.

Don't forget that science classifies human beings as belonging to the mammal family, so we have a lot of interesting comrades to raise hands and paws with in the enormous mammal army. Mammals get around: We can be found on every continent on earth, if you count the seals, whales, and orcas that swim the frigid waters of Antarctica (and the human beings who live in research stations there!). Mammals are highly adaptive thanks to our relatively large brains. Those brains allow mammals to build shelters, track food, nurture their young, and write fantastic *How to Draw* books!

So let's tackle just a few of the staggering assortment of incredible and sometimes implausible creatures known as mammals.

Rampage!

The African bush elephant is the largest land animal alive today. These huge, intelligent, tusked creatures can be very dangerous to human beings—especially if provoked. Elephants have been known to go on rampages to avenge the deaths, by hunting, of other elephants. And male elephants periodically enter a hormonal state, called musth, that literally makes them crazy—and more dangerous than ever.

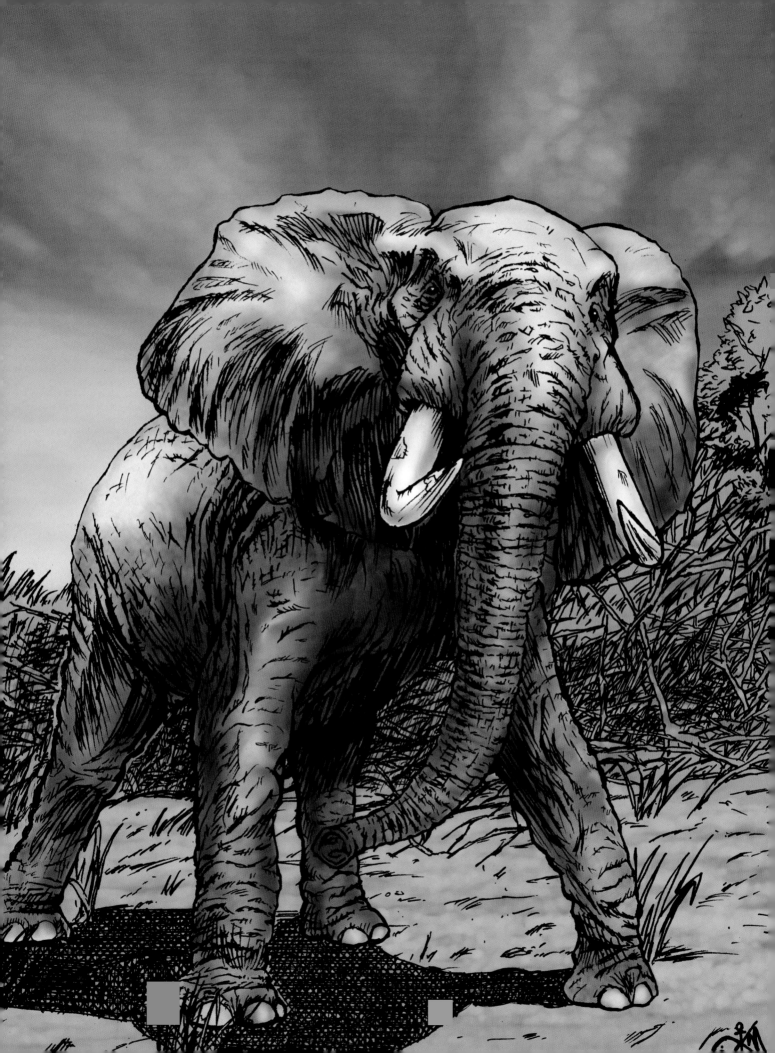

Hippopotamus

The name *hippopotamus* means "river horse," although I doubt you'd like to try to saddle one. When left alone, the hippo is a plant-eating, water-loving, river-dwelling, gentle giant—but get too close and the pool party is over.

Adult hippopotami (or "hippopotamuses," if you prefer tongue twisters) average eleven feet long, stand about five feet tall at the shoulder, and weigh anywhere from 3,300 up to 7,000 pounds. Related to pigs (and, a little more distantly, to camels and goats), the hippopotamus has a barrel-shaped, blue-gray body with a pink belly, a very large and imposing head, and almost comically stumpy legs.

Hippos spend the majority of the daylight hours in African swamps, wallows, ponds, or rivers keeping their sensitive skin hydrated and protected from the sun. (Hippos' skin secretes a natural form of sunscreen called "blood sweat" because of its red color.) But after sunset, the hippos stampede out of the water to partake of a moonlit vegetarian smorgasbord. Each hungry, *hungry* hippo can eat as much as a hundred pounds of grass in a single night.

The hippopotamus is the third-largest land animal alive today (after the elephant and the rhinoceros). Reportedly the most deadly of all African animals, hippos are responsible for more human fatalities than are crocodiles. Most deaths occur when people accidentally venture too close to a watering hole where super-protective mother hippos and their calves are living. Hippos may look like docile and clumsy, but when annoyed they are transformed into aggressive sumo-fighter animals that can really throw their weight around. And, amazingly, they can actually outrun human beings!

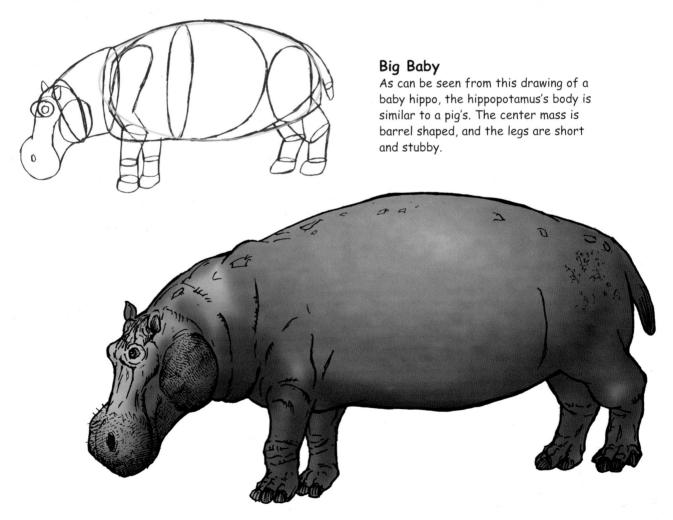

Big Baby
As can be seen from this drawing of a baby hippo, the hippopotamus's body is similar to a pig's. The center mass is barrel shaped, and the legs are short and stubby.

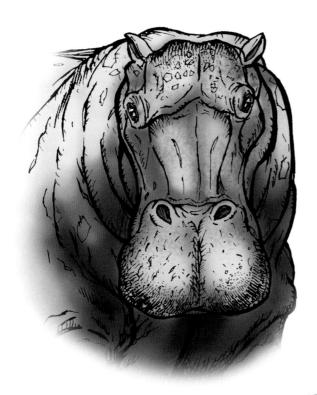

What a Yawn

Hippos have enormous heads and huge mouths that can open wider than four feet when the hippo bellows or yawns. Their teeth are pretty impressive, too—with the largest measuring up to twenty-eight inches in adult males.

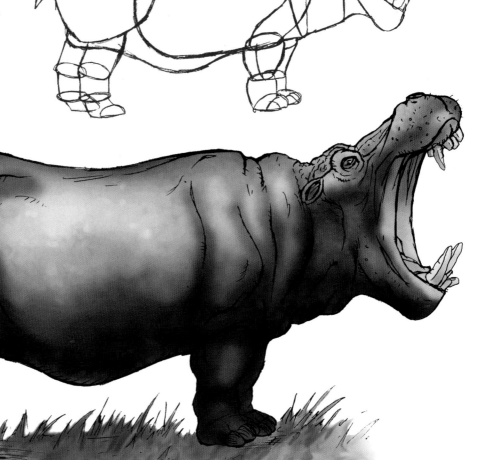

Wild Boar

Next time you call, "Here, piggy, piggy, piggy," be sure you aren't in the wild boar's habitat. These relatives of the domestic pig may look something like your common, everyday oinker, but they pack a whole lot more attitude.

Actually, these feral porkers are easy to distinguish from their bacon-making farm kin. They're not pink, and they don't have those cute, curly little tails. Wild boars are a dark brownish color with stiff black hair and straight black tails. Wild boars are also larger than domestic pigs, reaching lengths of more than six feet and weights in excess of four hundred pounds. Both males and females have razor-sharp tusks curling out of their mouths. The males' tusks are larger—measuring from two to five inches—but the females' can also be quite dangerous.

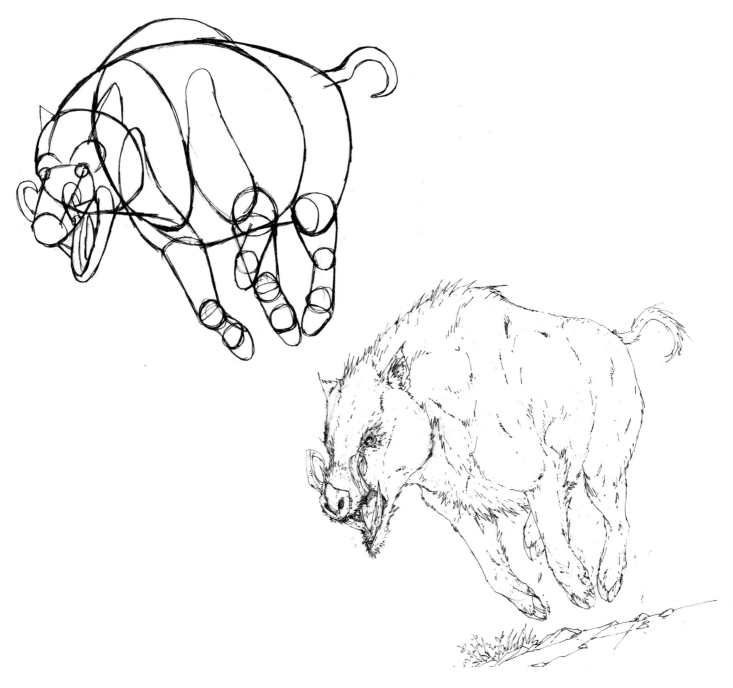

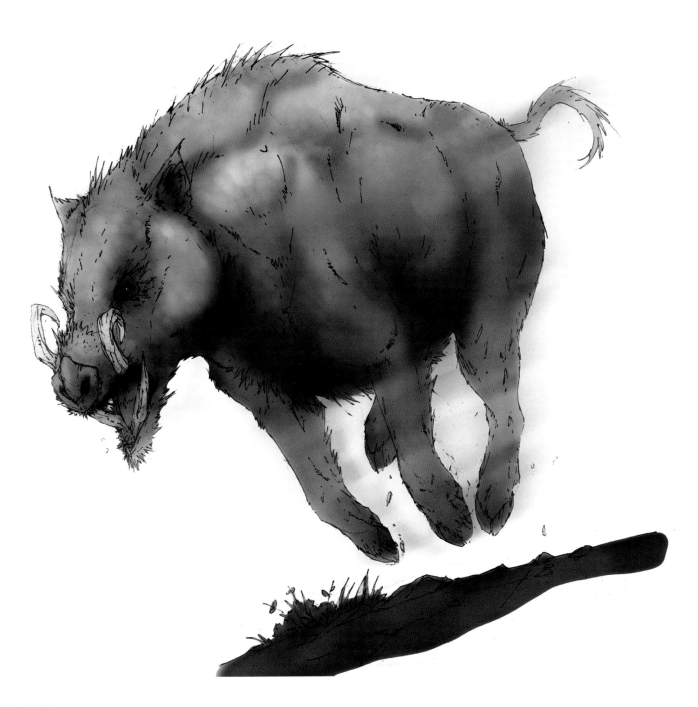

A Real Pig

As with any pig, the central mass of a wild boar's body shape is barrel shaped. Although wild boars are very aggressive, you don't want to emphasize their musculature. It's better to give the boar's body a relatively smooth texture, and to indicate the coarse hair that covers it with a few well-placed lines. Pigs have split hooves that look somewhat like toes—two in the front and a smaller third toe in the back.

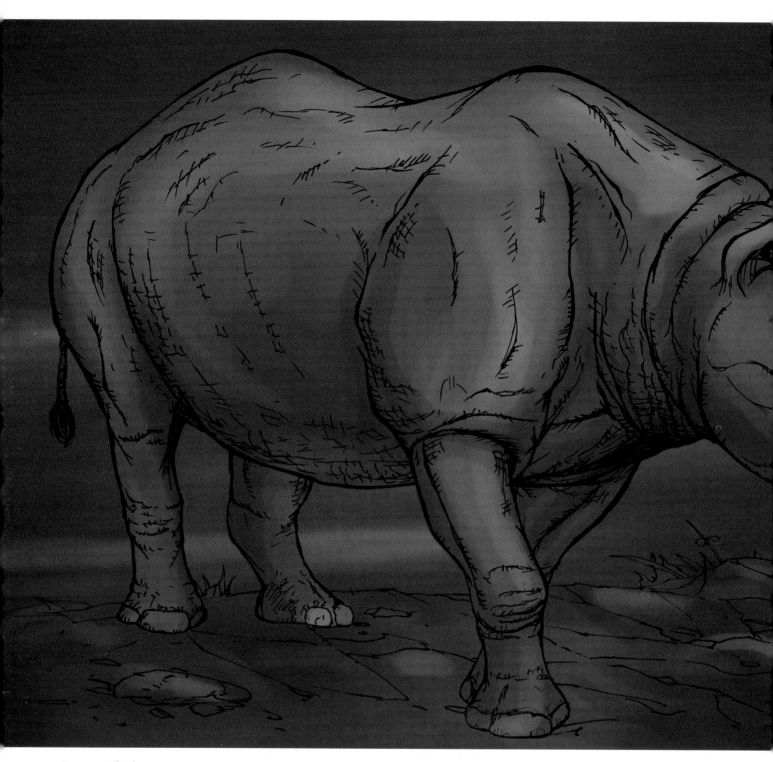

Armor Clad

African rhinos like the one depicted here have two horns—one at the
tip of the nose and another, smaller horn farther back on the snout.
The rhino has a stocky, barrel-like shape and thick, armor-like skin.
Its legs are short, with well-defined joints.

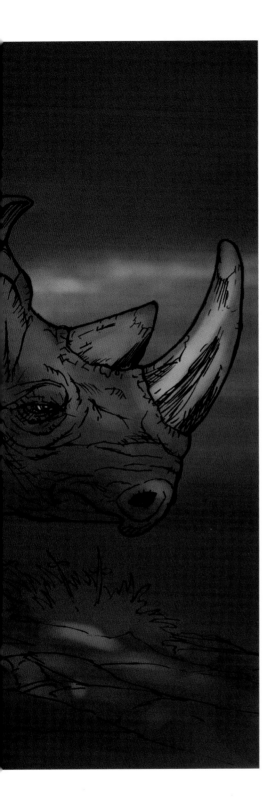

RHINOCEROS

The rhinoceros's most distinctive feature is the horn or horns atop its nose. (African rhinos have two horns; most Asian rhinos have just one.) In fact, the name *rhinoceros* comes from the Greek words *rhino,* meaning "nose," and *ceros,* meaning "horn." But I don't think I'd address a rhino as "Horn Nose"; I'd probably call him "Sir." Then again, I don't think I'd ever get close enough to this beast to say anything at all! Rhinos' horns, by the way, are actually made of a densely matted material similar to hair.

Rhinoceroses (the plural can also be *rhinoceros*) are usually solitary, usually peaceful animals that are content to spend their time wading in cool water holes or grazing the open grasslands. But if they feel threatened, they will trample or gore an intruder. They have acute hearing and a good sense of smell but very poor eyesight, so to a rhino a human being doesn't look all that different from its natural predators: lions, tigers, and hyenas. That's why rhinos are considered among the deadliest animals, surpassing even tigers and leopards in the number attacks on humans.

There are five living species of rhinoceros. The two African species are the white and black rhinos. Asian rhinos include the single-horned Indian and Javan rhinoceroses, as well the Sumatran, which like its African cousins has two horns. The white rhino is the largest rhinoceros—and the second-largest land mammal (after the elephant). Rhinoceroses range in weight from 750 up to 8,000 pounds and stand anywhere from four and a half to six feet tall. They are amazingly thick skinned: a rhino's hide, which is formed of layers of collagen and can be as thick as two inches, is like a living suit of armor. A male rhinoceros is called a bull, a female rhino a cow, and a young rhino a calf. The collective noun for a group of rhinoceros is a "crash," and, incidentally, this is also the last sound you'll hear if an angry rhino sets its sights on your vehicle.

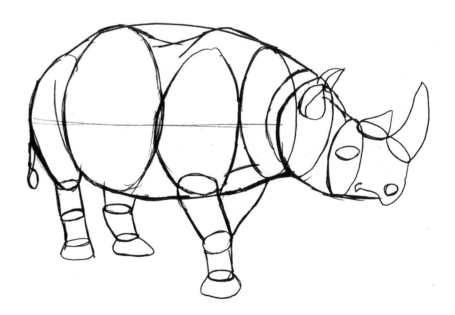

ELEPHANT

The elephant is the largest land animal alive today. Or, to be more precise, it's the African bush elephant (or savanna elephant) that holds that distinction. There are two basic kinds of elephants: African elephants and the somewhat smaller Asian elephants (also known as Indian elephants). Scientists used to think that all African elephants belonged to the same species, but DNA analysis has shown that there are actually two closely related African species: the bush elephant and the forest elephant.

Although African and Asian elephants differ in several ways, all elephants share some common traits—including, most notably, the trunk. An elephant's trunk is actually its nose and upper lip combined and elongated into one powerful organ. It is the elephant's multipurpose, Swiss army knife–type tool. An elephant uses its trunk to clean itself, feed itself, defend itself, snorkel, and communicate; it is powerful enough to uproot trees but so dexterous that its tip can pick up items as tiny as seeds.

Among the other distinctive features shared by elephants are the tusks—although the tusks of African elephants are much bigger than those of Asian elephants. (Also, males typically have thicker, heavier tusks than females.) Tusks are actually teeth—elongated upper incisors, to be exact. And, of course, elephants also have very large ears—with African elephants once again winning the size prize. Elephants use their ears as fans to help regulate body temperature. About the only thing that's small about an elephant is its tail—typically about four feet long (well, that's small for an elephant) and ending in a small tuft of hair.

Elephants' front feet are circular in shape, with five blunt toenails, while the hind feet are more oval, with four blunt toenails. The soles are padded, allowing this huge animal to move incredibly quietly and providing protection from the thorny jungle scrub.

Big and Wrinkly

An elephant's central body mass is a large oval shape; there is not a clear distinction between the elephant's torso and its pelvis. The legs are thick, column-like structures, with lots of wrinkles around the knees and ankles. When finishing off your elephant, remember that Asian elephants (like the one depicted here) have fewer wrinkles, especially around the face and trunk, than do African elephants. (Compare the drawing on page 57.)

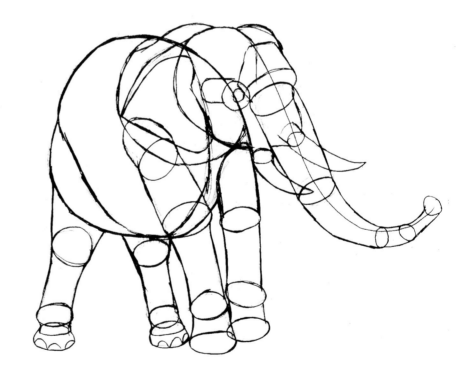

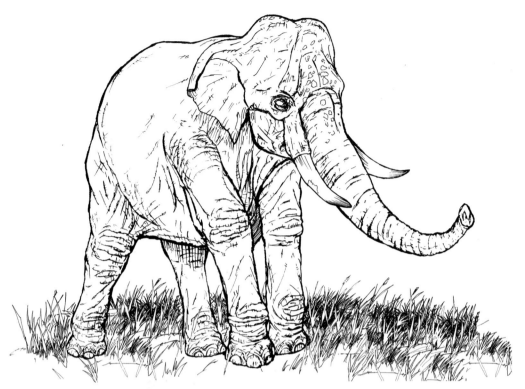

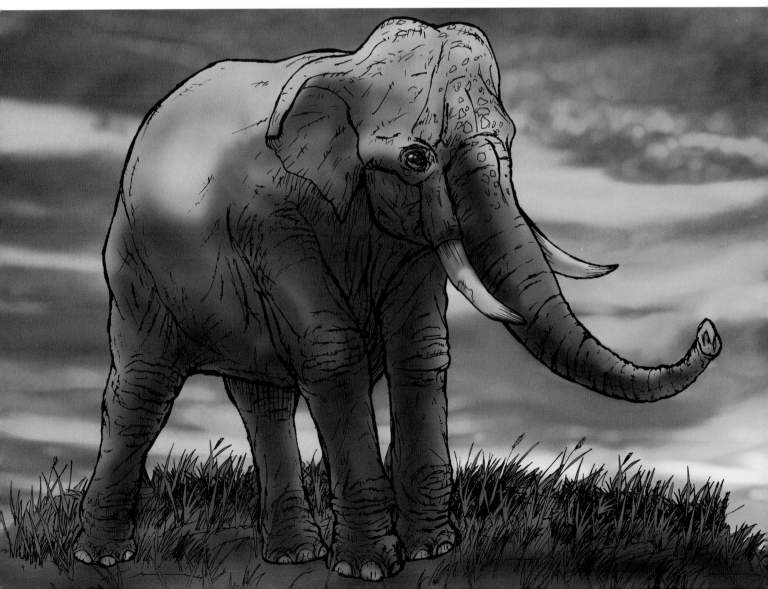

GORILLA

Zookeepers have noticed an interesting trend among some captive gorillas. They like to frighten—or maybe to amuse—little girls. For whatever reason, these primates find the sound of a little girl's shrill scream of delight to be as good a reward as a banana. The gorilla will lie still until an unsuspecting lass walks by his cage; then he'll jump into action, swinging and beating his chest to entertain the youngster. This is a peculiar habit, especially when you consider wild gorillas in the dense jungles of Africa probably get very few schoolgirl visitors.

Despite their King Kong reputation, gorillas in their natural habitat are shy creatures, shunning human contact. If provoked or startled, a gorilla will try to intimidate the intruder by standing erect and beating its chest. If that doesn't scare the intruder off, the gorilla will stop the monkey business and make the threat real. Because they're so intelligent and physically powerful, they can pose a real danger to any person who angers them. But fatal gorilla attacks are rare and usually result from human interference between a gorilla and its young.

Adult male gorillas reach an average height of between five and five and a half feet and weigh about 350 pounds. Older males are called silverbacks because of the graying of the fur along their upper backs. These alpha males rule over an extended family group, known as a troop, which may consist of as few as five or as many as thirty gorillas. Gorillas have a rigid social hierarchy, with the top-banana silverbacks making all the decisions. The silverbacks display humanlike organizational skills—mediating conflicts, orchestrating the movements of the group, leading it to feeding sites, overseeing the teaching of the young, and taking responsibility for every troop member's safety and well-being.

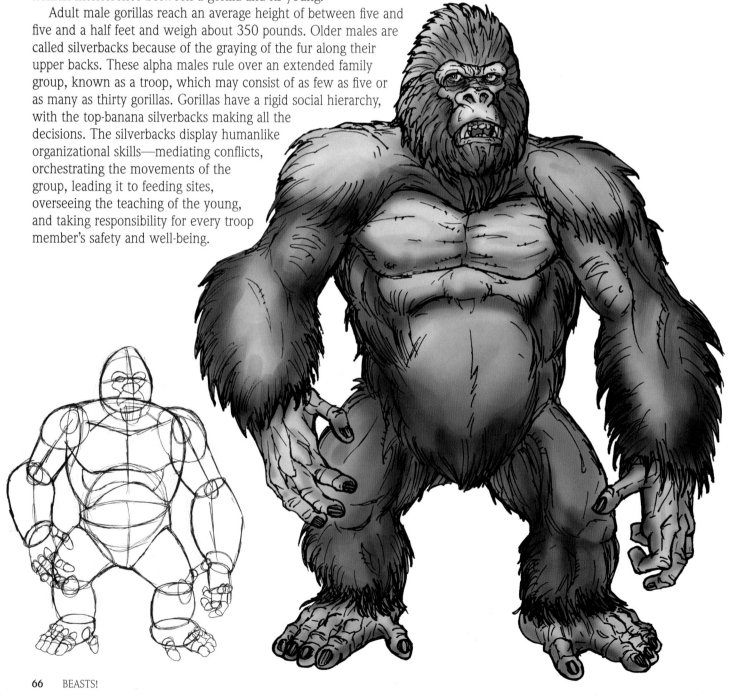

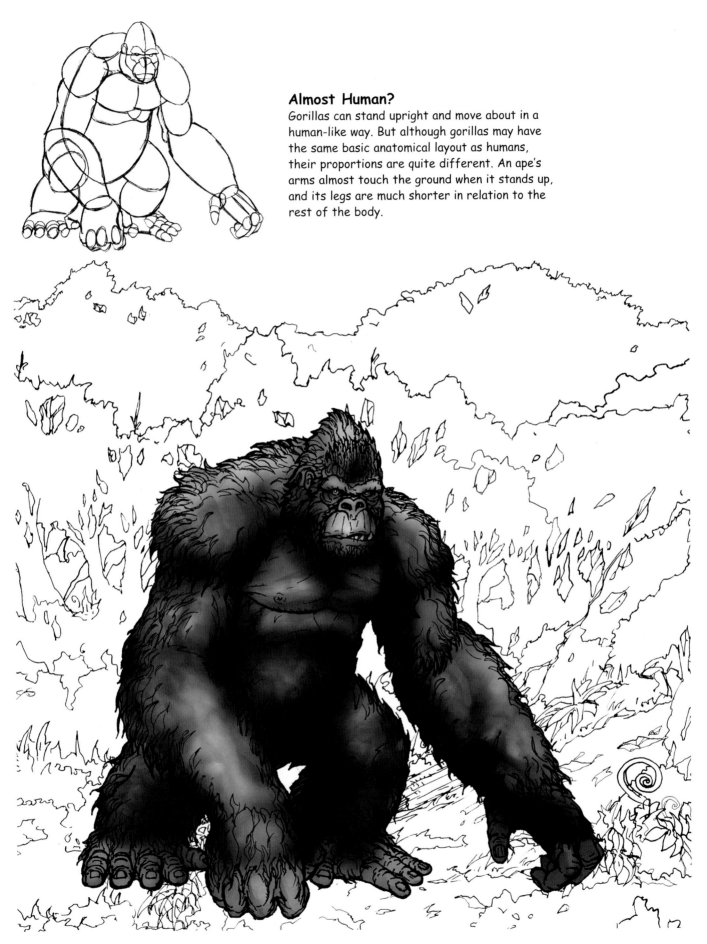

Almost Human?
Gorillas can stand upright and move about in a human-like way. But although gorillas may have the same basic anatomical layout as humans, their proportions are quite different. An ape's arms almost touch the ground when it stands up, and its legs are much shorter in relation to the rest of the body.

Fearsome Fliers

Some predators mount their attacks from the air. Virtually all such predators are birds, but the airborne attackers do include one group of highly unusual mammals—bats, which are the only living animals besides birds capable of true flight.

Birds of prey are also known as raptors. When hunting, birds of this group use their sharp talons to snatch their prey from treetops, ground, or sea and then carry their victims back to their nests. All raptors—eagles, hawks, falcons, and owls—have beaks with curved tips, designed for penetrating their victims' bodies and pulling out the meat and innards. And all birds of prey have superb vision; some are capable of zeroing in on prey from several thousand feet in the air.

Bald Eagle

The bald eagle is the national bird of the United States, but it wouldn't have been if Benjamin Franklin had had his way. Old Ben thought that the bald eagle had a bad moral character, and he proposed the wild turkey, instead!

Bald eagles are found only in North America, with more than half of the total population (estimated at about seventy thousand) in the state of Alaska. Their wings and bodies are a dark brown color (some of the feathers are actually a mottled brown and white). The species' distinctive white head feathers, from which this eagle gets its name, do not appear until bald eagles are four to five years old. It's at this same time—between their fourth and fifth birthdays—that the eagles' beaks and eyes turn yellow. Adult bald eagles range from about two and a half to about three and a half feet in length, generally weigh between seven and fifteen pounds, and have massive wingspans of six to eight feet.

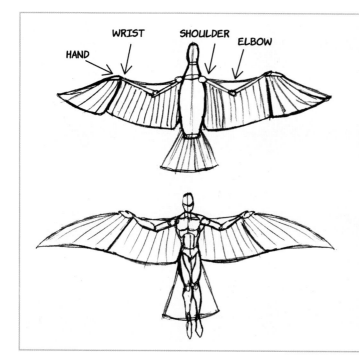

WRIST SHOULDER ELBOW
HAND

Feathered "Arms"

If you're having trouble picturing how a wing works, look at your own arm. Just like you, a bird has "elbow" and "wrist" joints. A bird's wing feathers radiate out in an arch from wrist bone to the tip of the wing. From the wrist bone to the body, the feathers run roughly parallel to the bird's body. Most of a bird's ability to "swim" through the air is controlled by the feathers from the wrist out. Think of your own hands and how you can bring your fingers together to form a cup if you want to catch something or splay them apart if you want to let sand run between them. By varying the direction and distance of a bird's "hand feathers" you can greatly increase the illusion of your bird's mastering the winds. Never draw birds' wings as if they were static airplane wings; always remember that they have joints that allow them to flap or fold to cut through the air.

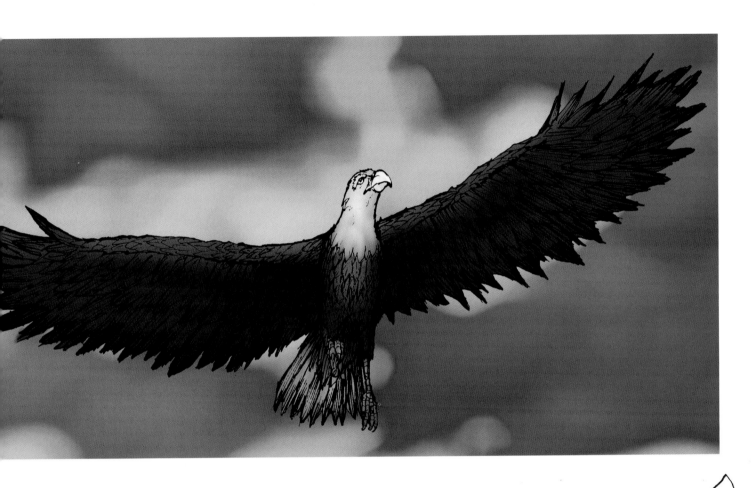

Soaring Symbol

The bald eagle is the living symbol of the United States and of the country's spirit, freedom, and pursuit of excellence. The eagle's image is found on U.S. currency and incorporated into the official seals of most federal departments and agencies. It's also used as a decorative element in much government architecture.

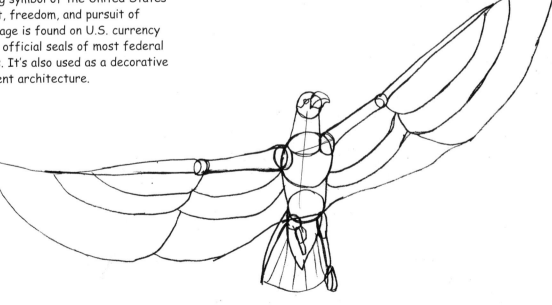

Scientists group the bald eagle with other sea eagles, or fish eagles, because its diet is so heavily dependant on salmon. But although bald eagles' favorite menu item is fish, they will also eat small animals (ducks, coots, muskrats, turtles, rabbits, and snakes) and will occasionally scavenge for carrion. Watching a bald eagle hunt is quite impressive; it swoops down to seize its prey in its long, sharp, powerful talons and then flies off with the kill, which it will eat at its leisure. Bald eagles have been clocked flying at speeds of up to forty-four miles per hour. They can soar to altitudes of ten thousand feet, where they can stay aloft for hours by utilizing thermal updrafts.

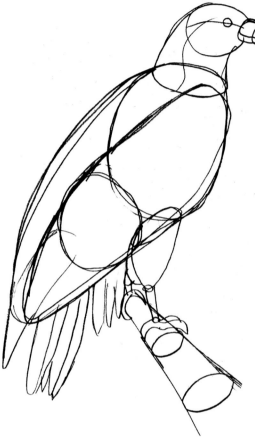

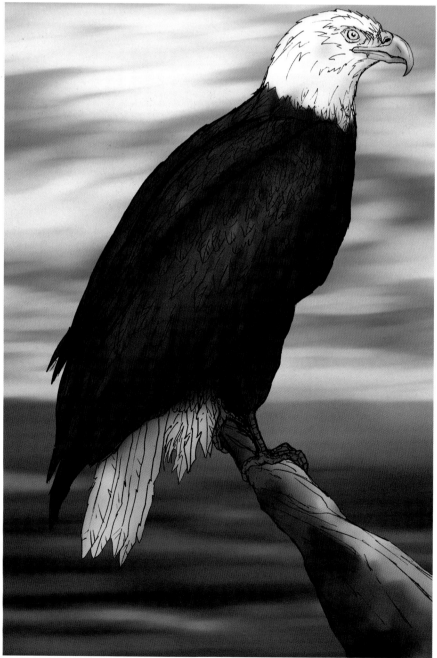

Neatly Folded

When a bird perches on a branch, it folds its wings against its body. To help yourself understand how a bird collapses its wings, put your palms on your upper chest with your hands pointed straight down and then bring your elbows as close to your sides as you can. When folded, a bird's wings are almost indistinguishable from the rest of its body; this keeps the body aerodynamic, allowing the bird to stay on its perch even in gusty winds. When drawing a perched bird, just draw the outline of the wing where it runs along the body as well as the ends of the wing feathers, which point out toward the tail.

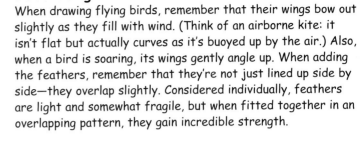

Bird in Flight

When drawing flying birds, remember that their wings bow out slightly as they fill with wind. (Think of an airborne kite: it isn't flat but actually curves as it's buoyed up by the air.) Also, when a bird is soaring, its wings gently angle up. When adding the feathers, remember that they're not just lined up side by side—they overlap slightly. Considered individually, feathers are light and somewhat fragile, but when fitted together in an overlapping pattern, they gain incredible strength.

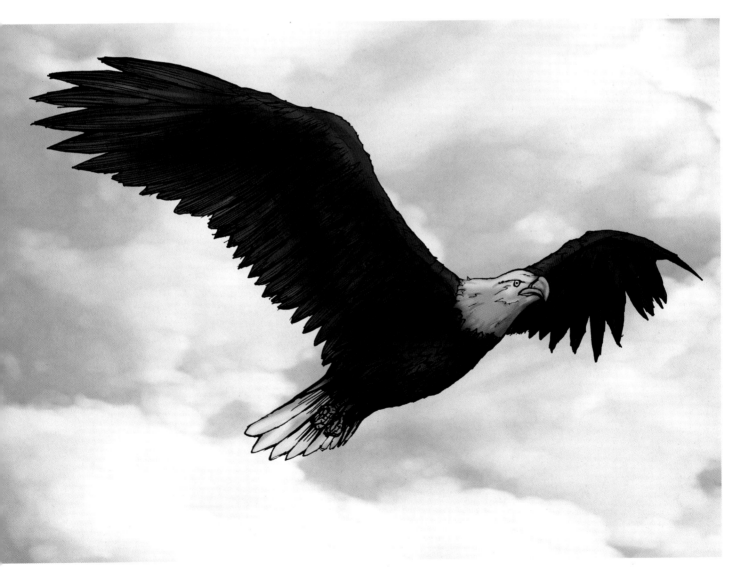

Black Eagle

The black eagle eats small mammals and other birds. Pretty much any animal that lives in the jungle canopy is fair game for the black eagle. It is also a successful egg thief and is known for raiding other birds' nests and leaving them bare. But the eagle's favorite food is monkeys. Think about that for a minute. It eats monkeys. Which makes me glad I didn't grow up in a tree house in a jungle patrolled by these raptors: If I skipped a haircut, I might have been confused with bird food.

The black eagle is native to the mountain forests of India, Sri Lanka, and Southeast Asia, including the Philippines, where it is the national bird and where it's referred to as the Philippine eagle. (I guess the other birds that tried out for the position of national bird flew home in shame when they saw that monkey-snatching trick.)

Black eagles are large birds, averaging three feet in length and possessing wingspans of six feet; adults weigh between thirteen and fifteen and a half pounds. And by the way, when monkeys are slim pickings, black eagles are happy to expand their airborne grocery lists to include Philippine flying lemurs, squirrels and other rodents, and even small dogs.

Fine Feathered Foe

The black eagle is shaped like many other birds, but everything is bigger. Its talons are specially designed for snatching and grasping prey, while its curved, sharp beak allows it to clean the flesh off the bones of its victims. When drawing birds' wings, don't get lost in trying to draw every individual feather. Think of the wing as a large, unified shape.

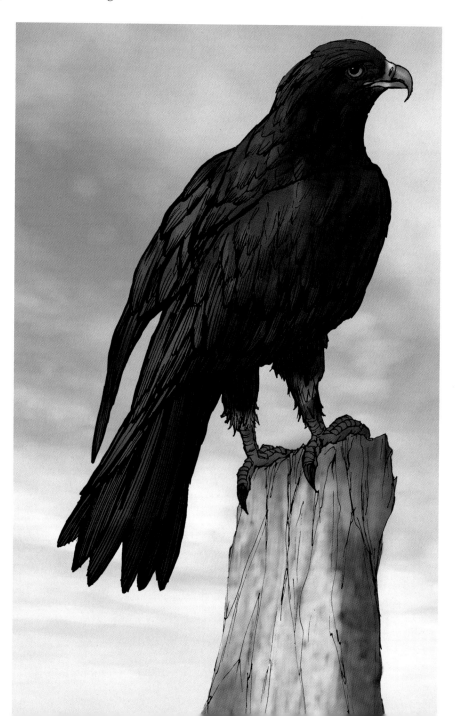

Red-Tailed Hawk

When you describe someone as a hawk, you mean that he's shrewd and sharp-eyed, like a good hunter. Well, the red-tailed hawk is certainly an accomplished and focused hunter. The red-tailed is the largest hawk, usually weighing from two to four pounds and having a wingspan of about four and a half feet. Hawks have superlative eyesight—about eight times more acute than a person with perfect 20/20 vision.

All hawks are carnivores, and every aspect of a hawk's body is specially designed to take out smaller birds and small animals. Red-tailed hawks kill their prey with their long, curved talons, and if the prey is too large to swallow whole, they tear it into bite-size pieces with their sharp beaks. The hawk's diet changes as it grows older and graduates from beetles and worms to larger game, like rabbits, other rodents, snakes, frogs, and lizards. Not content just to pick off targets on the ground, adult hawks seem almost to enjoy the aerial dogfights required to take down fellow birds.

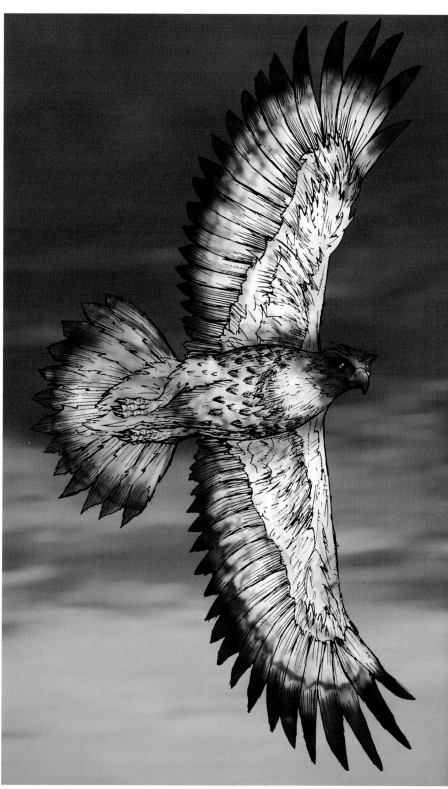

Sharp Eyed, Sharp Billed, Sharp Clawed

Red-tailed hawks have hooked bills. Draw the bill so that it curves along the main shaft and terminates in a sharp, angular point. The bird is reddish-brown in color, with a black stripe along the outer edge of the tail. Its feet have three toes pointed forward and one turned back; the claws are long, curved, and very sharp.

Owl

Owls are said to possess great wisdom. It's rather curious that they manage to learn so much, since the only question they ever ask is "Who?"

Solitary, nocturnal birds of prey, owls feed on small animals such as rodents, insects, birds, frogs, and, in some cases, fish. Their keen sense of sight enables them to locate prey in the dark—even though they are mostly color-blind. There are many types of owls, and owls inhabit every region on earth except for Antarctica, most of Greenland, and some remote islands. A group of owls, by the way, is called a parliament.

Owls are at the top of the food chain and have no major predators. Owls are stealth flyers; the flight feathers (remiges) of their wings have fluffy trailing edges that act as sound dampeners, making an owl's airborne approach practically soundless. These birds' generally dull colors and patterns make them difficult to see, especially during their prime nighttime hunting hours.

Owls' powerful clawed feet and sharp beaks enable them to tear their prey to pieces before eating, although most entrées are swallowed whole.

The Better to See You With

Owls have a large, elliptical heads and large binocular eyes, which means they face forward. (Other birds' eyes are on the sides of their heads.) This frontal eye placement allows owls to see three-dimensionally (as human beings do) and gives them precise depth perception except at extremely close distances, where they become practically blind.

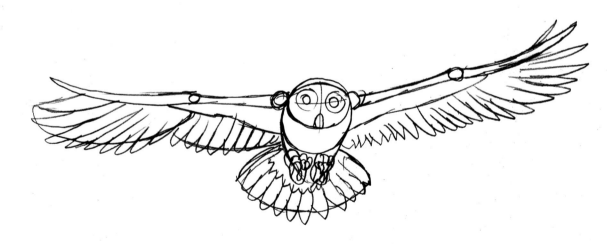

Snowbird

Most owls' plumage is predominantly gray or brown, but the Arctic-dwelling snowy owl's feathers are almost entirely white—which makes good camouflage in this bird's northern habitat, especially during the winter. Remember when drawing an owl that its body and wings are similar to other birds' but its head is proportionally larger.

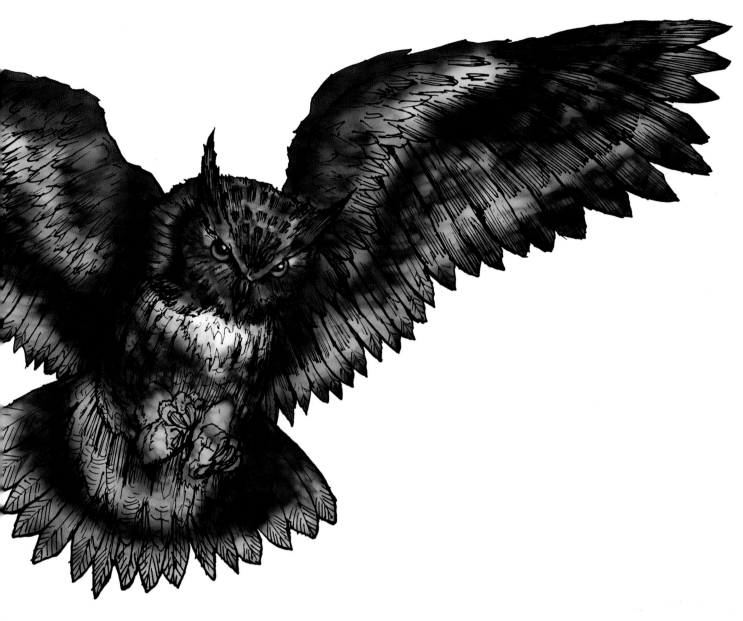

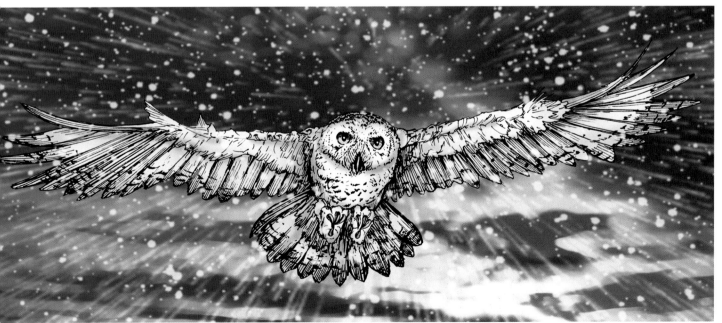

BAT

Bats fly! That's stating the obvious, of course, but it's remarkable when you think about it. They are the only mammals capable of puling off that neat little trick. Sure, there are some other mammals (like the so-called flying squirrel) that can glide through the air. But bats alone have real wings—forelimbs with fingerlike phalanges webbed together by a thin membrane of skin—that allow them to take flight.

There are an estimated eleven hundred species of bats worldwide, which translates into about 20 percent of all mammal species. In other words, if every mammal species sent a delegate to the Mammals' Annual Convention, one out of every five guys you'd meet there would be a bat! About 70 percent of bats are insectivores, which means they eat bugs. (No one likes to be called just a "bug eater." "Insectivore" sounds much more impressive.) The rest mainly eat fruit or small animals, but three species—the vampire bats—have the objectionable habit of drinking blood.

Bats are active only at night, hiding themselves during the day in barns, attics, caves, and other secluded locations, where they sleep hanging upside down. Bats maneuver and hunt using a radar-like sense. As they fly, they send out high-pitched sounds and then listen as the sounds bounce back; these sounds' patterns reveal the shapes, contours, and distances of the objects surrounding the bat. Bats' funnel-like ears are specially designed to catch the returning signals.

Mobile Radar Station
Bats' fur conceals their heads, necks, and abdomens. You can rough-in the bat's body quickly by using a flattened football shape. The head is a sphere. And don't forget those large, radar-catching ears; they can easily be drawn using half-cone shapes.

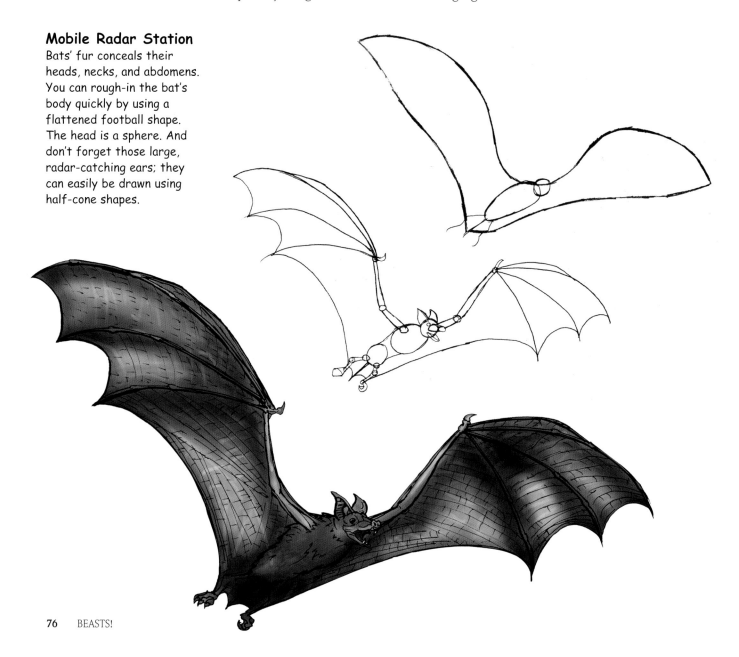

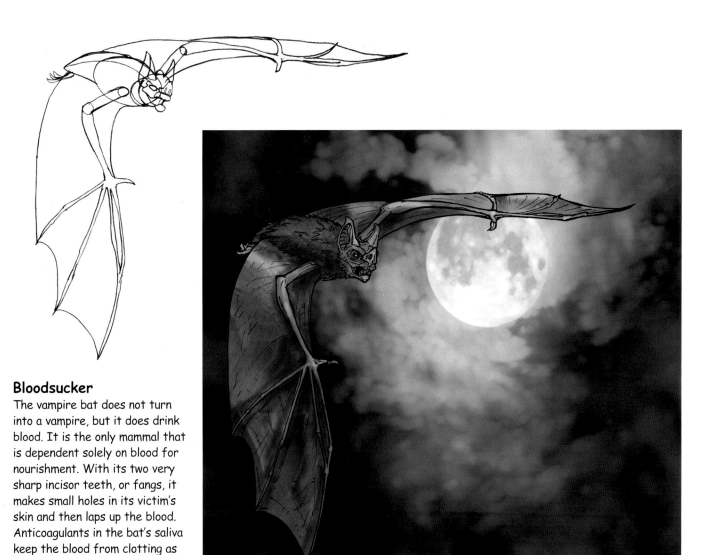

Bloodsucker

The vampire bat does not turn into a vampire, but it does drink blood. It is the only mammal that is dependent solely on blood for nourishment. With its two very sharp incisor teeth, or fangs, it makes small holes in its victim's skin and then laps up the blood. Anticoagulants in the bat's saliva keep the blood from clotting as the bat drinks its meal.

Winged Rat

Bats fly like birds, but their body shape is quite different. They've been called winged rats, which isn't too far from the truth. Their wings resemble webbed hands thanks to the fine leathery membrane that stretches between their bones of their "fingers."

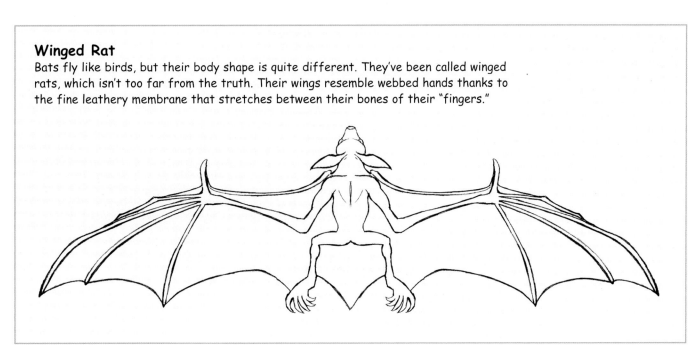

Cold-Blooded Killers

THINK OF ALL THE NEGATIVE SAYINGS THAT involve reptiles: You're a cold-hearted snake. Your skin's as dry as a lizard's. Don't cry crocodile tears. He speaks with a forked tongue. You need to come out of your shell. And so on. Now think of the positive references. Can't think of any? Me neither. But this should not be, considering just how adaptive and marvelous reptiles are.

The class of animals called reptiles (scientific name: Sauropsida) includes the long-extinct dinosaurs as well as modern lizards, snakes, turtles, and crocodilians. The living reptiles range greatly in size, from the huge (and terrifying) alligators of Florida swamps and Louisiana bayous to the four-inch-long, bug-eating wall gecko of the Canary Islands. Reptiles are cold blooded, covered in scales, and in most cases reproduce by laying eggs. Reptiles have adapted to living on every continent and in every environment except the frigid cold of Antarctica. They can be carnivores, herbivores, or omnivores. Not all reptiles are scary (what could be less frightening than a box turtle?), but in this chapter we focus on some of the more dangerous members of the reptilian fold. (Snakes deserve their own chapter— coming up next.)

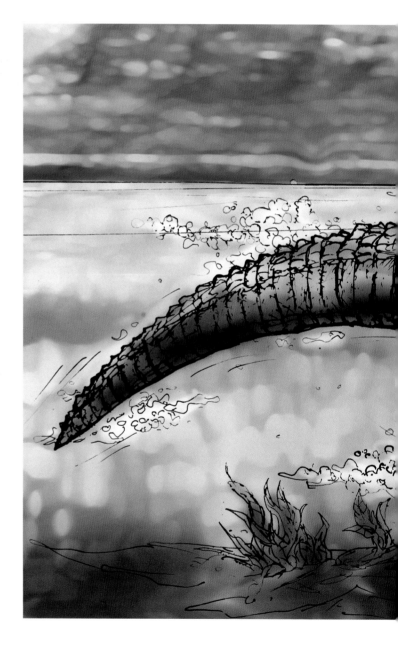

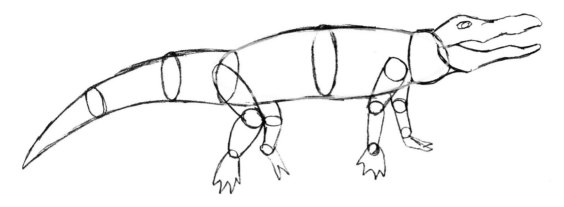

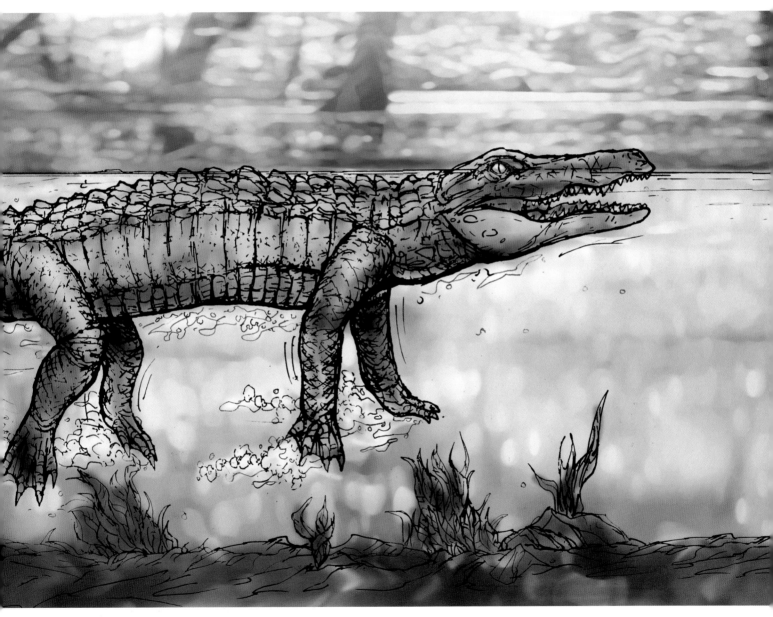

Swamp Terror
Alligators and their close cousins the crocodiles are the largest living reptiles. Gators' thick hides obscure their internal anatomy (except for the skull); you should therefore concentrate on drawing the basic shapes correctly. Although alligators have a fair range of movement in their necks and tails, the central body mass can curve only slightly along the spine.

ALLIGATOR

Alligator skin is used for shoes, boots, belts, luggage, and wallets, and it usually greatly increases the price of the product. The costliness results from the fact that alligators like their skin and part with it only under great resistance.

The name *alligator* comes from the Spanish *el lagarto* ("the lizard"). And what lizards they are! An average American alligator weighs about six hundred pounds and is around thirteen feet long, although alligators can reach lengths nearing twenty feet and can weigh close to a ton. Alligators' long bodies are similar to a tree trunk in shape; attached to that massive form, their short, stubby legs look almost comically inappropriate. Their long, tapering tails aid greatly with swimming, as do their webbed toes. Their eyes have protective lids that act like contact lenses, allowing gators to see better underwater.

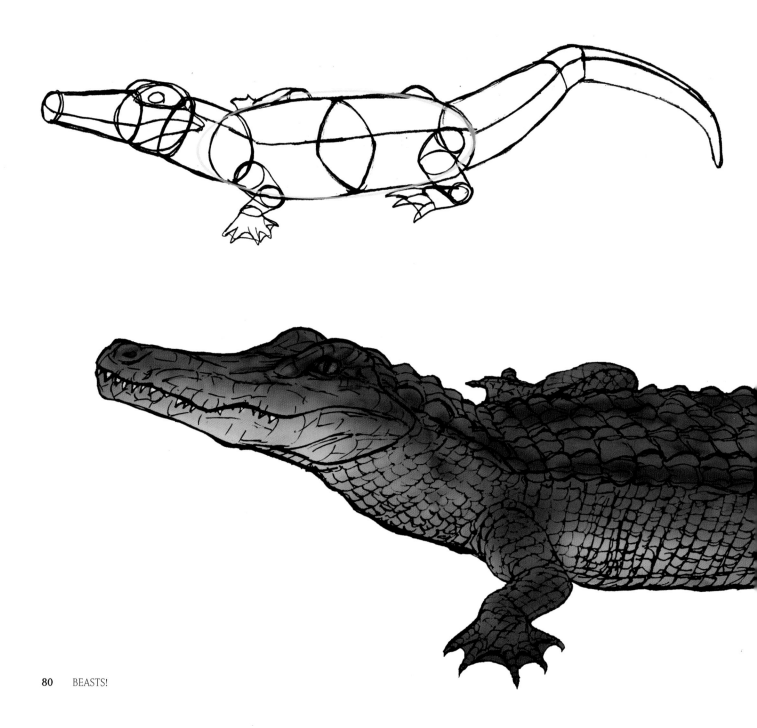

The alligator is a dangerous creature. Its feet are outfitted with very sharp claws, and its broad, flat skull is equipped with a set of extremely lethal teeth. But alligators—although they will eat almost anything they come across in the wild—do not automatically view people as prey. When they are young they eat small fish, insects, snails, and crustaceans, but as they grow they develop a taste for larger game, like turtles, birds, razorback hogs, and deer. Their diet sometimes has a cannibalistic streak: large alligators are known to occasionally feast on juvenile alligators.

Although alligators are not as aggressive toward human beings as are their close cousins the crocodiles, they will attack anyone foolish enough to venture into their territory. Alligator-caused deaths are on the rise as people claim more and more of their natural habitat. From 2001 to 2006, eleven people were killed by alligators in the United States.

Don't Step on This Log!
The central part of an alligator's body is one long, tree-trunk-shaped cylinder. There is no clear line dividing the torso from the hips, and the neck is just a thick, cubical mass connecting the head to the shoulders.

CROCODILE

There is an African saying that goes, "If two crocodiles fight over the same food, the third crocodile gets a good meal." Well, I don't care which crocodile eats what, as long as it's not me.

Crocodiles are famous for their phony tears. According to an old legend, crocs fake remorseful sobs to lure their prey, so people who weep insincerely are said to be "crying crocodile tears." I tend to believe a crocodile should be given a wide berth no matter what its emotional state.

The crocodile was given its name by Greek travelers who saw the reptiles sunning themselves on rocks along the Nile River in Egypt. The crocodiles' sunbathing reminded the Greeks of a small lizard they knew from their homeland, which also warmed itself by basking on sun-warmed stones. The little lizard was called a *krokodilos*—a compound word from *kroke,* meaning "pebbles," and *dilos,* meaning "worm." So next time you see a crocodile smiling at you, just remind him he is nothing but a little "pebble worm."

Yeah, right. Although the different crocodile species vary greatly in size, the largest croc—the male saltwater crocodile of Southeast Asia and Australia—averages more than sixteen feet in length and typically weighs about *seventeen hundred* pounds. Some worm. (The saltwater croc is, by the way, the biggest living reptile.)

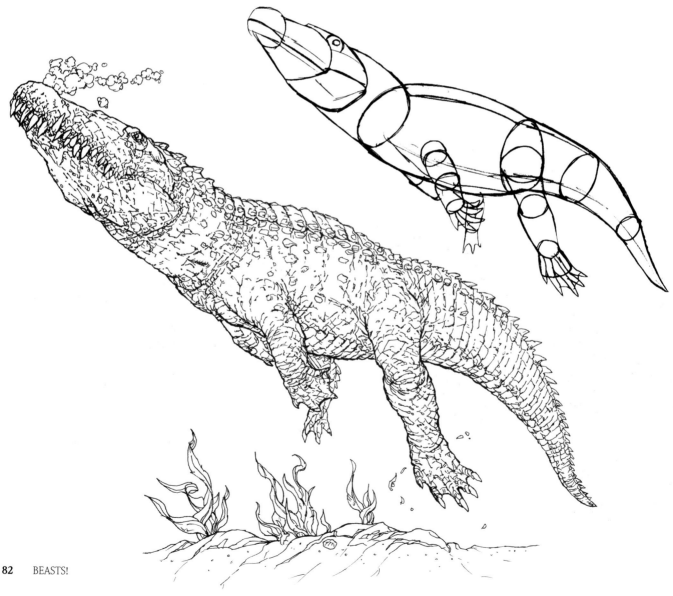

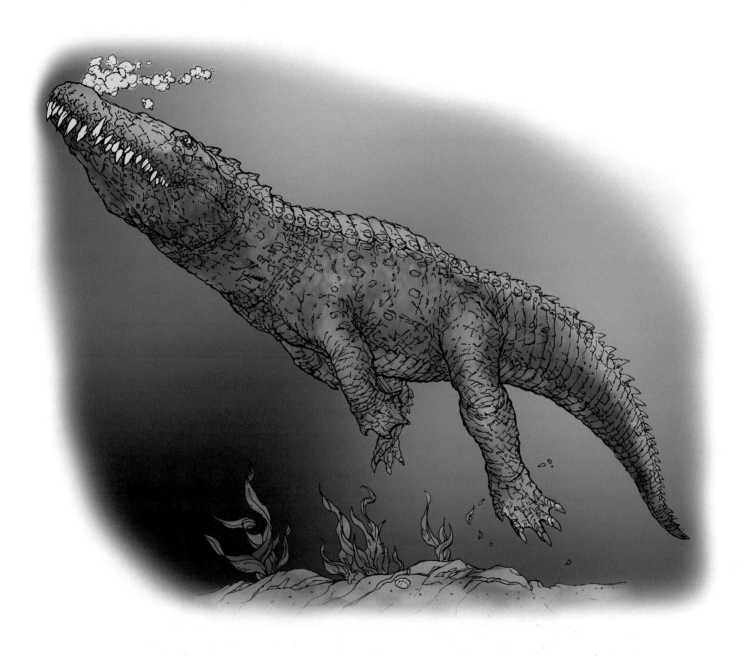

What a Croc!

The crocodile is very similar in construction to the alligator. It has short legs attached to an elongated body. Because most of its muscles and bones are hidden by its thick hide, you will want to clearly denote the joints on the legs to help give the crocodile its familiar outline.

Crocodiles can be found throughout the tropics—in Africa, Asia, the Americas, and Australia. Being aquatic reptiles, crocs tend to congregate in and around rivers, lakes, wetlands, and the occasional swimming pool. You may think you are safe from crocs in the ocean, but the aforementioned saltwater crocodile has a specially adapted gland in its mouth that allows it to thrive in seawater. It's because of their highly adaptive nature that crocodiles have survived since the age of dinosaurs. Crocodiles are not picky eaters: They will chomp on just about anything they find thrashing around in the water, although their diet consists mostly of fish, mammals, and other reptiles, with the occasional mollusk or crustacean thrown in for good measure.

The crocodile's basic anatomy is almost identical to the alligator's. Its streamlined body enables it to swim very fast; as it swims, it pulls its legs in close to its body and propels itself forward by paddling its powerful tail back and forth. Crocodiles' webbed feet have sharp claws, and their V-shaped jaws (equipped with a formidable set of huge teeth) can exert a crushing pressure of three thousand pounds per square inch. (By contrast, the crushing pressure of a large dog's jaws is about one hundred psi.)

Crocodiles are very dangerous to humans. In parts of Southeast Asia and Africa, crocodiles are responsible for hundreds of deaths every year.

Swims Fast. Runs Fast, Too.
Crocodiles are amazingly swift swimmers, but they can also move quickly on land. Despite their stubby legs, they can clock speeds of up to thirty miles per hour over short distances.

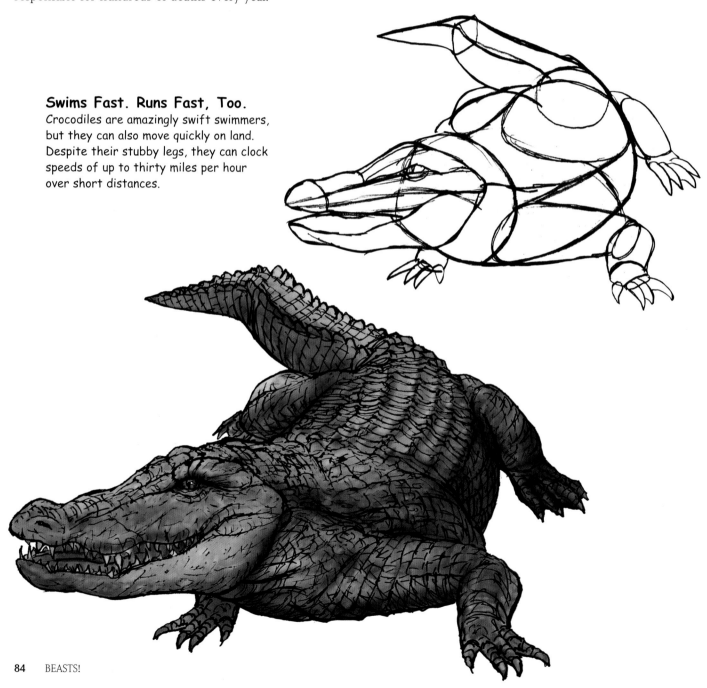

GATORS VERSUS CROCS

What is the difference between an alligator and a crocodile?

If you encounter any crocodilian in the wild, you should first get out of its way! They can be quite aggressive attackers, especially around the water's edge. Once you're at a safe distance, you can think about which sort of animal you've just narrowly escaped from—so that you can use the correct terminology when you tell the story to your friends.

Alligators and crocodiles have many similarities, but there are also significant physical differences between them. The easiest way to tell which is which is to look at the shape of the snout: a crocodile's snout is long, narrow, and V-shaped; an alligator's is wider and U-shaped. The shape of its snout is linked to each animal's diet: While crocodiles chiefly eat fish and mammals, alligators include turtles in their diet and use their broad, heavy snouts to crack the turtles' shells. There are also differences in the ways that gators' and crocs' teeth are arranged, as the drawings below show.

Color can also help distinguish the reptiles. Alligators, which are usually darker than crocs, range in color from olive, to gray, to nearly black, while crocodiles are generally brown or brownish green.

Another clue to which animal attacked you is to stop and look around to find out where you are. Alligators are found only in the southeastern United States and China's Yangtze River valley. If you're not in either of these two places, it was definitely a crocodile that almost got you. But if you're in southern Florida, you've got a problem: it's the only place in the world where *both* alligators and crocodiles live.

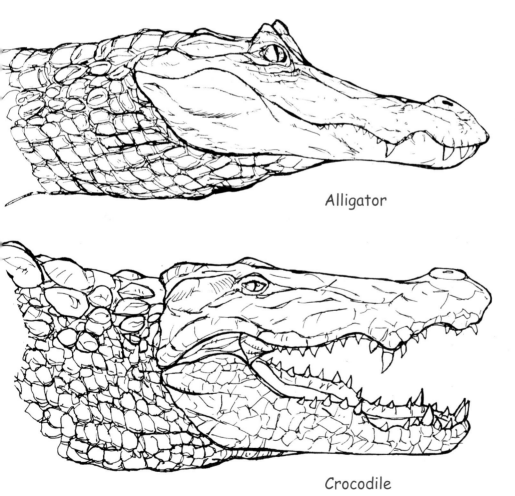

Alligator

Crocodile

Crocodile Smile, Gator Grin

It's often joked that crocodiles always wear a smile. This is because a crocodile's upper and lower jaws are nearly the same width, so its teeth are exposed all along the jawline in an interlocking pattern, even when its mouth is closed. Crocs also have an enormous fourth tooth on both sides of the lower jaw, which is accommodated by a depression in the upper jaw just behind the nostril. By contrast, an alligator's lower jaw fits into its larger upper jaw, so when its mouth is closed the teeth in the lower jaw are hidden from view. Only the teeth of the upper jaw are exposed. Even the enormous fourth tooth of the bottom jaw, which is exposed in a crocodile, is hidden in the alligator.

KOMODO DRAGON

Mythical dragons are said to breathe fire, and it's possible this idea grew out of stories about the Komodo dragon's breath. I've heard of chronic halitosis, but these guys' saliva can actually kill! When a Komodo dragon bites, it infects its prey with deadly bacteria that live in its mouth. Even if the victim gets away, it usually dies from the infection within a few days.

Found only on a few small islands in Indonesia, the Komodo dragon is the largest lizard in the world today. A true modern-day monster, it can grow up to twelve feet in length and weigh up to three hundred pounds. Although they are scavengers for the most part, Komodo dragons do capture live prey, including deer, pigs, birds, and even young Komodos. In fact, a Komodo dragon will devour any animal it is capable of dismembering and gulping down. And just like fairy-tale dragons, Komodo dragons are man-eaters. The Komodo does not fear humans, and many attacks and deaths have been reported.

Like most lizards, the Komodo dragon should be drawn using a long oval for the central body mass. The four legs attach directly to the body, in the front near the base of the neck and in the rear at the base of the tale. When drawing lizards' tails (and snakes' bodies and tails, too), it is important to remember they are not hollow constructs but have bones and muscles running through them. They should always be drawn with flowing curved lines, never with garden-hose-like kinks.

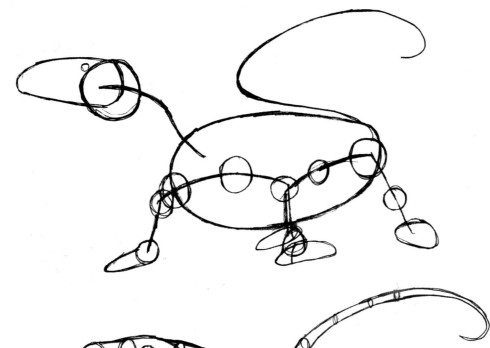

Gobble, Gobble

The Komodo dragon has a durable hide, but it is not as thick as an alligator's or a crocodile's. This lizard's body comprises a series of cylinders connected to a central, oval-shaped mass. The dewlap is an important feature of lizard anatomy. A flap of compressed skin under the lizard's throat, the dewlap can stretch out to help the lizard gobble down any prey that won't fit inside the throat at its normal size. The Komodo's tail is extremely flexible—like a whip. Draw it so that it narrows to just a thin strand at the end.

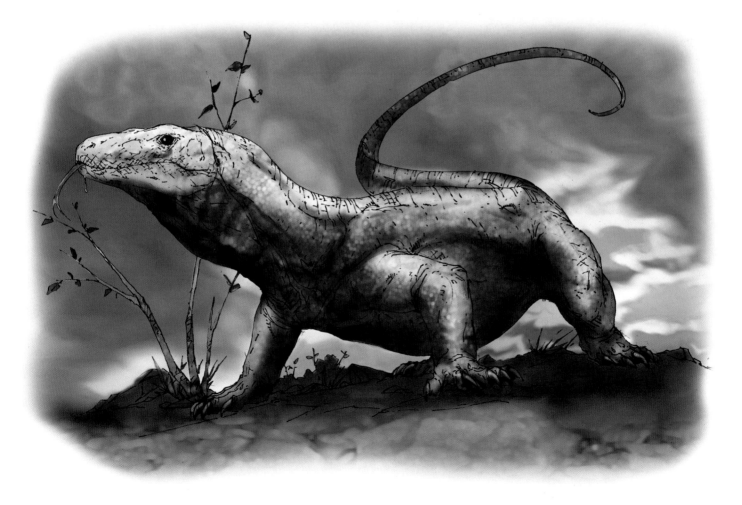

Gila Monster

Anyone who's ever seen the silly 1959 horror film *The Giant Gila Monster* would have to agree that this "monster" looks more goofy than scary. I mean, come on—its head and tail are basically the same shape! Still, goofy-looking or not, the Gila monster has to be treated with respect. Why? Because of its venom.

The Gila monster—named after a river in Arizona, pronounced HEE-luh—delivers its poison in an unusual way. Unlike, say, a rattlesnake, it does not inject its victims. Its venom is in its spit, and when it bites an animal, it hangs on, chewing through its skin and letting a set of grooves in its lower teeth push the toxic saliva into the prey's bloodstream.

The lizard's nasty reputation isn't fully deserved, however. Its venom isn't strong enough to be fatal to human beings in most cases (although its bite is painful and can cause a severe infection if not properly treated). It's also a lethargic, slow-moving creature. In other words, it's not going to jump out of the sagebrush and attack you. Even so, Gila monsters can be quick to bite if disturbed, so it's wise to tread carefully when hiking around their habitat—the deserts of the southwestern United States and northwestern Mexico.

Gila monsters average about two feet in length. Their hides have a distinctive, pebbly texture—almost as if they were beaded. Their coloring is very distinctive, too: a mottled pattern of black, pink, orange, and yellow, which some describe as looking like macramé. The Gila monster's preferred diet consists of small rodents and young birds, as well as the eggs of both birds and reptiles.

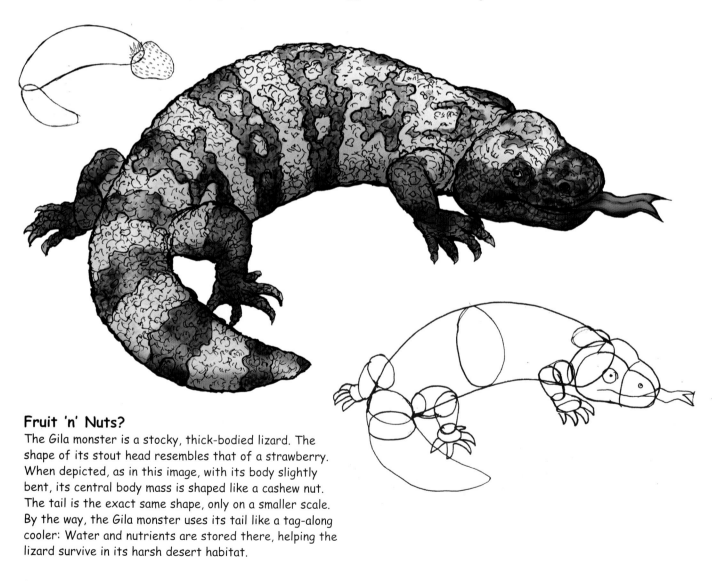

Fruit 'n' Nuts?

The Gila monster is a stocky, thick-bodied lizard. The shape of its stout head resembles that of a strawberry. When depicted, as in this image, with its body slightly bent, its central body mass is shaped like a cashew nut. The tail is the exact same shape, only on a smaller scale. By the way, the Gila monster uses its tail like a tag-along cooler: Water and nutrients are stored there, helping the lizard survive in its harsh desert habitat.

ALLIGATOR SNAPPING TURTLE

Turtles are often thought of as passive creatures that retreat into their shells at the first sign of danger. That isn't true, however, of the alligator snapping turtles, the largest freshwater turtle in North America. This turtle's disposition turns angry when anything ventures into its favorite watering hole, and it viselike jaws are capable of severing fingers and toes. Not only does it have a mean set of choppers, but its neck is extremely long and flexible, enabling the turtle to reach almost straight back and snap anyone foolish enough to grab hold of its shell. The alligator snapping turtle gets its name from the fact that its shell looks like gator hide, and its skin is pebbly textured, too.

With their thick heads and tails, alligator snapping turtles look like something from the Age of the Dinosaurs. These monsters continue to grow for almost their entire lives, adding size and weight in direct proportion to the abundance of prey. There are unconfirmed reports of specimens weighing as much as four hundred pounds. Although the largest alligator snapper whose capture was confirmed weighed a "mere" 236 pounds, these creatures are very elusive, so there are sure to be bigger turtles hiding out in river bottoms and deep swamps. The alligator snapping turtle's range, by the way, extends from the southern United States all the way up into Lower Canada.

An alligator snapping turtle's mouth is a equipped like a tackle box, with a worm-shaped appendage at the end of its tongue. When it wiggles this enticing-looking morsel, fish, invertebrates, small mammals, amphibians, snakes, and even other turtles are lured into its maw. The turtle's long neck then propels its jaws forward, snapping up the helpless prey.

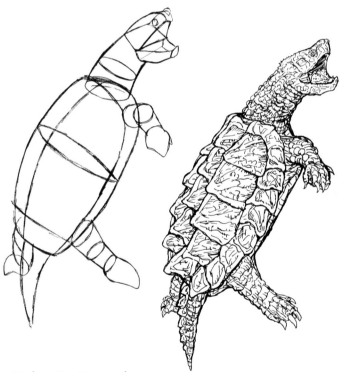

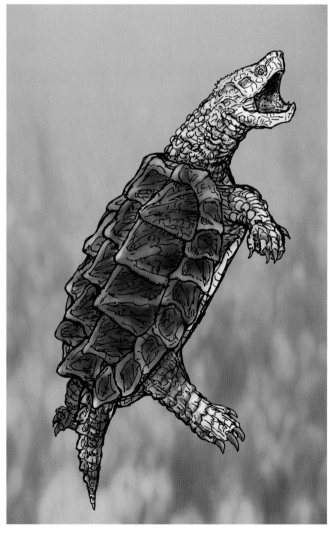

Make It Snappy!
The turtle's central mass is its shell, which you will want to draw first. Note that the shell isn't perfectly round but rather an oval shape that's longer than it is wide. This snapper's shell has three distinct ridges on the carapace (the top of the shell). The head emerges from a lip on the front of the shell, and the legs come out of openings that angle downward, not directly out of the sides. The alligator snapping turtle has a thick tail with a dorsal ridge of large scales.

VENOMOUS VIPERS (AND CRUEL CONSTRICTORS)

EVER SINCE THE SERPENT ENCOURAGED EVE TO EAT THE FORBIDDEN FRUIT IN THE Garden of Eden, snakes have been symbols of evil. Perhaps if snakes had a slicker PR agent they could manage to get some better press. For one thing, snakes play a vital role in stabilizing the ecosystems in which they live. Their dietary needs ensure that insect and rodent populations do not get out of control.

All snakes are carnivorous. Their diets range from insects to small mammals (rodents being a favorite) to creatures as large as deer, in the case of the huge South American serpent known as the anaconda. Snakes use one of three methods to dispatch their victims: Poisonous snakes inject their prey with venom. Constrictors squeeze their prey to death. And other snakes dispense with pre-killing their meals and just swallow their quarry alive and whole. You know, maybe there is a good reason that snakes can't get better press!

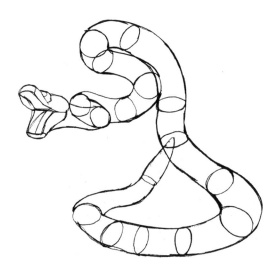

Preemptive Strike

Rattlesnakes are, along with king cobras, probably the best-known poisonous snakes. Rattlers kill their prey by striking in a lightning-fast way and injecting the victim with a powerful venom that flows through their hypodermic-like teeth. Like all snakes, rattlers swallow their prey whole, headfirst. Then, the snake slowly contracts the muscles of its body to crush and guide the kill down its digestive tract. The top and bottom jaws are attached to each other with flexible ligaments, which let the snake expand its mouth to engulf animals that are bigger around than the snake itself.

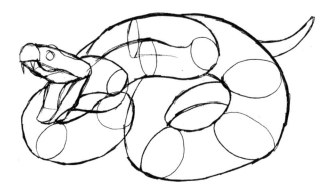

Telling Head from Tail

This green viper shows the basic method for constructing any snake. Other than the reptilian head, you really only have to concentrate on drawing graceful loops of scale-covered snakeskin. One thing I do to help me keep straight which end of the snake is which is to quickly lay down a few scales pointing toward the tail. The scales on a snake's body are designed to lie flat with a slight overlap; this allows the snake to move in a forward direction without getting stuck on debris or leaf matter on the ground. Think of the scales as arrowheads that always point toward the rear of the snake.

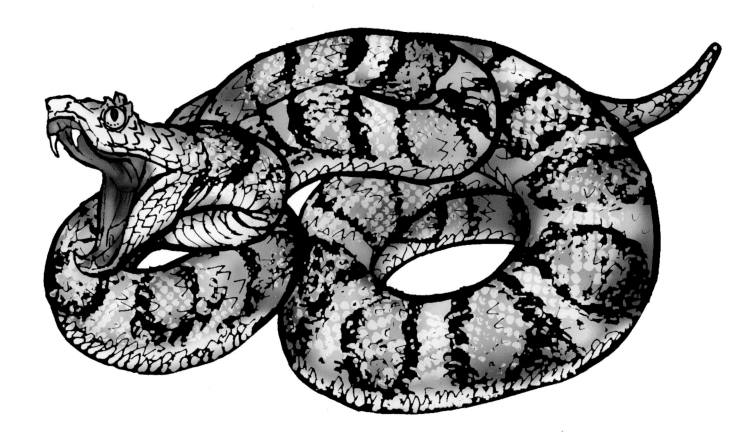

There are more than 450 species of poisonous snakes, and a little more than half of these produce venom toxic enough to kill a human being. Each year, more than seven thousand people in the United States are bitten by a venomous snake, but thanks to advances in antivenom, fewer than twenty of these snakebites will prove fatal. India is not nearly so lucky: Because the proper medical treatment is not always readily available there, an estimated fifty thousand Indian citizens die annually from the bites of cobras and other venomous snakes.

No matter which killing method they use, all snakes swallow their food whole—and they are capable of ingesting disproportionately large prey. (An ordinary garter snake can, for example, swallow a sizable frog.) Snakes are able to wolf down such outsize meals because of a special anatomical feature: A snake's pliable skull is equipped with a flexible lower jaw that allows the snake to stretch out its whole head, conforming it to the shape of whatever it's swallowing.

Snakes do not normally prey on people. They have little interest in killing animals that are too big for them to eat, but there have been instances in which large constrictors have captured and eaten children. Although a few snake species are aggressive, most will quickly retreat from humans, and most snakebites occur when someone steps on a snake by accident or frightens it.

Snakes are miraculously well designed. Though their bodies are basically just simple, scale-covered tubes, they are able to accomplish almost all of the biological functions of much larger and more complicated organisms. A snake's skeleton is essentially a skull attached to one end of a long spinal column (with anywhere between 120 and 600 vertebrae), to which the ribs are connected. This structure is overlaid with muscles, and a snake travels by contracting its muscles; as it does so, specialized scales on its belly grip the ground or the bark of a tree, pulling the snake forward.

Snakes are functionally deaf, but they have a keen sense of smell—not just in their noses but, more important, in their tongues. As it flicks in and out, a snake's tongue is constantly collecting small airborne particles, which it then passes along to a sensory organ in its mouth called the Jacobson's organ, or vomeronasal organ. It's this specialized sense that allows the snake to distinguish between predators and prey.

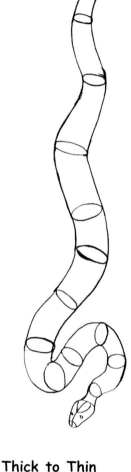

Thick to Thin
The neck and tail are the narrowest parts of a snake; its body gradually widens toward the middle. In this example, you can see how the thickness of an anaconda varies from place to place along its body.

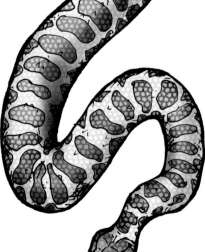

KING COBRA

I don't know whether there was an election or a hostile takeover, but somehow this serpent was named king. I can't imagine there were a whole lot of snakes willing to go up against the cobra's claim to the throne. Wardrobe note: Instead of a crown, this king wears a hood.

The king cobra is the longest venomous snake in the world, growing to lengths of up to nineteen feet. It's a fast, ferocious, and frightening hunter. When threatened, the cobra will elevate the front third of its body into an upright striking position and extend its neck bones outward—flattening and flaring its upper body into a "hood." Big cobras can raise themselves *really* high—putting themselves eye-to-eye with attackers up to six feet tall.

King cobras range across much of mainland India, southern China, Malaysia, the Philippines, and throughout the forests of southeastern Asia. Their venom is notoriously toxic: If left untreated, cobra bites are fatal about 75 percent of the time. Fortunately, antivenom does exist. But take heart: King cobras—whose diet consists almost exclusively of other snakes—would much rather retreat than face down a human being.

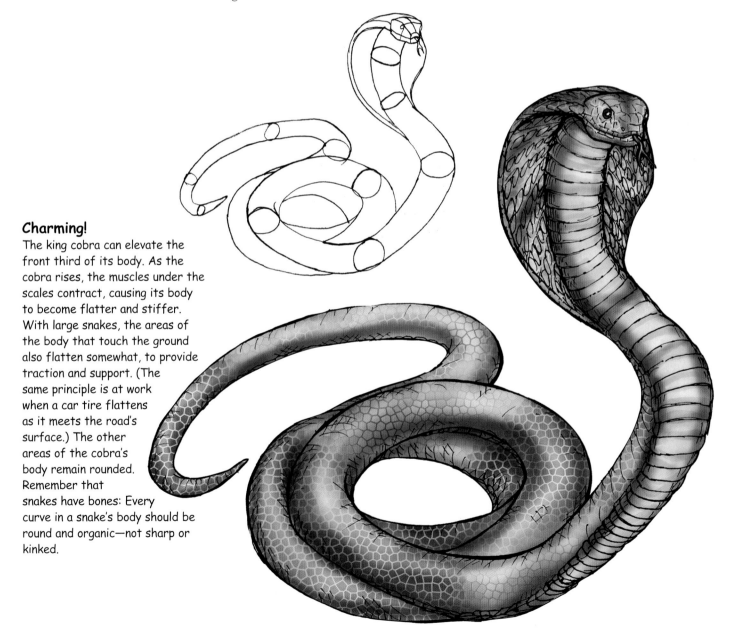

Charming!

The king cobra can elevate the front third of its body. As the cobra rises, the muscles under the scales contract, causing its body to become flatter and stiffer. With large snakes, the areas of the body that touch the ground also flatten somewhat, to provide traction and support. (The same principle is at work when a car tire flattens as it meets the road's surface.) The other areas of the cobra's body remain rounded. Remember that snakes have bones: Every curve in a snake's body should be round and organic—not sharp or kinked.

TAIPAN

When researching this book, I thought about naming it "Thirty Reasons Not to Visit Australia." That's because Australia has *thirty* different kinds of poisonous snakes (among many other lethal animals)! The largest and most poisonous of them is the taipan. It can grow to well over seven feet in length. It's intelligent, nervous, and alert. It has excellent senses of smell and eyesight. It quickly moves in on its prey and makes lightning-fast strikes, often delivering several blows before the victim has time to react to the initial bite. It then draws back and waits for the poison to work. As soon as the prey becomes paralyzed, it's down the hatch, headfirst.

There are actually two species of taipan: the common taipan and the (less common) inland taipan, which is also known as the fierce snake and the small-scaled snake. Both species have pale, creamy-colored heads and bodies that range from light brown, to dark brown, to copper, to an overall olive coloration.

Taipans' preferred menu includes entrées of rats, mice, birds, lizards, and small marsupials. Although these snakes generally stay away from humans, choosing to flee before they are noticed, taipans will defend themselves fiercely if cornered or threatened. Most people who are bitten by poisonous snakes are bitten on their hands or forearms—and could have avoided the bite if they'd taken a bit more care about where they were reaching. It goes without saying one should *never* pick up a strange snake—no matter how easy they make it look on *Animal Planet*!

Elbow Macaroni

When doing the preliminary sketch of any snake, it can be helpful to place several ellipses along the length of the body to make sure that you'll keep the form round in appearance. To avoid any unnatural-looking bends or folds, I imagine the snake's body as a series of elbow macaroni noodles strung together end to end.

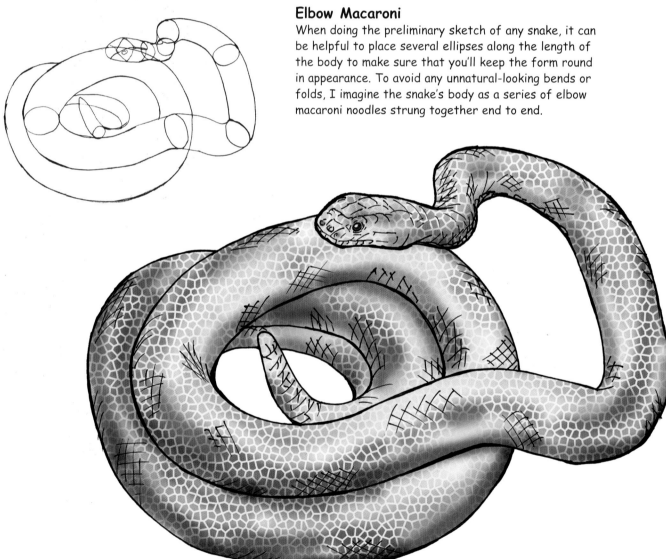

Rattlesnake

The rattlesnake is the best-known American poisonous snake. Although we mostly associate rattlers with the deserts of the southwestern United States, they actually range throughout large sections of North, Central, and South America. There are about fifty different species, and all share this type of snake's most distinctive feature: the rattle. A rattlesnake's rattle forms gradually over the course of its life. When the snake molts its skin, it retains a ring of old scales at the tip of its tail. These scales dry and harden, becoming a section of the rattle; with successive moltings, the rattle lengthens. You may be surprised to learn that the rattle is actually empty—the rattling, buzzing sound is produced by the sections vibrating against one another as the snake moves. (By the way, there's no truth to the idea that you can tell a rattlesnake's age by the number of sections in its rattle. That's because the rattles often break; the lost sections are then replaced as the snake continues to molt.)

Rattlesnakes belong to a class of poisonous snakes known as pit vipers. These snakes have a specialized organ—the pit—near the front of the head that allows them to sense heat given off by potential prey. This "sixth sense" helps rattlers to hunt at night. Their preferred prey includes rodents, lizards, and other small animals. Like other poisonous snakes, rattlers tend to avoid encounters with human beings if at all possible, but they will attack if surprised or cornered. Rattlesnake bites are very painful and can cause severe medical complications if not properly treated—including loss of limbs or even death. Antivenom is readily available in most areas where rattlesnakes live, however, and U.S. deaths from rattlesnake bites average fewer than half a dozen per year.

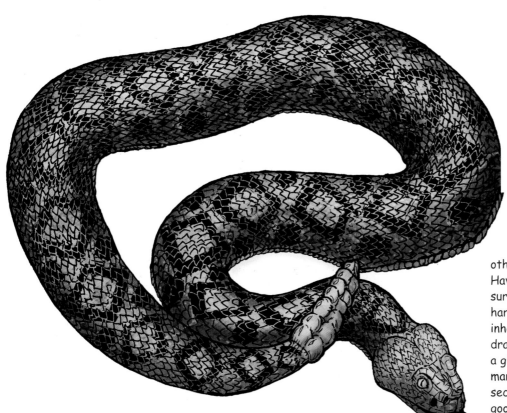

Hamster Tube

Rattlesnakes are not as long as the other snakes featured in this book. Having less body mass helps them survive on less food and water in the harsh desert environments they inhabit. As you can see from the step drawing here, a rattlesnake resembles a giant hamster tube, with the ellipses marking the places where the various sections connect. (This is a pretty good analogy when you consider the rattlesnake's rodent-heavy diet!) If you lay out the snake using three-dimensional forms, your final drawing will have a more solid, realistic appearance.

ANACONDA

Now we leave the vipers behind—and come to the equally scary constrictors! Constrictors don't bite their prey; they wrap themselves around a victim, squeezing the life out of it before swallowing it whole, headfirst. The biggest of these—in fact, the biggest snake in the world—is the anaconda. Also known as the water boa, this giant meat-eater lives in swampy areas of tropical South America. Juvenile anacondas can be found in trees, but larger adults spend most of their time partially submerged in shallow water.

No one knows for sure just how big an anaconda can get, because they continue to grow during their entire lives. The largest one ever documented was more than thirty-seven feet long, although in 1906 an explorer claimed to measure a specimen at sixty-two feet. It is a good bet that the largest living anaconda has yet to be discovered. Generally, anacondas are greenish-brown with a double row of black oval spots running down their backs. (Sometimes these double spots converge into a single row of larger spots.) The snake has smaller white or yellow markings along its sides.

Tree Climber

Adult anacondas spend most of their time in the water, but younger, smaller anacondas can be found dangling from trees. Looking at this example, you can see how an anaconda can wrap its coils around a tree trunk as easily as it can around a victim.

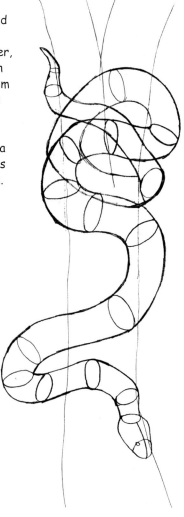

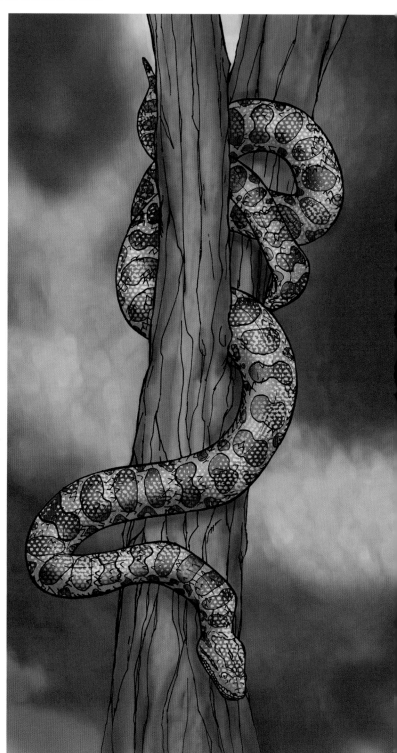

PYTHON

Pythons are also constrictors, subduing their victims by crushing them. But they begin their attack by biting. A python will wait for a victim to get within striking range, then lunge forward, usually hitting the quarry in the head or neck. Instantly, the python will then start to wrap itself in tight coils around its prey until it is completely immobilized. It will squeeze the life out of its prey before starting the process of swallowing it headfirst.

Pythons are large snakes, growing to more than thirty feet and reaching weights up to three hundred pounds. Common in tropical and subtropical regions of the globe, they can be found in Africa, Asia, Australia, and the Pacific islands. There are numerous species, of which the reticulated python of Southeast Asia is among the largest. Other well-known pythons are the Indian python, the African rock python, the green tree python, and the ball python (or royal python) of equatorial Africa, which curls itself into a ball so tight that it can be rolled on the ground.

Hidden Danger
Many snakes—including the python—have patterned skins. The patterns camouflage the snakes, concealing them from their prey even when they are mere inches away.

Deep-Sea Demons

MORE THAN 70 PERCENT OF OUR PLANET IS COVERED WITH WATER, AND 97 PERCENT of that is salt water. Without water no life could exist for long, so it's little wonder to find the oceans, seas, lakes, and ponds teeming with life.

We humans are always visitors rather than natural inhabitants when we visit the undersea realm, so it's natural that many people fear the water. And when we do swim we spend most of the time with our heads above the water line, oblivious to what is mere inches from our bodies below the surface. Unfortunately, I'm going to do little to relieve your aquaphobia (fear of water) in this chapter. The movie *Jaws* terrified people so badly that many swore off ever going into the ocean again. But the fear of sharks is mostly unfounded—especially when you consider how many other terrifying creatures are swimming around just a few yards away from our public beaches! Octopuses, jellyfish, eels, and rays are anxiously waiting to make swimmers' acquaintance when they visit their home turf—or, rather, surf.

But be not afraid. Throw on your swimsuit, don your snorkeling gear, and grab your waterproof drawing pen. We are going to travel down into the deeps to see what wild and deadly denizens live in the inky blue.

Octopuses

Octopuses have eight arms, or tentacles, whose undersides are covered with suction cups. But they possess no skeleton—in fact, their bodies have no hard features at all, aside from a beak that resembles that of a parrot. (This beak is located up inside the octopus's "skirt"—the area between the head and the arms.) Because it isn't much more than a kind of living rubber, an octopus is able to squeeze into and out of almost any enclosure.

An octopus propels itself headfirst by drawing water into its mantle cavity, where it passes through its gills, and then expelling the water in a jet. Octopuses can also crawl across the ocean floor by pulling themselves along with their arms.

Living Jell-O

The octopus is extremely flexible; think of its body a rubbery hide filled with living Jell-O. You can draw an octopus in countless poses. Octopus tentacles aren't exactly like the bodies of snakes, in that they can bend at 90-degree angles. To maintain a fluid, organic look, however, you will want to keep the majority of the lines curved and flowing. For the most natural-looking result, sketch the arms as segmented cylinders—placing ellipses at intervals along the arms to emphasize their rounded shape.

BLUE-RINGED OCTOPUS

The blue-ringed octopus weighs only an ounce and is only about the size of a golf ball. But this is one *seriously mean* golf ball. Of all the creatures in the sea, the blue-ringed octopus is *the* single most toxic. Its little body contains enough of its extremely powerful venom to kill twenty-six adult human beings. And there is no known antivenom. So don't tangle with this pretty little sea monster!

Actually, the blue-ringed octopus is usually a timid, retiring creature. For the most part, it's content to hide out among coral, avoiding predators. When calm, the octopus is pale brown or yellow in color. It's only when it feels threatened that its blue rings start glowing—with a fluorescent brilliance that makes the octopus look like a swimming neon sign. And what's this sign's message? "Stay away!"

The blue-ringed octopus's venom causes paralysis and sometimes respiratory failure. If a victim lives through the first twenty-four hours following the bite, he or she generally goes on to make a complete recovery. But getting through that first day is hardly guaranteed.

It seems a little like overkill for such a tiny creature. After all, the blue-ringed octopus's diet typically consists of small crabs and shrimp. But if it can catch them, it will also feed on fish—pouncing on its prey, biting it, and then using its beak to tear off bits of flesh. If the octopus wasn't able to instantly paralyze its prey, it would risk being torn apart by the intended victim as it tried to escape.

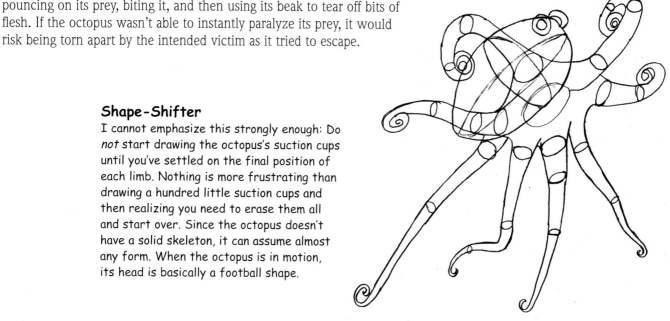

Shape-Shifter
I cannot emphasize this strongly enough: Do *not* start drawing the octopus's suction cups until you've settled on the final position of each limb. Nothing is more frustrating than drawing a hundred little suction cups and then realizing you need to erase them all and start over. Since the octopus doesn't have a solid skeleton, it can assume almost any form. When the octopus is in motion, its head is basically a football shape.

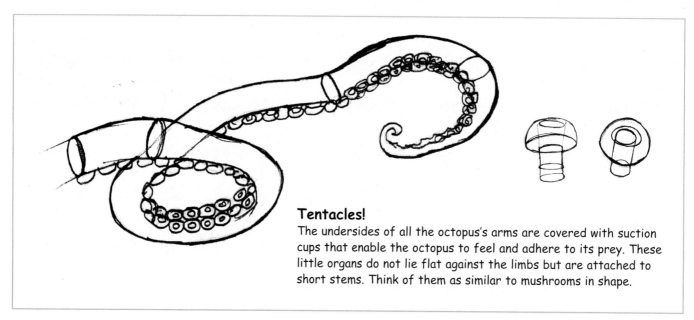

Tentacles!
The undersides of all the octopus's arms are covered with suction cups that enable the octopus to feel and adhere to its prey. These little organs do not lie flat against the limbs but are attached to short stems. Think of them as similar to mushrooms in shape.

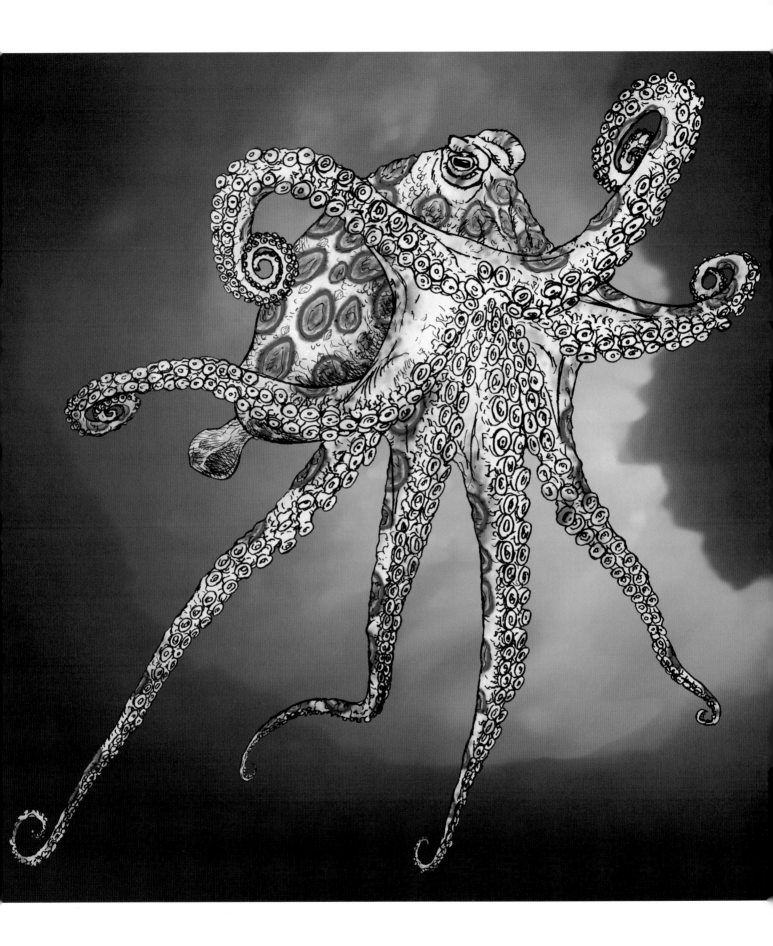

JELLYFISH

Jellyfish are marine invertebrates (that is, creatures without backbones) with bell-shaped bodies. Numerous tentacles hang down from the body, and each tentacle is covered with stinging cells, called cnidocytes, that can stun or kill other animals. Most jellyfish use these stingers to secure prey or as a defense mechanism.

Complicated but Easy

Jellyfish are fun to draw because although they look complex, they are really extremely easy. For this jellyfish, I used a mushroom-cap shape as the basic form for the bell.

Pasta with Mushrooms

Jellyfish often have a combination of thicker and thinner tentacles. I base the wavy shape of the wider tentacles on a lasagna noodle and think of the narrower tentacles as strands of spaghetti. Mushrooms, lasagna, and spaghetti . . . yum! That's not just a recipe for a successful drawing but, if you throw on a little red sauce, for a great Italian dish as well!

SEA WASP

The sea wasp, or box jellyfish, is found in the waters off Hawaii, Australia, the Philippines, and in many other tropical areas. It has a translucent, pale blue bell that's actually cubical in shape, with four distinct sides—hence the alternate name. Measuring up to eight inches along each side of its cube-shaped bell, the jellyfish can have as many as fifteen tentacles hanging down from each side. Each tentacle, which might measure nine feet, can have five thousand stinging cells. Not only that, but this creature can propel itself along in a jetlike motion at speeds of up to four knots. Although the sea wasp isn't as toxic as the blue-ringed octopus, it's considered the deadliest animal in the oceans for human beings, since swimmers are much more likely to bump into it.

Sea wasps use their powerful venom to stun or kill their prey prior to ingestion, or as an instrument for defense. The poison is among the most deadly in the animal kingdom and has caused at least sixty-three recorded deaths since 1884. For such a deadly species, the sea wasp is actually quite delicate. If it did not immediately kill its prey, its body might be ripped apart by its struggling quarry.

Wet Paper Bag

You've probably heard the expression about not being able to fight your way out of a wet paper bag, I don't know how applicable it is to your fighting skills, but if you can *draw* a wet paper bag, you can capture the essence of the sea wasp's boxy shape. Start with a shape that's similar to a paper bag's, then add several noodly strings drooping down from the lower edges. Jellyfish tentacles often get entangled and pulled off, so you don't have to worry about having the same number on each side.

LIONFISH

The lionfish is a venomous member of the scorpion fish family, but despite its poisonous nature, it's still a popular animal in the saltwater pet trade because of its striking, highly unusual appearance. Various species of lionfish can be found around the world, although most are concentrated in the Indian and Pacific Ocean regions. Ferocious predators, lionfish trap their prey with their large fins and then quickly devour the victim whole.

Its long spines are what give the lionfish its distinctive look. Typically, a lionfish will have twelve or thirteen dorsal spines, two pelvic spines, and three anal spines. The spines are striped in red, brown, or black, and each has two grooves containing venom-producing tissue.

Beautiful—or Ugly?

I guess beauty's a matter of taste, but I can definitely say that the lionfish is one of the *weirdest-looking* fish alive. Because of its long spines, it may seem difficult to draw, so start with a basic fish shape with the fin placement roughed in. Draw the spines as long, graceful arcs originating from the dorsal and pelvic regions. Add a little weight to the spines, and then add in the secondary features such as the eyes and the short antennae protruding from above the eyes.

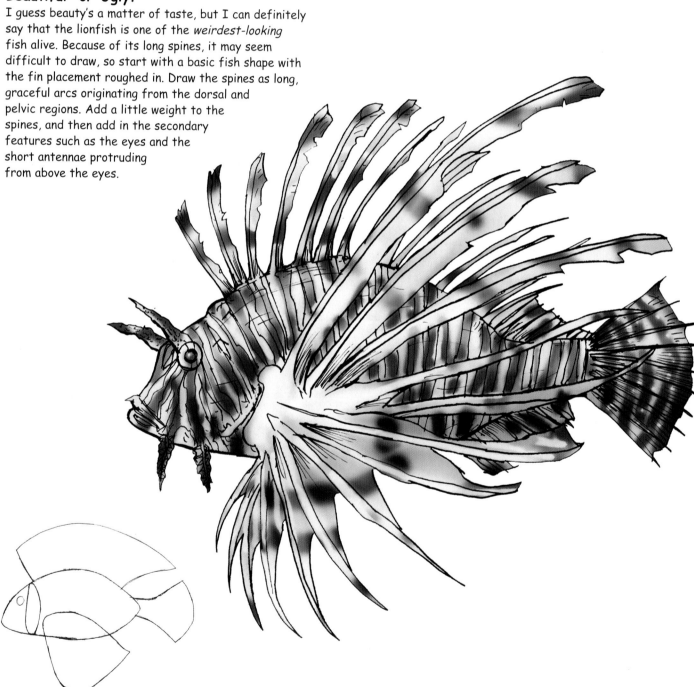

PIRANHA

Most of the creatures described in this chapter live in salt water—either in the deep oceans or the coral reefs lining tropical coasts—but piranhas are freshwater carnivores. There are many species of piranha (pronounced pee-RAHN-yah). Most live in the rivers of South America, but they can occasionally be found in rivers in the United States (where they have most likely been released from aquariums by tropical-fish hobbyists).

Piranhas are smaller than their vicious reputation might lead you to believe. Most range from six to ten inches in length. But the reason they're so dangerous is that they hunt in schools, usually of about twenty fish. From birth, they come into the world armed with a wicked set of teeth and ready to eat anything unfortunate enough to venture into their territory. They use a variety of hunting strategies to attack their prey. These nasty little fish are equipped with taste bud–like organs on their scales, which allow them to get an appetizing foretaste of any potential meal they bump into. Although their feeding habits are pretty gruesome, they perform an important service to the environment by devouring carcasses, which if left alone would decay and spread disease.

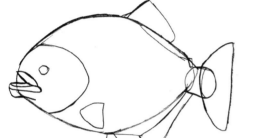

What a Set of Choppers!

Piranhas are relatively flat fish. A piranha's body is an oval shape; use triangular shapes for the tail and fins. The fish are generally silvery in color, with gold, green, black, or red spots. The lower jaw juts out to show off all those beautiful, razor-sharp teeth. It is rumored that piranhas maintain their underbite because no dentist will accept them as patients.

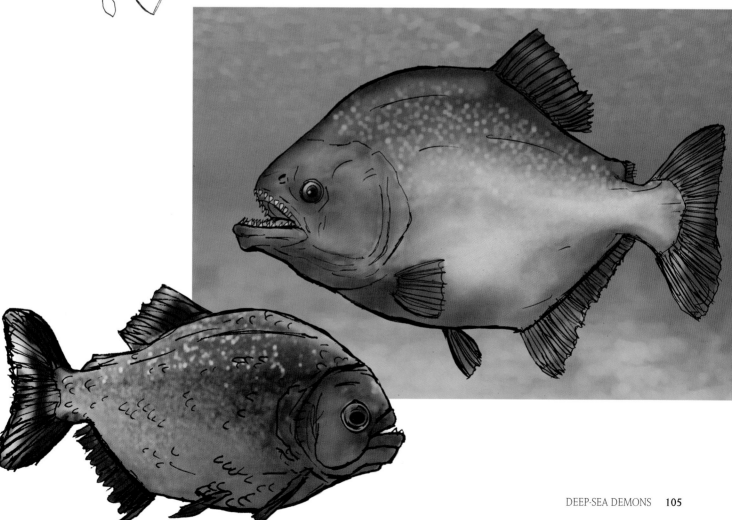

Manta Ray

Found in most tropical seas, manta rays are the largest rays. Unlike their relatives the stingrays, manta rays have short tails and no stinging spines. These graceful swimmers seem to float through the water while performing beautiful acrobatic maneuvers. Although they have an alien and forbidding look, they're not at all dangerous to human beings.

Mantas can reach sizes of almost thirty feet wide, but adults average about twenty-two feet from the tip of one "wing" to the tip of the other. The largest weigh about three thousand pounds. Dark brown to black on top, mantas are nearly pure white on their undersides. They funnel water through their gills as they swim, using the two little lobes at the front of their faces to guide microscopic plankton, small fish, and tiny crustaceans into their mouths.

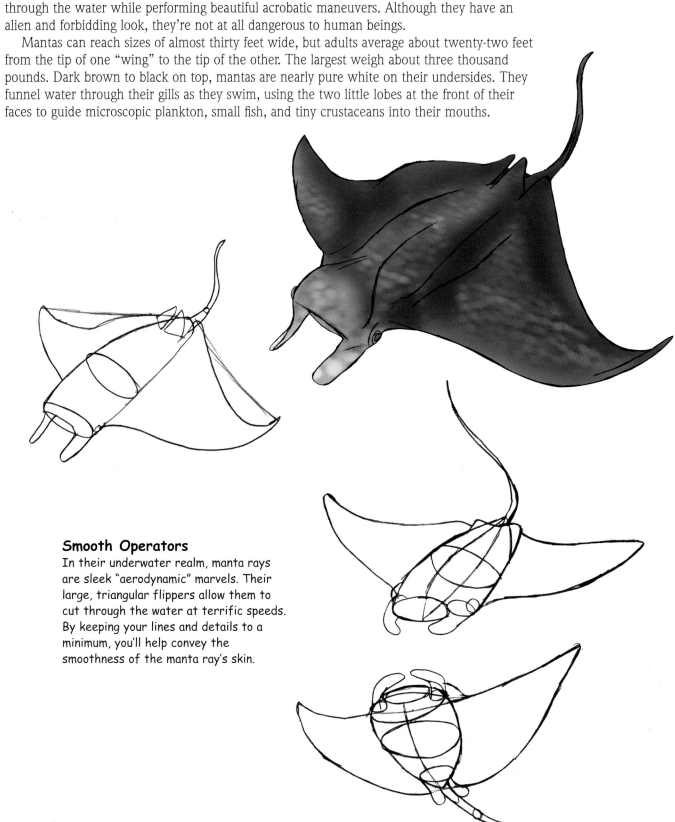

Smooth Operators
In their underwater realm, manta rays are sleek "aerodynamic" marvels. Their large, triangular flippers allow them to cut through the water at terrific speeds. By keeping your lines and details to a minimum, you'll help convey the smoothness of the manta ray's skin.

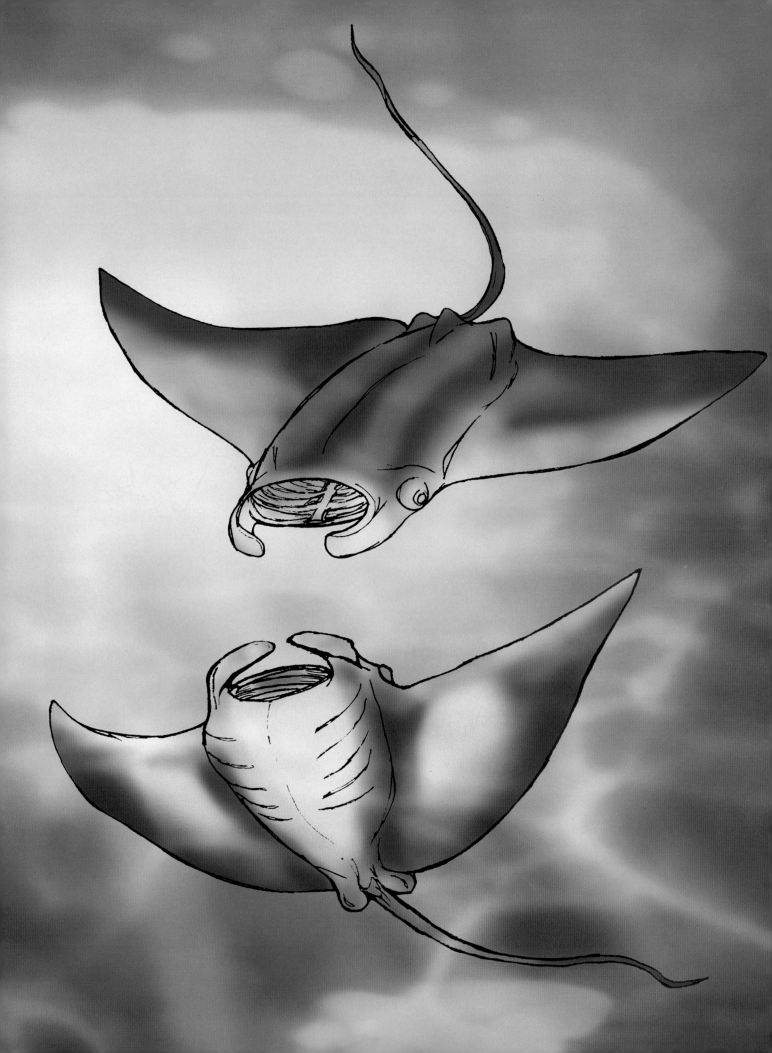

STINGRAY

There are more than thirty-five species of stingrays, but they all share some similar characteristics: a flat, triangular, pancake-shaped body ending in a tapering tail armed with one or more stinging spines.

Stingrays live in warm tropical seas. They're not usually aggressive—being content to rummage around on the sea bottom for squid, other mollusks, and small fish—but if threatened they will extend the spines on their tail, whipping the tail toward the enemy. Although stingrays are slightly venomous, the major problem suffered by a person stung by a ray is the puncture wound caused by the sharp barb.

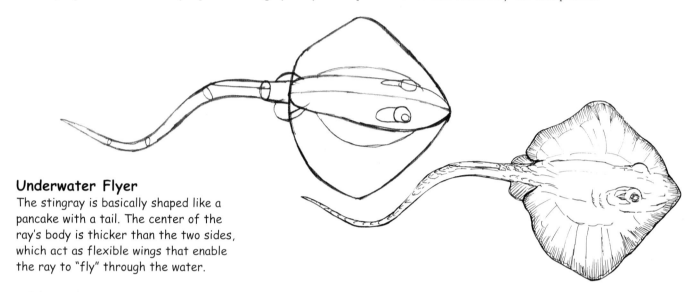

Underwater Flyer

The stingray is basically shaped like a pancake with a tail. The center of the ray's body is thicker than the two sides, which act as flexible wings that enable the ray to "fly" through the water.

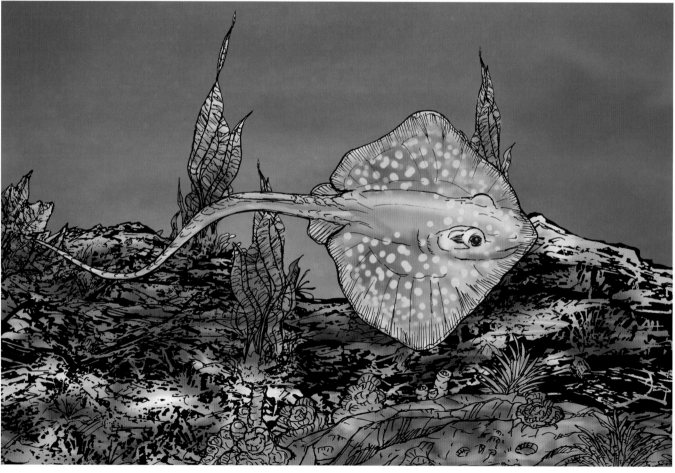

Great White Shark

Thanks partly to the film *Jaws,* no shark is better known or more feared than the great white. Great whites are big sharks, but they're not quite as big as the movies might lead you to believe. They average between twelve and fifteen feet in length—the very largest are about twenty feet long—and can reach weights of about five thousand pounds. (Interestingly, female great whites are generally larger and heavier than males.)

The great white shark is aptly described as an eating machine. Its diet typically includes fish, other sharks, sea lions, seals, seabirds, turtles, porpoises, small whales, and carrion. But although the great white shark has a reputation for eating anything, it's not true: This mistaken idea probably stems from the fact that a great white will tentatively bite into any unknown item to "taste test" its suitability as food.

Other shark species present a greater danger to human beings, but great whites get the most media attention. In actuality, there have been 224 attacks on humans by great white sharks worldwide, resulting in sixty-three fatalities, since accurate records began being kept in 1876. That may sound like a lot, but it averages out to less than two attacks per year.

Still, they do pose a risk to swimmers. These sharks are *fast,* and no human could possibly outswim a great white, which can boost its speed up to thirty-five miles per hour when in pursuit of prey.

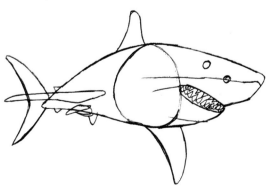

Torpedo with Teeth

Sharks are scary because they are basically just eating machines. From a design standpoint there isn't much to a shark—it's like drawing a torpedo with teeth.

Like a Knife

All sharks are sleek and "aerodynamically" shaped, capable of cutting through the water at enormous speeds. Sharks' fins should always be positioned so the leading edge of the fin splits through the water in the direction the shark is moving. Think of how the blade of a knife slices through butter. Fins operate according to the same principle.

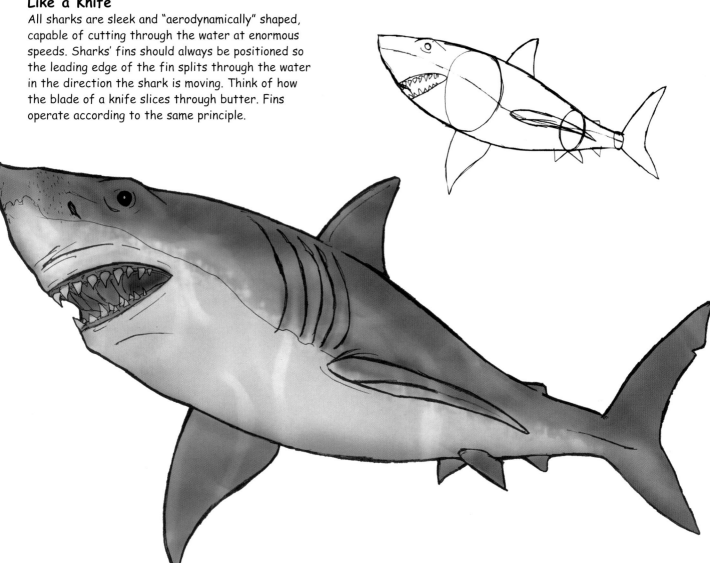

Toothy Grin

Sharks' teeth grow in endless rows along their jawlines. Different sharks have differently shaped teeth, so be sure to find a photo reference for the species you are drawing. As a shark's old teeth fall out or are lost in fights with prey, new ones grow in to take their place. When you draw a shark, be sure to give it a very toothy grin, with several rows of choppers evident.

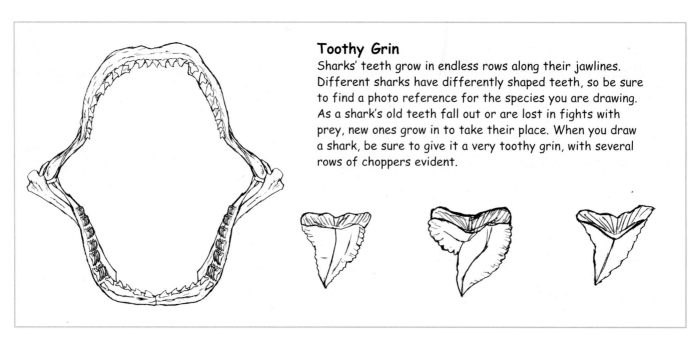

Tiger Shark

The tiger shark is one of the largest sharks, averaging between ten and fourteen feet long and usually weighing between 850 and 1,400 pounds. Its name comes from the striped patterns that appear on juveniles but that fade as tiger sharks grow. It is found in tropical and temperate waters around the world, favoring many of the same destinations as beach-going vacationers—including Hawaii. Tiger sharks are solitary hunters, usually hunting at night. Their usual diet consists of fish, seals, birds, smaller sharks, squid, and turtles, but they also chow down on the occasional surfer.

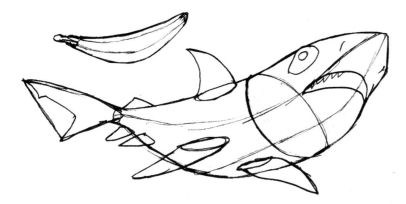

Bananafish?

When I draw a shark, I think of the body as banana shaped, though with a less pronounced curve. The head end of this "banana" is thicker than the tail end, which tapers off. The fins are all based on triangular shapes.

GREAT HAMMERHEAD SHARK

The great hammerhead shark is found in tropical and subtropical waters worldwide. As its name implies, it's an unusual-looking fish, with a wide, almost rectangular head. Its eyes are located at either end of this "hammer." The great hammerhead is gray-brown above, with an off-white belly. The first dorsal fin (the large fin on the top of the shark) is very big and pointed.

Great hammerhead sharks average a little more than eleven feet in length, but the largest ever reported was twenty feet long. They usually weigh somewhere in the vicinity of five hundred pounds, but they can reach weights of up to a thousand pounds.

The great hammerhead is a fierce predator with a good sense of smell that helps it find its prey. The hammerhead eats fish, including rays, as well as other sharks, squid, octopuses, and crustaceans. Although it looks extremely threatening, the great hammerhead is usually timid around human beings, and relatively few hammerhead attacks have been reported.

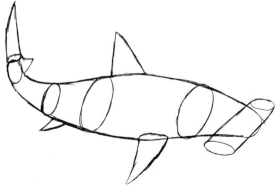

What's in a Name?
Hmm . . . I wonder where the hammerhead shark got its name. Actually, drawing a hammerhead isn't much more difficult than drawing a shark with a typical head. The body is based on the same banana shape discussed on the previous page, and the head is really just an extremely flat cylinder similar to an airplane's tail fin.

KILLER WHALE

Killer whales tend to view all the wildlife in the sea as a swimming smorgasbord. Their diet includes fish, squid, sharks, seals, turtles, octopuses, birds, and even other whales; if it's an animal and it gets wet, chances are the killer whale will give it a try. These black-and-white, dramatic-looking creatures—which are also called orcas—are social animals, living in groups (called pods) of between six and forty individuals. They frequently hunt together using cooperative teamwork to herd prey into an ambush. Because killer whales (like all whales) are mammals, they need to surface for air.

As whales go, killer whales are on the small side, growing to lengths of twenty-seven to thirty-three feet and typically weighing between eight thousand and ten thousand pounds. (Compare this to the blue whale's hundred-plus-foot length and 400,000-pound bulk.) Killer whales do attack human beings, but interestingly enough, all documented attacks have taken place in water theme parks. In the wild, they tend to avoid human contact.

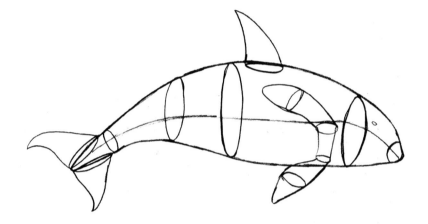

A Distinctive Look
The killer whale's black-and-white coloring is very distinctive. It has an extremely large, rounded dorsal fin.

Moray Eel

Moray eels are found in coral reefs across the tropics. These nocturnal animals spend most of their time hidden away in cracks and crevices in the reefs. Long, sharp teeth fill their enormous jaws—and many an unlucky scuba diver has been nipped by one of these aggressive eels. Their diet consists mainly of fish and mollusks, but they aren't too picky and will even chow down on other eels.

The typical moray eel measures about five feet in length. Morays are scaleless; their thick, smooth skin feels similar to that of a catfish. The skin produces a protective mucus secretion that in some species is toxic to people.

Snakelike Fish
Drawing an eel is pretty simple. The eel's body is long and flat—somewhere between a snake and a fish. The dorsal fin runs all the way along the top of the eel's body from just behind the head to the end of the tail.

ELECTRIC EEL

The first underwater explorer who caught an electric eel didn't know it, but he was in for quite a shock. This swimming stun gun—which isn't a true eel but rather a species of knifefish—is capable of delivering powerful electric shocks (500 volts and 1 ampere of current), which it uses for both hunting and self-defense. Interestingly, the electricity-producing organs in the eel's body generate voltage in much the same way a battery does.

Found in the Amazon, Orinoco, and surrounding rivers of South America, electric eels can reach lengths greater than eight feet and can weigh more than forty pounds.

High Voltage
An electric eel's touch may be shocking, but its appearance is anything but. The eel's elongated cylindrical body is a dark grayish-green color with a paler, yellowish underside. Its flattened head is similar to that of a catfish.

BIG BAD BUGS

NOTHING BUGS PEOPLE LIKE . . . WELL, BUGS. SOME PEOPLE WILL SWAT any flying bug and squash any creepy crawlie on sight, which is unfortunate. That's because bugs play a vital role in maintaining our environment by doing everything from eating decaying plants and animals, to providing a food supply for larger animals, to pollinating the majority of the world's flowering plants.

Because of their small size, many bugs come equipped with defensive weaponry designed to keep would-be swatters at bay. Depending on what type of animal preys on the little bugger, it may have a poisonous sting or a toxic bite. Because bugs have no internal skeletal system, they must rely on their sturdy exoskeletons—external skeletons—to hold their bodies together. And when you're only a few centimeters in size, you may need extra-powerful venom to keep yourself from being crushed by an organism hundreds of times your size. That's why some bugs are harmful—even lethal—to human beings.

Bug is sort of a catchall term—covering not just insects but also some other animals belonging to the phylum Arthropoda, which in terms of number of species is the largest phylum, or major subgrouping, of the animal kingdom. All arthropods—insects and other "bugs," such as spiders, scorpions, and centipedes—share some major characteristics. They all have segmented bodies, and, as I've mentioned, they're all covered by hard exoskeletons, which are made of a material called chiton.

About insects: Of the arthropods, insects form the largest class. In fact, insects are the most diverse group of animals on the planet. About a million different insects species are known (that's more than all other animal groups combined), and scientists believe that many, many more have yet to be discovered. Class Insecta is currently divided into thirty-one orders, and insects thrive in almost every environment on the face of the earth.

The word *insect* comes from a Latin word meaning "segmented." In the case of insects, that segmentation has three parts—with every adult insect's body being divided into a head, a thorax, and an abdomen. When drawing insects, always keep in mind that they all have this same basic, three-part body structure. Every insect also has three pairs of jointed legs, compound eyes, and two antennae. The legs are attached to the thorax, as are the wings, if the insect has wings (not all insects do).

Caught!
This spider hasn't caught a fly in her web, but a potentially more dangerous creature: a stinging bee. It's hard to tell from the honeybee's looks whether it belongs to the lethal strain known as killer, of "Africanized," bees, but, in any case, the spider may have gotten more than she bargained for.

ANT

Ants understand the principles of teamwork. They have developed highly organized social structures and live in colonies that can have millions of individual members, each specialized to perform a particular task. The different ranks of ants include the queen (at the top of social order), the drones (males whose only function is to mate with the queen), the soldiers (which protect the colony), and the workers (which do everything else).

A single ant poses no danger to a human being. But when ants operate as a single, unified entity—sometimes referred to as a "superorganism"—they can cause real problems. When a colony is united, ants can perform tasks that even animals hundreds of times larger would find impossible. For instance, the combined bites of thousands of ants can chase off almost any trespasser (including the mighty lion). Working together, a colony of ants can strip the vegetation from an entire field or clean the flesh off a large carcass in a matter of days.

Almost twelve thousand species of ants are known to science. Although most of these species are tropical, ants have set up colonies on almost every landmass on the planet. Taken as a whole, ants constitute somewhere between 15 and 25 percent of the *total* animal biomass; there are 750 billion tons of ants alive on the earth at any given time. So the next time you are tempted to squish an ant that's invading your family picnic, just remember that it has several billion relatives close by who may not look favorably on your practice of insecticide!

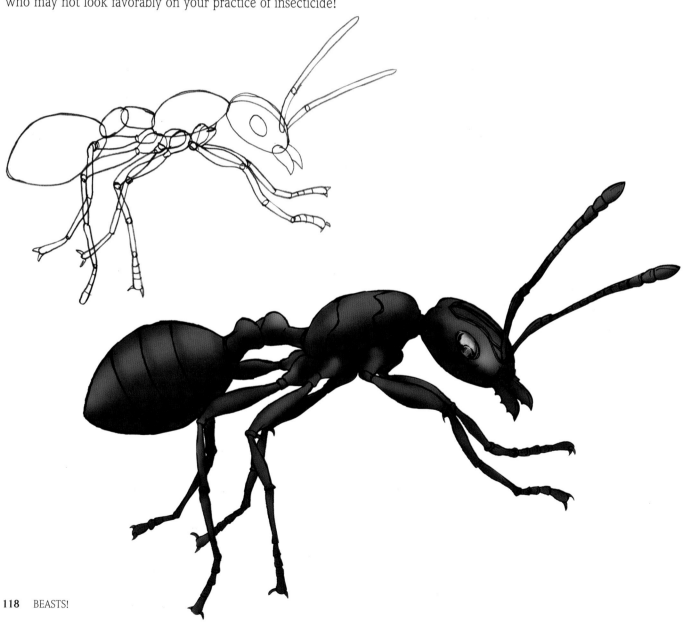

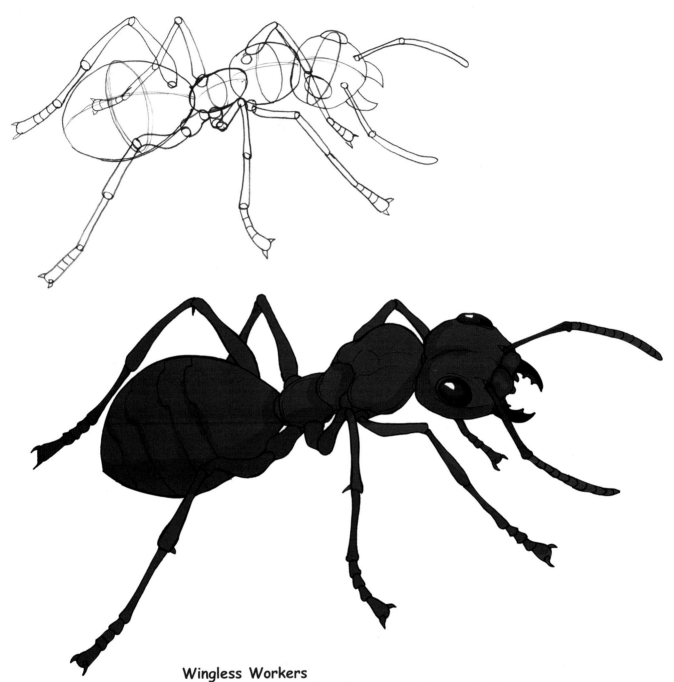

Wingless Workers

Like other insects, ants have three main body parts: head, thorax, and abdomen. The six legs connect to the middle segment (thorax). Workers, like the ants depicted here, have no wings—which makes ants a little easier to draw than some other insects. The final shape is not going to change much from the simple spherical shapes you initially lay down. An ant's head has large mandibles for chewing and self-defense, as well as two feelers near the eyes.

Praying Mantis

Praying mantises are predatory insects that live in most warm areas worldwide. They are very sneaky and sly. A mantis sits still, with its front legs cocked near its head (giving it the appearance of being deep in prayer or meditation), just waiting to ambush any small bug that may happen by. When it does, the mantis catches it with its strong, barbed front legs, then pinches it tight and begins eating its prey while it is still alive. Ironically, it's the victim that should have been saying its prayers!

There are about eighteen hundred species of mantises. To deceive their prey, they camouflage themselves in two ways: by resembling leaves when they are sitting still and also through their coloration, which can range from bright green, to tan, to more extravagant patterns of yellow, red, and violet. Mantises can rotate their triangular heads almost full-circle. Most adult mantises are from two to six inches long; females are a bit larger than males.

Mantises' preferred diet consists of flies, butterflies, crickets, moths, and spiders, but they will also eat small lizards, birds, and even other mantises. In fact, female praying mantises have gotten a bad rap around the insect dating scene for their reported habit of eating males shortly after mating. Such cannibalism does occasionally occur in the wild, but it happens much more frequently in the laboratory setting, where the male is usually trapped inside the same terrarium as the hungry female. Outdoors, male mantises usually select a mating spot that will allow them to make a quick escape when they are finished.

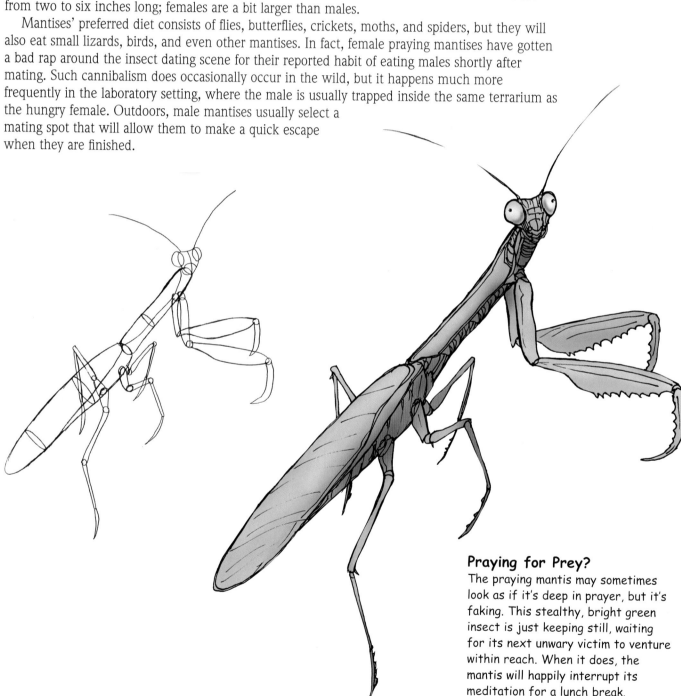

Praying for Prey?
The praying mantis may sometimes look as if it's deep in prayer, but it's faking. This stealthy, bright green insect is just keeping still, waiting for its next unwary victim to venture within reach. When it does, the mantis will happily interrupt its meditation for a lunch break.

Dismantling a Mantis

The praying mantis appears complex, but if you take your time and draw it in small steps, it should be a breeze. The thorax and abdomen are basically cylinders. The head is a rounded triangle shape. The front legs are composed of three segments: The segment connected to the body looks like an upside-down bowling pin; the middle segment is an oval; and the "hand" is shaped like a scythe.

WASP

Scientists have identified more than thirty thousand species of wasps. Some wasps have learned there is strength in numbers and choose to live socially. (Their societies can be very complex.) Others are solitary wasps, who prefer to go it alone. An individual wasp is dangerous enough, but a group of wasps is truly formidable. Many of us have made the painful mistake of wandering too close to a wasp nest and learned the hard way that this is one critter that does not take well to visitors.

Wasps share characteristics common to all insects, but it's the stinger, at the tip of the wasp's abdomen, that gives us reason to fear them. Unlike honeybees, which die after delivering a single sting, a wasp is capable of stinging again and again, raising a multitude of painful welts. Fortunately for us, wasps would much rather attack (and eat) pesky insects than to go after a human target. And remember: Wasps provide a beneficial service to us all by controlling bug populations—just as wasps themselves are a nutritious staple of larger animals' diets. (Though, personally, I can't imagine what could convince an animal to crunch down on an angry, stinging wasp!)

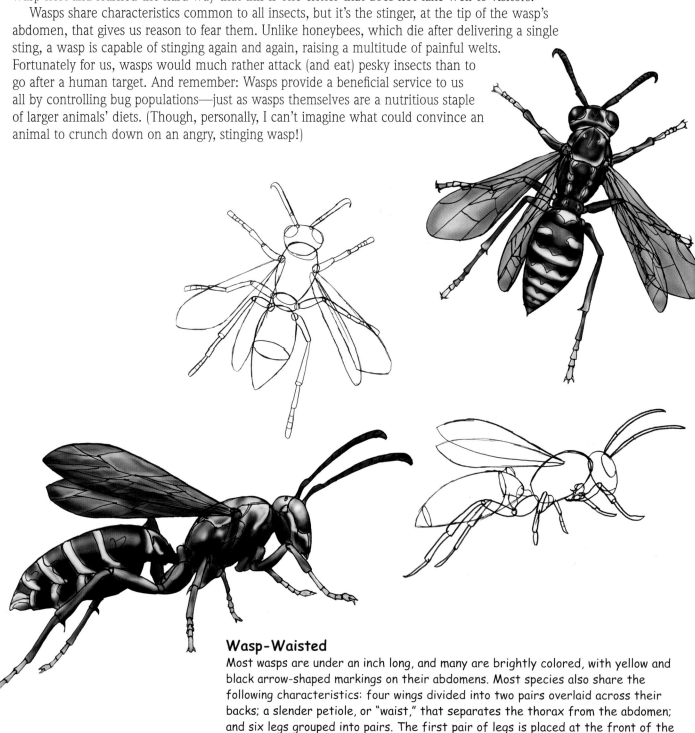

Wasp-Waisted

Most wasps are under an inch long, and many are brightly colored, with yellow and black arrow-shaped markings on their abdomens. Most species also share the following characteristics: four wings divided into two pairs overlaid across their backs; a slender petiole, or "waist," that separates the thorax from the abdomen; and six legs grouped into pairs. The first pair of legs is placed at the front of the thorax, and the other two pairs sit at the back of the thorax just before the petiole. Note that the thorax and abdomen are both based on simple oval shapes.

Mosquito

Are you ready to meet the deadliest animal in this whole book? Look no further than the common mosquito. Although these tiny insects may not look like much, mosquitoes are responsible for more than five million deaths worldwide each year because of malaria and other diseases they carry.

It is primarily the female mosquito you have to watch out for. Most of the time, mosquitoes feed on nectar—*until* the female decides that it might be nice to have some little skeeters buzzing around. The female requires protein for egg development and laying, and since the normal mosquito diet contains no protein she has to go out and find some. That's where we and all our warm-blooded animal friends come into the picture. To a female mosquito, we look like walking blood banks, and she is just dying to make a withdrawal.

A female mosquito's mouth parts include a long, needlelike proboscis that allows her to pierce an animal's—or person's!—skin and suck out the blood. Unlike your doctor's hypodermic, however, the mosquito's "needle" is serrated. But it is so thin that the "bite" itself doesn't hurt much at all, and most people don't even feel it initially. It is not until the mosquito flies away and the bite site begins to swell that you realize you've just given a hungry bug a free take-out meal.

Bite-Size Bug

Most mosquitoes are very small—you might even say they're bite-size!—so this drawing is obviously a magnification. Like other insects' bodies, mosquitoes' are divided into head, thorax, and abdomen. The mosquito has extremely long and slender legs, which emerge from its body and angle upward before taking a sharp turn downward—giving them a checkmark shape. Mosquitoes have two long antennae to sense the world around them—and help them find their next meal.

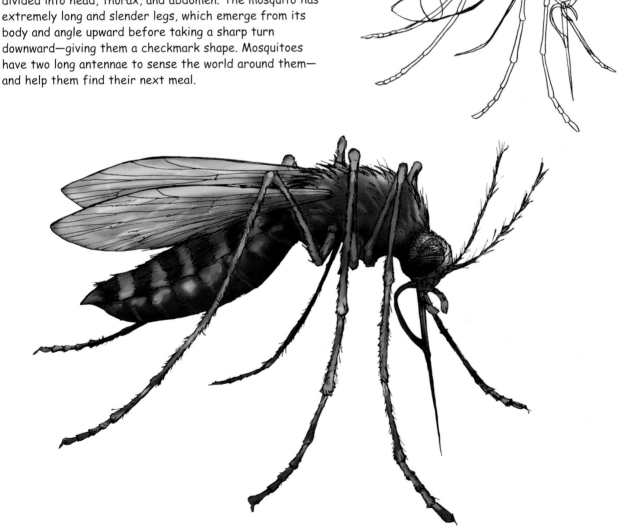

KILLER BEE

"Attack of the Killer Bees" sounds like the title of a schlock horror movie, but killer bees present a real danger in South and Central America, and now in North America, too.

The story of the origin of so-called killer bees does sound like something right out of a B-grade horror film. Just like in the movies, a group of well-meaning scientists conducted an experiment—and ended up making a monster when the experiment went wrong.

A couple of decades ago, Brazilian breeders crossed imported African bees with ordinary honeybees to create a more robust breed, better suited to the tropics. (Killer bees are sometimes known as "Africanized" bees.) It worked, but a little too well. The new strain of bees was hearty but also quite aggressive. Swarms escaped captivity and started taking over hives, eventually spreading all the way to the United States.

Africanized bees acquired the nickname "killer bees" because they attack and sting as a swarm—which can result in serious injury or death. When an individual bee stings someone, it releases a special scent that attracts the rest of the hive, sending all the bees them into a stinging frenzy. Although a single sting is no more potent than that of a common bee, the cumulative effect of hundreds of stings results in a victim being injected with more venom than that delivered by a rattlesnake bite. Unfortunately, unlike B-movie monsters, these bees are for real, and science has yet to find a solution to the problem.

Looks Can Deceive

Killer bees are radically more dangerous than ordinary honeybees, but they don't really look any different. Like any honeybee, the "Africanized" bee has a large head—almost as big as it abdomen. Its six legs connect to its furry thorax. (The hairs help capture pollen as the bee travels from flower to flower.)

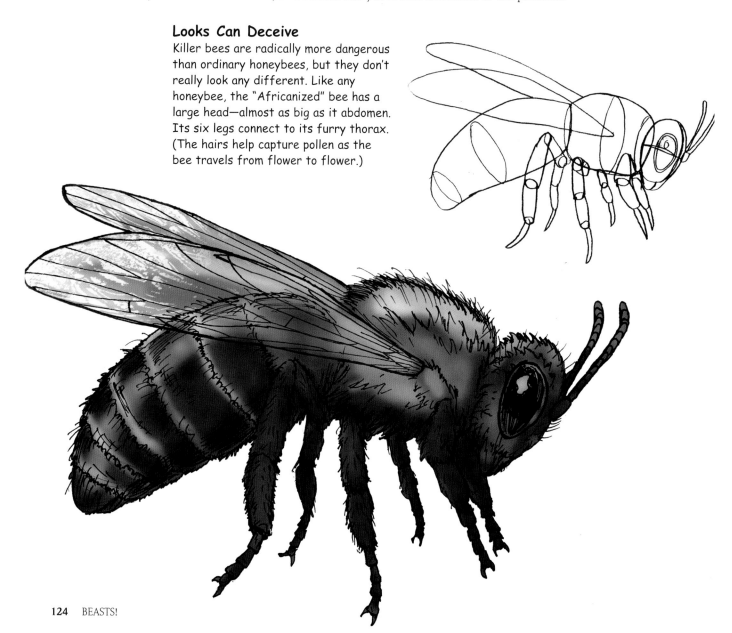

SCORPION

There is a famous story about a frog and a scorpion. One day, as a frog is preparing to swim across a stream, a scorpion stops him and asks the frog if he can ride across on the frog's back.

"If I let you ride on my back, you'll sting me," the frog says.

"Now why would I do that?" the scorpion replies. "If I sting you, you'll become paralyzed, and we'll both drown."

So the frog agrees to give the scorpion a ride. When they are halfway across the stream, the scorpion flicks its tail and stings the frog.

"Why did you sting me? Now we're both going to die!" the poor frog croaks. And as the pair begins to sink, the scorpion explains, "Because I am a scorpion. That's what I do."

I'm not sure, but I think the moral of the story is that you should not swim with scorpions. If you think about it, there are few recreational activities that would be made more enjoyable by including a scorpion. In fact, I did a little experiment: biking, parachuting, canoeing, and bowling have all been tested with and without scorpions, and the control group—the one without the scorpions—came away with the bigger smiles 100 percent of the time.

Scorpions are arachnids—a class of arthropods that also includes spiders and ticks. More than fifteen hundred scorpion species have been identified. These creatures are sort of like back-alley muggers: They hide out and let their victims come to them. A scorpion will wait under a rock or in a hole for an insect, spider, lizard, or small rodent to happen by—and then—blammo!—it will spring on the prey, gripping it with its pincers and using the stinger at the tip of its tail to inject it with venom. The prey quickly becomes paralyzed, allowing the scorpion to pull off chunks of flesh with the small, clawlike structures protruding from its mouth.

The sting of most scorpions is only irritating to people, but about twenty-five species of scorpions are capable of killing human beings. A general rule of thumb is that the smaller the scorpion's pincer, the more potent its venom.

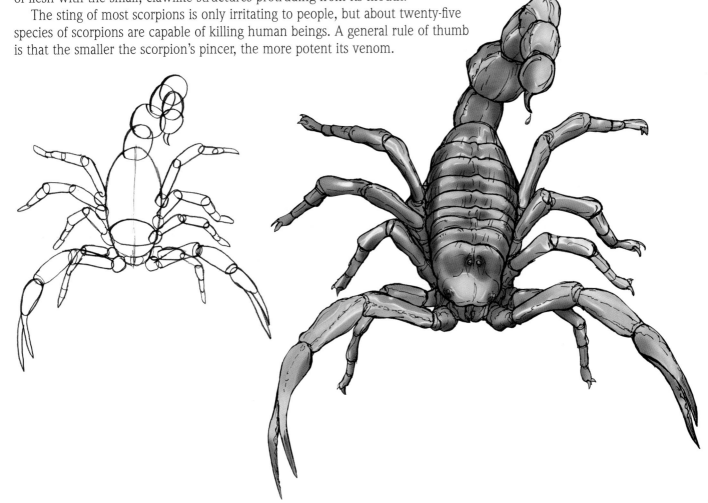

Suit of Armor

Scorpions range greatly in size, from half an inch to more than eight inches long. Different species also vary in color, from black to brown to tan to red. Each section of the scorpion is clearly separated from the rest, and the segments fit together almost like a toy suit of armor. The segments are rigid, and movement occurs only at the joints. It may help you to think of the tail sections as being similar to a string of beads.

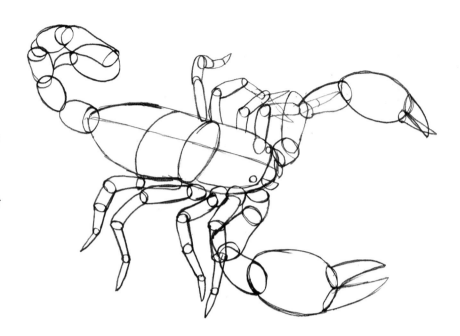

BLACK WIDOW

Usually content to catch and eat insects, the black widow spider gets its name from a peculiar habit of the female's. Occasionally, female black widows will chow down on their male partners shortly after mating. So if you're a male black widow out on a date, I suggest that you not stick around for dinner—because it may turn out to be you!

The black widow is the most dangerous spider in North America, with venom fifteen times as potent as the prairie rattlesnake's. Fortunately, this femme fatale—whose lustrous black body sports a reddish hourglass shape on her underside—is easy to spot. With her thin waist, shiny black dress, and red tattoo, she's just the type of woman your mom warned you about. Although she's petite—less than an inch and a half long and weighing only about a gram—the black widow packs a wallop. (By the way, only the adult female is dangerous to humans. But I don't want to be accused of discrimination, so I'm not going anywhere near black widow males or juveniles, either.)

Your Time Is Up!
The underside of the black widow's abdomen is emblazoned with a red hourglass—maybe to give you an idea of how long you have to live if she bites you!

Leggy Lady
Like all spiders, black widows have eight legs. The front and rear pairs are longer than the two pairs in the middle. Remember: The legs of arachnids and insects legs are stiff, like sections of pipe. They bend at the joints but nowhere else.

Brown Recluse

When you meet a lonely person who stays hidden away all day, you sometimes feel compelled to befriend him and encourage him to take a more active role in society. But I think we'd all be in agreement that the venomous brown recluse spider should be free to be as reclusive as it desires.

The tiny brown recluse—which measures no more than three-quarters of an inch, tops—is native to the central United States. Golden brown in color, it is less hairy than most spiders. But the best way of identifying a brown recluse for certain is by the black marking on its back—a distinctive violin shape. (The spiders are sometimes called fiddleback spiders because of this marking.) Brown recluse anatomy is distinctive in one regard: The recluse has only six eyes rather than the standard eight possessed by most spiders.

The brown recluse spider is a lot easier to draw than it is to find. As its name suggests, it likes to stay hidden in unfrequented places like crawl spaces and old sheds. No human death has ever resulted from a brown recluse bite, but bites have caused people who are extremely sensitive to the venom to lose fingers and toes.

Portrait of a Spider

Like this brown recluse, all spiders have two main body parts: a cephalothorax at the front end, with the head directly attached, and an abdomen at the rear. The eight limbs are connected to the cephalothorax. Each leg has several jointed segments. The leg joints all bend in only one direction (like a knee), but the joint that connects the leg to the body allows the entire leg to move in almost any direction.

TARANTULA

Tarantulas are as furry as kittens and have twice as many legs, so why aren't these guys more popular as pets? Heck, they don't even need a litter box. I just don't understand why tarantulas get such a bad rap.

Tarantulas, of which there are more than eight hundred species, are found worldwide (except in the Arctic and Antarctic). Tarantulas are surprisingly sluggish, choosing to spend most of their time hidden in burrows or other retreats and only becoming active in the late afternoon from spring through fall. Some dig their own burrows; others use ready-made crevices or abandoned rodent holes; and still others make their homes under rocks or logs or beneath the bark of trees. Tarantulas come in a wide variety of colors, from a soft tan, to reddish brown, to dark brown, black, and even blue. This spider's eight eyes are closely grouped, with a pair in the middle and three on either side of the face.

Tarantulas are mostly harmless to humans, but they have been known to inflict painful bites in self-defense. Unlike most other spiders, the tarantula spins no web but catches its victims by ambushing them or chasing them down. These spiders feed primarily on small insects, smaller spiders, lizards, frogs, rodents, and occasionally birds. The tarantula strikes with its large fangs, injecting venom and grasping the prey with its palps—the armlike appendages between its mouth and legs. Then the tarantula forms its victim into a ball and secretes digestive juices onto it, which liquefy the prey. And then it slurps up the goop. Yum!

Blue, Hairy, and Fanged
This is a cobalt blue tarantula, named for its bright blue legs. The two main sections of a tarantula's body—the cephalothorax (front) and abdomen (rear)—are round and hairy. When you draw the tarantula's eight legs, start with the four "corner" legs; this will help you space the legs evenly and prevent them from looking too crowded together.

Animal Anomalies

NOW THAT YOU'VE WORKED YOUR WAY THROUGH DOZENS OF VERIFIABLE animal species, we're going to unleash your imaginations on something a little more challenging. This chapter is devoted to animals for which science has no real, solid evidence, so there is plenty of wiggle room for you to take what you know about real-world animals and adapt those skills to depicting subject matter that's more fanciful. And so . . . I give you the fantastic world of the cryptids!

Cryptids are animals that may or may not walk the earth. Some cryptids are creatures that science presumes to be extinct—but that may continue to exist in remote locales. Others are creatures known only from anecdotal evidence insufficient to prove their existence with scientific certainty. They are the boogiemen of the animal kingdom—the creatures that your uncle's friend's friend's second cousin once saw. They are the "unconfirmed" animals that exist at the fringes of credibility. Some, like the saber-toothed tiger, are real animals that most believe to be long extinct but that continue to be spotted in far-off jungles.

Those who search for the truth about these marvelous animals are called cryptozoologists. Evidence for these creatures' existence ranges from travelers' accounts to blurry photographs to plaster castings of footprints. (In the case of the yeti—the abominable snowman—there's even what's supposed to be a preserved scalp!) Some of this "proof" is easily rejected as fraudulent, but some stories about these mysterious creatures have been repeated by numerous sources and are quite compelling.

Maybe it doesn't really matter whether any of these animal exist. What's for certain is that they occupy a special place in pop culture, and that their fan base is growing. So sharpen your pencils—and your wits—and let's start drawing some fantastic cryptids!

Crunch!
Some cryptid sightings are reports of existing animals grown to enormous size. There are tales of alligator snapping turtles weighing over four hundred pounds, but I think this loggerhead turtle, depicted by master artist Bernie Wrightson, is large enough to push it into the realm of the fantastic.

DRAGON

Dragons have a long and rich history. They're mentioned in the Bible and in Shakespeare, and both Western and Eastern cultures have many legends and stories about dragons. Dragons are typically depicted as large, powerful, reptilian beasts with scaly bodies, serpentine necks, horns, wings, and four or more legs.

Dragons are believed to have magical or spiritual powers. Some cultures portray dragons as the guardians of huge stockpiles of treasure. In other cultures, dragons are believed capable of human speech and are seen as purveyors of hidden knowledge.

There are several possible explanations for why stories of dragons are so widespread. They may have arisen from people's encounters with dinosaur-like creatures that have since gone extinct. Or they may have grown out of travelers' reports of crocodiles or other unusual animals—animals that grew larger and larger as the stories were retold. As such tales were repeated, the storytellers may have used a little poetic license, exaggerating the animals' attributes and gradually turning them into the flying, fire-breathing dragons of legend.

Fire Breather

There are almost as many different types of dragons as there are human cultures. This one has a large, plated head similar to that of some dinosaurs. Its thick hide is scaly, like a crocodile's.

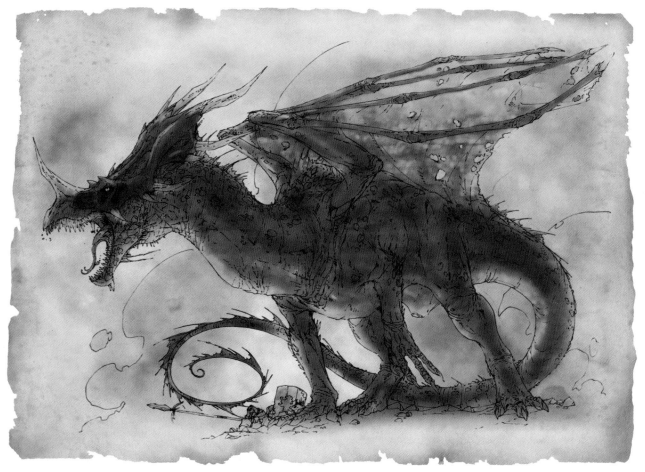

LOCH NESS MONSTER

There is a lake in Scotland with a warning sign that reads, "No Swimming. No Fishing. No Feeding the Giant Aquatic Plesiosaurus." It causes boaters to pause for a moment before setting out across the waters of Loch Ness.

Loch Ness has for centuries been famous as the home of the Loch Ness monster, a prehistoric creature that supposedly inhabits its murky depths. Sightings of the monster date back to the year 565, when St. Columba, an Irish monk, told of having crossed paths with a man-eating dragon near the lake. Since then, there have been numerous other reports of Nessie—as the creature is popularly nicknamed—including one by two young boys who claimed to have seen a smaller "Baby Nessie" swimming in the lake. (Altogether, about three thousand people have claimed to have sighted Nessie.) In the 1960s, the investigation into Nessie's existence became high-tech: Underwater cameras and sonar equipment were hauled in, but no definitive proof was ever found.

Whether or not she exists, Nessie is a true cultural phenomenon—and one of the most famous cryptids ever.

Lady of the Lake
This depiction of Nessie is based on a plesiosaur, an extinct marine reptile. She has a long, serpentine neck, a barrel-shaped body, a small head, and four large fins.

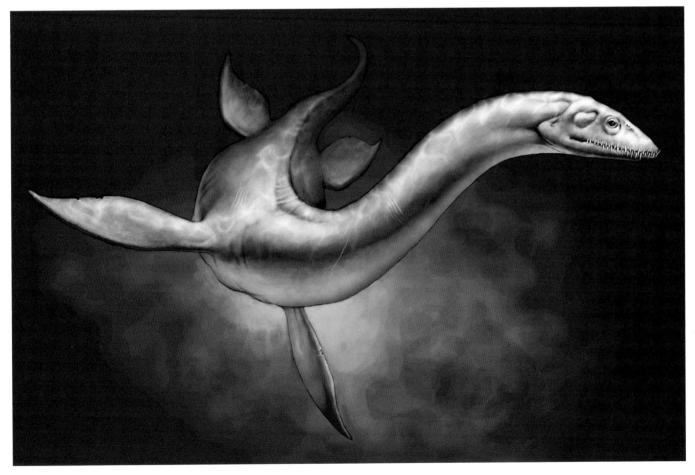

KONGAMATO

With several areas still unexplored, Africa seems to be a hotbed of cryptid activity, and several of Africa's cryptids appear to be holdovers from the Age of Dinosaurs.

The kongamato appears to be a pterosaur—a flying dinosaur. Reports that this ancient airborne reptile has survived into modern times include one from an explorer named Frank Melland. In his 1923 book *Witchbound Africa,* Melland said that the kongamato lived along certain rivers on central Africa and described it as very dangerous, often attacking small boats. According to Melland's account, the kongamato was red in color, with a wingspan somewhere between four and seven feet. Members of the local Kaonde tribe identified it as a pterodactyl after Melland showed them a picture from a book on dinosaurs.

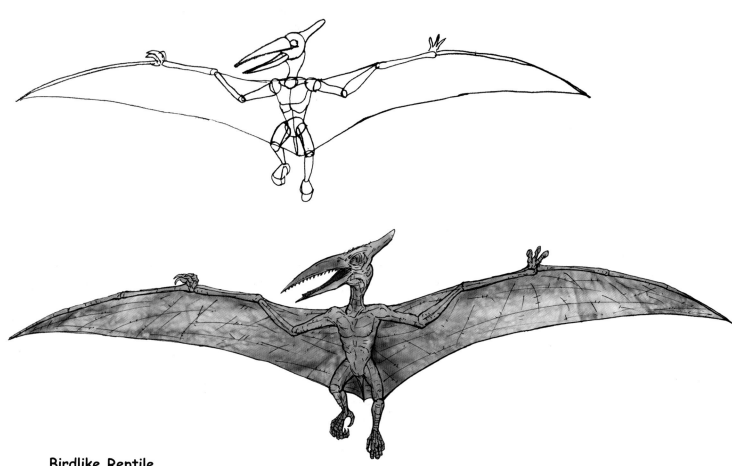

Birdlike Reptile

The kongamato's body is similar to a bird's, but it's covered with red, reptilian skin. The creature has a long, beaklike mouth and a protrusion that emerges from the back of its skull and acts as a rudder in flight. The "arms" form wings like a bat's, and each "hand" is equipped with a set of short but lethal claws.

Extinct? (Or Not?)

Did the Age of the Dinosaurs ever actually end? Although most people believe that all the dinosaurs vanished from the earth millions of years ago, there are reports that some dinosaurs still roam our planet—or fly through its air, as in the case of the kongamato, a pterosaur-like reptile supposedly living in remote areas of Africa.

KASAI REX

Kasai rex is a another dinosaur supposedly living in Africa. It apparently belongs to the group of dinosaurs known as theropods—large, carnivorous dinosaurs that walk upright, on their two hind legs (like the better-known *Tyrannosaurus rex*).There are conflicting descriptions of this creature, but most report that it is reddish in color, with dark stripes running down its back. (The varying descriptions may be due to the fact that people are so afraid of *Kasai rex* that they run away before getting a good look—or maybe there's more than one theropod still walking around Africa!)

Kasai rex has short forelimbs and a tail that's as thick as a tree trunk. Villagers who claim to have seen the monster tell stories of *Kasai rex* attacking and eating rhinoceroses. Needless to say, if *K. rex* does exist, it's at the very top of the food chain.

There have also been reports of a similar dinosaur in the United States—but this one, supposedly, is bright purple in color and is known to sing and play with children. Such reports are widely dismissed as being just too fantastic and absurd to be believed.

T. Rex's Cousin
To draw *Kasai rex,* begin with two ovals—one for the chest and the other for the pelvic area. Like all theropods, *K. rex* has a stiff spine, a semi-flexible tail, and a blocky head. Its long, thick neck should have a slight S-curve.

MOKELE-MBEMBE

Mokele-mbembe's name (pronounced moh-KAY-lee mmm-BEM-bee) means "the one that stops the flow of rivers." This dinosaur-like creature has reportedly been spotted living in the swampy Likouala region of the Republic of the Congo. Much like sauropod dinosaurs—the group of dinosaurs to which it may belong—it has a body similar to an elephant's, with a thick hide and a long, tree trunk-like neck and tail. Its thick, stumpy legs end in flat, clawed feet. It is described as aggressive—and even as a killer—but not as a meat-eater, which lends credence to the theory that the mokele-mbembe is a herbivorous dinosaur that has somehow managed to survive to the present day.

Thunder Lizard

The mokele-mbembe is described in terms identical to some sauropod dinosaurs, so books on dinosaurs will be valuable references when drawing this cryptid. (As will my own book *Dinosaurs: How to Draw Thunder Lizards and Other Prehistoric Beasts*.) The mokele-mbembe's central body mass is barrel shaped. It has stout legs and a long neck, but a very small head. The skin is pebbly, with many wrinkles.

MEGALODON

In the movie *Jaws,* the great white shark is called "a perfect killing machine," but if it is perfect, then the megalodon was the *ultimate* killing machine. Great whites max out at about twenty feet in length; megalodon was over fifty feet long! It is widely believed that the megalodon (scientific name, *Carcharodon megalodon*) was the largest predatory fish ever to have lived. If the fear of great whites keeps swimmers away from the beaches, imagine what would happen if reports could be corroborated that this awesome hunter still prowls the murky ocean deeps. Of course, a megalodon would find a human being less filling than an order of fish sticks. Megalodons much preferred to dine on slightly larger fare—like full-grown whales! There has been a steady increase in sightings of large, sharklike forms patrolling the oceans, but most scientists believe the megalodon to be extinct. Regardless, megalodon was at one time the top predator of all the seas.

Swimmers Beware
When drawing a megalodon, remember that its body is similar to a cigar in shape; with its mouth open this huge shark looks like an airplane hull with the cockpit cut off.

Saber-toothed Tiger

Sometimes animal's names just sound like playground taunts. If you had teeth the size of bananas, would you want everyone calling you saber-tooth?

Fortunately for him, this cat could give as good as he got. His outsize canines could reach lengths of up to seven inches. While it's generally agreed that the saber-toothed tiger used its tusklike teeth for hunting, no one knows what the teeth's exact function was. Some speculate that the cat used them for grabbing and holding prey, allowing the saber-tooth to deliver the slashing death blows with its feet.

A more plausible theory is that the saber-tooth would lunge onto its quarry and plunge its teeth into the victim's neck, achieving a kill in one strike. Since this method of attacking prey is common to most stalking cats today, it makes sense to think that the saber-tooth used it, too. The saber-toothed tiger was between four and five feet long, stood three feet tall at the shoulder, and weighed about 440 pounds, making it close to a modern leopard in size, so it seems logical that it may have lived, hunted, and mated in way similar to that present-day great cat.

Note that although there's no scientific evidence for the existence of some cryptids, others, like the saber-tooth, were at one time very real—and we have the fossils to prove it. The only real question is whether they all died out, or if some still exist in a remote corner of the world.

Dentist's Nightmare

The saber-tooth is a close cousin to some of the large cats we drew earlier. Its legs are shorter and it has a stockier build, but otherwise you'll use the same basic forms you used when drawing lions and tigers. One minor difference is that the saber-tooth has a large muscle mass between its shoulder blades, giving it a hump.

CHUPACABRA

One of the best known and most feared cryptids is the chupacabra. The creature earned its name, which means "goat sucker" in Spanish, because it supposedly attacks livestock (especially goats), drinking the blood of the animals it kills.

The chupacabra, if it exists, appears to inhabit the Americas; there have been widespread sightings in Puerto Rico, Mexico, South America, and even in the southern and southwestern United States—although one report of a chupacabra attack came from Russia! (It also makes occasional appearances on the Sci-Fi Network.)

In September 1995, a group of eyewitnesses claimed to have spotted a creature "three or four feet tall, with skin like that of a dinosaur. It had bright eyes the size of hen's eggs, long fangs, and multicolored spikes down its head and back." Other witnesses have said that the chupacabra looks like it's part kangaroo and part space alien, with the wings of a bat. Yet another eyewitness said, "Its height was about four feet tall, with a large head, a lipless mouth, fangs, and lidless red eyes. . . . Its body was small, and it had scrawny, clawed arms and webbed bat wings and muscular hind legs that appeared to be for leaping."

Because the chupacabra seems to prey mainly on livestock, it probably won't be especially interested in you (unless, of course, you have horns and udders). It makes a single hole in its victim, from which it sucks its blood, but it's not clear how it accomplishes this—whether through a specialized "tongue straw" or by using mouth parts similar to a spider's. Several attempts have been made to capture this creature, but none has been successful. For all the reports of mutilated livestock and all the apparent sightings, there is no solid evidence for the chupacabra's existence. Possibly, it's just a story that mother goats tell their kids to get them to behave.

Goat Sucker
There's no "correct" way to draw a chupacabra, because the various reports of this cryptid differ so widely. But no matter how you draw the creature, it had better look like it's capable of sucking the juice out of goats.

SASQUATCH

Sasquatch means "hairy man" in the Salish Indian language. The northern cousin of the American cryptid called Bigfoot, Sasquatch dwells in western Canada and is described as a hairy, nine-foot-tall nomadic humanoid with a pointy head. Sasquatch also stinks—with a strong, musky odor. Not exactly the type of guy who finds it easy to land a date, so maybe that's why there seem to be so few Sasquatches in existence.

Sasquatch stands erect like a human being but is several times stronger than a man. From the reports, it sounds as if he looks similar to a Neanderthal, with a highly expressive face and piercing, intelligent eyes. On rare occasions, two Sasquatches have been spotted together, and witnesses say that the creatures appear to communicate in a rudimentary language. The long hair that completely covers Sasquatch's body can be black, brown, or reddish with lighter highlights; it's possible that the color changes with the seasons. Sasquatch's pungent odor has won him the nickname "skunk ape."

Ape Man

Sasquatch is built like a cross between a man and an ape. He has a large, somewhat pointed forehead, which gives him a slight cone-headed appearance. The strong muscles in his arms are evident even through the thick fur.

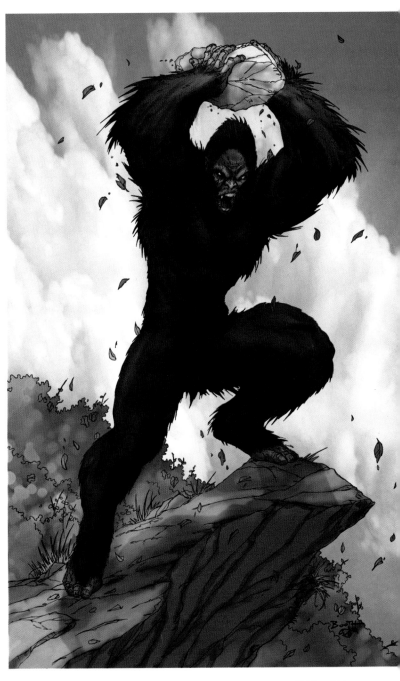

YETI

The yeti, or abominable snowman, is a humanoid creature that supposedly lurks in the Himalaya Mountains. The yeti is said to be surprisingly silent for its size—reportedly over seven feet tall and weighing between four hundred and five hundred pounds. Described as shy, a yeti will only attack people if cornered. Those who have escaped such attacks report that the yeti is stocky, agile, covered with thick fur, and malodorous. The yeti has humanlike facial features and can walk upright or in an apelike way, using its long arms for support in heavy snow.

Many scientists believe the yeti to be a hoax, but (as with many other well-known cryptids) the many eyewitness reports and the yeti's frequent appearances in folk literature lend some credibility to the creature's existence. In fact, the "wild man of the woods" is a popular character in folklore from around the world, and these tales may be the basis for the yeti and his humanoid cousins Bigfoot and Sasquatch. In folktales, the wild man is sometimes a demon, sometimes a unique force of nature not meant to be seen by human eyes, and sometimes an ordinary man who has devolved to a more primitive state because of his prolonged life alone in the wilderness. In Slavic folklore, he is a wood spirit known as the leszi; in ancient Sumerian mythology he appears as Enkidu in the *Epic of Gilgamesh*; and in the Anglo-Saxon epic *Beowulf,* he is the subhuman monster Grendel.

Contemporary reports of giant footprints found along Himalayan trails and sightings of a strange primate-like creature that disappears into the whipping snow are routinely dismissed as tall tales. But—who knows?—perhaps as scientists continue to study Neanderthals and other "missing links," their investigations might lead them to find harder evidence of this nomadic mountain dweller's existence.

Abominable Snowman
The yeti is very similar to Sasquatch, and the two may be subspecies of the same creature.
Draw the yeti with elongated arms—which it uses to propel himself through thick snow

MERMAID

So you're hopelessly lost at sea, when out of the deep blue comes a topless lass with an alluring voice who pulls you in to shore. What do you do? Apparently, most salty dogs hit the nearest saloon and tell of their perilous adventure over a stiff pint.

Sailors from all parts of the world have told amazingly similar tales of beautiful, half-woman, half-fish creatures that live in the sea. These fantastic beings were long ago dubbed "mermaids"—a name that comes from the Middle English word *mere,* meaning "sea," combined with "maid" (in the sense of "maiden").

All mermaids are beautiful—but not all of them are helpful to wayward seamen. In some stories, they entice seafarers to follow them and then run their ships aground on rocks or sandbars. (I can't imagine that the excuse "A mermaid made me do it" carries a lot of weight with the shipping companies.) In some stories, mermaids' singing causes madness—just like the Sirens from Greek mythology or the modern-day Spice Girls. And then there are the stories in which the mermaids skip the whole song-and-dance routine and go straight for the kill—drowning hapless sailors and sucking the marrow from their bones. Apparently, most warnings about the hazards of mermaids have been ignored by sailors, who are just too enchanted by the promise of attractive topless girls.

A Fishy Tale (and a Fishy Tail)

Drawing a mermaid is just a matter of combining a fish with a lady. But do be sure that the lady half goes on top and the fish half on the bottom, because the other way around would be too weird. Even though a mermaid's scales begin at the waistline, the waist itself is that of a human female. The tail should be fluid and curvy to accentuate the overall feminine form.

INDEX